People

100

THE 100 BEST CELEBRITY PHOTOS

Table of **CONTENTS** | 100

➜ RED CARPET MOMENTS

Army Sgt. Elvis Presley meets
photographers (1960).

SNAPSHOTS FROM HOLLYWOOD'S MOUNT OLYMPUS

BY JESS CAGLE

MORE THAN 90 MILLION PEOPLE FOLLOW JUSTIN BIEBER on Instagram. On July 13, 2017, he posted a photo of himself with his pastor, and it received 2.2 million "likes." But the next day Beyoncé (105 million followers) surpassed Bieber when she shared a photo of herself holding her new twins, Rumi and Sir Carter. Nearly 10 million people liked it—and the whole world loved it. While Instagram is relatively new, our fascination with celebrities is not. Before Bieber, there were the Beatles. Before Beyoncé, there was Madonna. Media empires have been built on our desire to look at pictures of celebrities in magazines, on websites, on social platforms—to see what they're wearing, to see what they're up to, to see who they're with. Why do we care? How did star-gazing become one of humanity's favorite pastimes?

Evolutionary psychologists and behavioral experts offer various answers. Some say we are social creatures who instinctually observe and sometimes mimic individuals with status: Americans have their movie stars, the British have their royalty, and the Greeks had their gods and goddesses. A lot of us, especially young people, look to the stars to help us form our own identities.

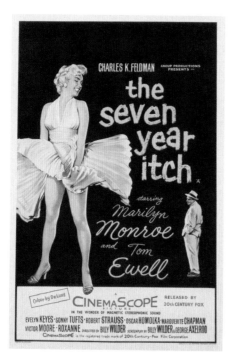

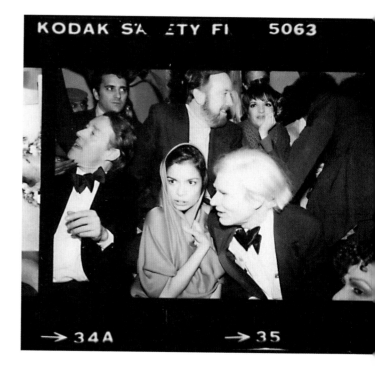

Of course, we also like to look at pretty people, simple as that. Pictures of celebrities going about their lush lives provide a kind of escape. (It's fun to imagine, for a moment, that you're surfing with a Hemsworth.) Insight on the most-talked-about celebrities gives you social currency. I've been to a lot of parties, and I can tell you that without fail there are five words that will cause the whole room—academics, scientists, politicians, titans of business—to stop and listen: Brad Pitt and Angelina Jolie.

When I was a kid, looking at photos of movie and TV stars in magazines provided proof of life beyond the small town in Texas where I lived, proof that people like me—guys more at home in a movie theater than on a football field—stood a chance of belonging. As we put this book together, I came across Robin Platzer's famous picture of Halston, Andy Warhol, Bianca Jagger and Liza Minnelli at Studio 54 on New Year's Eve 1978. I experienced once again the excitement and envy I felt for their glamorous lives—at least they seemed glamorous to a 12-year-old in Abilene.

It sounds like a fool's errand to set out to pick the best celebrity photographs. So many to choose from! But this is *People* magazine, which every year voluntarily assumes the impossible responsibility of determining the Sexiest Man Alive; we are not afraid to go out on a limb. Photos in this book made the cut for various reasons. Some are iconic (Marilyn Monroe on a subway grate in a billowing skirt, page 156); some rocked the world (Jane Fonda

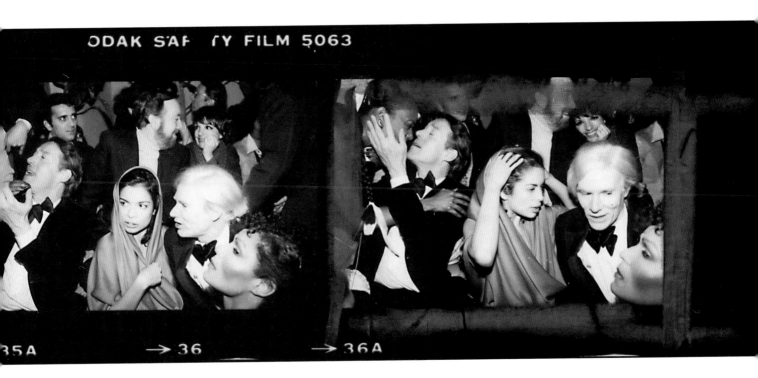

ODAK SAF TY FILM 5063

35A → 36 → 36A

Left: Sam Shaw's Marilyn Monroe became the basis for a *Seven Year Itch* poster. Above: three views from Studio 54 by Robin Platzer.

surrounded by North Vietnamese soldiers in Hanoi, page 176); some capture our idols in very human situations (Jack Nicholson and Anjelica Huston at home and in love, page 90); some cleverly reflect the culture (Bradley Cooper taking a selfie on Ellen DeGeneres's phone with a constellation of stars at the Oscars, page 208).

Other pictures here have become great over time. In a 1963 image taken by Lawrence Schiller, 6-year-old Carrie Fisher sits alone in the wings of a Las Vegas theater, not missing a beat while she observes her mother, Debbie Reynolds, holding the stage alone (page 80). It's a lovely photo, but its real power wouldn't be realized until decades later, after both Carrie and Debbie had taken their final bows. Among my personal favorites: a picture of Joan Crawford accepting her Oscar in bed in 1946 (page 152). The photo says so much about showbiz—a star who's mastered the art of self-promotion (by calling in "sick" on Oscar night, she made them come to her) and a grateful press, happy to play along. Another favorite: Amy Schumer "falling" in front of Kim Kardashian and Kanye West on the *Time* 100 Gala red carpet (page 214). One of the funniest people on the planet pranking two of the most humorless. Priceless.

I hope to do more books like this, because, to be honest, there are so many great photos we just didn't have room for. You could do entire books, for example, on red carpet style or images from Old Hollywood. By and large the 100

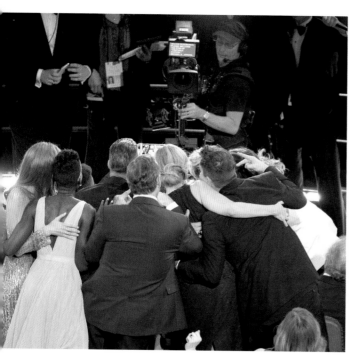

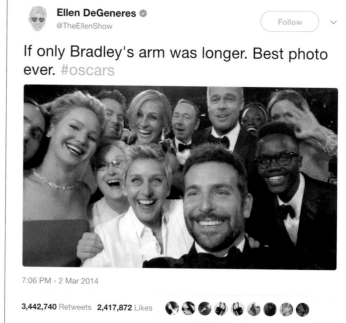

> Ellen DeGeneres ✓
> @TheEllenShow
>
> [Follow]
>
> If only Bradley's arm was longer. Best photo ever. #oscars
>
> 7:06 PM - 2 Mar 2014
>
> **3,442,740** Retweets **2,417,872** Likes

The making of a viral image (above): Oscar guests squeeze in for a 2014 group selfie seen in Ellen DeGeneres's much-shared tweet. Opposite: Some of the photographers whose work is featured inside.

photos included here—at turns poignant and hilarious, profound and silly—show the evolution of modern celebrity. They are the work of some of the greatest photographers in any genre. You'll see portraits by early masters of glamour like Sid Avery, who took on a reticent Humphrey Bogart (page 66) to capture the tough guy's domestic side, and the best of current-day artists like Robert Trachtenberg, whose collaboration with a more willing subject, Jennifer Aniston (page 36), shows the actress gamely posing with mannequins from the confines of a box in order to give a knowing nod to the singular fame of her "Rachel" hair. Also here is the too rarely celebrated work of unnamed news or studio staff photographers—anonymous shooters who created some of our favorite images, including the one on the cover of George and Amal Clooney in Venice, hours before becoming husband and wife.

The pictures inside speak volumes about the eras in which they were taken and capture the essence of their subjects. Just look at that adorable photo of Drew Barrymore at age 7 sitting on Johnny Carson's couch (page 184). Her feet won't touch the floor for a few more years. But look at that face, those eyes—already radiating the warmth and charisma that would make her a star and the intelligence that would make her a producer, a survivor, an icon. By capturing a fascinating subject at the perfect moment, this unassuming photo tells the future.

Cagle is editor-in-chief of People *and editorial director of Time Inc. Style & Entertainment Group.*

Sid Avery

Danielle Levitt

Robert Trachtenberg

Gordon Parks

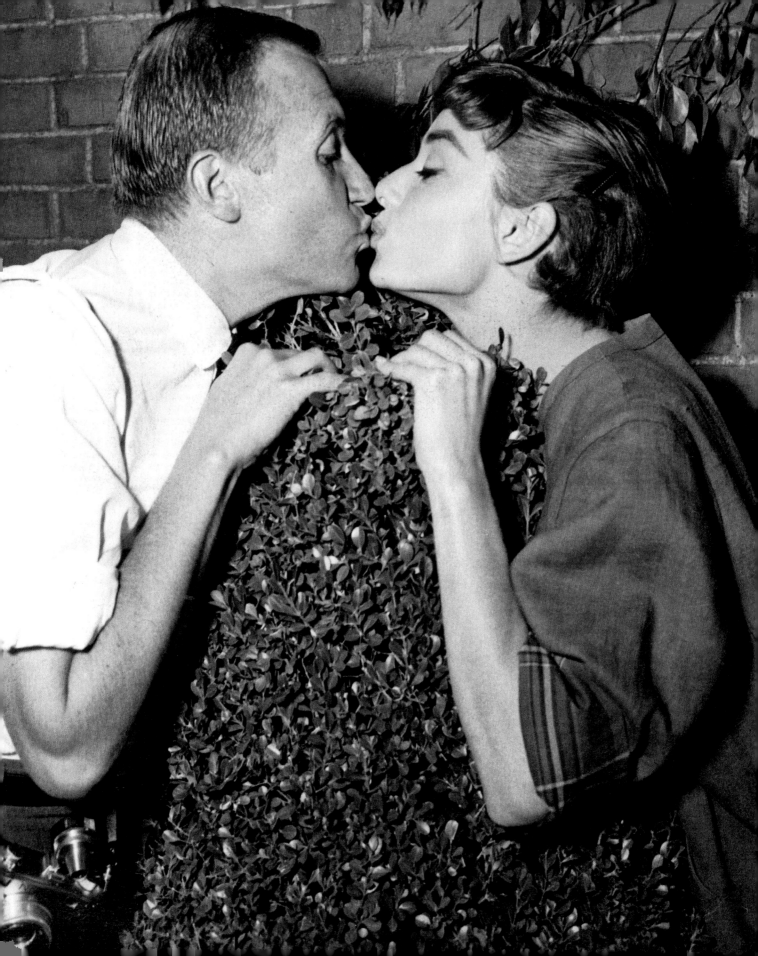

STRIKING A POSE

BY CATRIONA NI AOLAIN

IT'S MATCHMAKING, REALLY. PAIR THE RIGHT PHOTOGRAPHER and subject. To me, that's what makes an ideal celebrity portrait. Every photograph stops a moment in time, and the best ones endure for the ages. But unlike news images or, say, fashion pictures, a great celebrity portrait requires manufacturing—then capturing—a spark not so different from the adrenaline hit of a crush. That's what I find delightful about the images on these pages. Martin Schoeller turns a spotlight on Taylor Swift at a crossroads, and the star confidently shows us her bright future. As Art Streiber and Tracee Ellis Ross send up awards-show egotism with some selfie fun for *People*'s Emmy-nominee portfolio, his camera also sees the glow of her well-deserved pride. Robert Whitman meets Prince when both are struggling to get their careers going. That shared drive bonds them enough for the earnest young musician to crack a smile and allows Whitman to preserve a little-seen side of a future legend. Mark Shaw's dawn-to-dusk shoot with Audrey Hepburn led to the playful photo at left—they had time to get to know each other and to goof around. These days that's a rarity. Many sessions are produced in tiny pockets of time, owing to stars' well-guarded schedules. Complicating matters, celebrities hold strong ideas of how they want to be portrayed, so it's more important than ever to get the match right: Set a star up with a photographer who can make them feel comfortable dropping the artifice, showing an authentic self and, by doing so, letting us all fall in love.

Ni Aolain is People*'s director of photography.*

AUDREY HEPBURN | *Mark Shaw, 1953*

'She had it. And there will not be
another' — Billy Wilder

TODAY THIS IS A PICTURE OF A SCREEN AND STYLE LEGEND. In 1953 it captured a young woman on the brink of stardom. Up to that point Audrey Hepburn had made only one Hollywood movie, *Life* magazine observed in 1953, "but already…she has caused more talk than any recent actress, including Marilyn Monroe." In part that was because the movie in question—*Roman Holiday,* in which Hepburn plays a duty-bound princess who escapes for a day of incognito fun with an American reporter (Gregory Peck)—was a smash. But it's also because the 24-year-old Dutch import had a gamine glamour, as well as an elusive je ne sais quoi, that set her apart. "She is both waif and woman of the world," *Life* reported in its Dec. 7 cover story, shot by photographer Mark Shaw (later famed for his Kennedy family snapshots). "You can imagine her lifting a lorgnette at a ball or milking a cow in a barn." Shaw recorded her day's labors, beginning with a 6:30 a.m. commute to the studio, script study, makeup—and, in this shot, a ride to the set of her next film, *Sabrina,* directed by Billy Wilder. Hepburn's work ethic and soulful grace reflected her extraordinary origins: The daughter of a Dutch baroness and a British businessman, she'd spent her adolescence in Nazi-occupied Amsterdam, where she and her family ate tulip bulbs to ward off starvation, and she gave ballet recitals to raise funds for the Resistance. After *Roman Holiday* earned her an Oscar for Best Actress, she went on to star in classics like *Breakfast at Tiffany's* (1961) and *My Fair Lady* (1964), to do humanitarian work as a Goodwill Ambassador for UNICEF and to serve as a style inspiration for generations to come. "There is no one like her," director Billy Wilder told *Life*'s reporter. Nor has there been since.

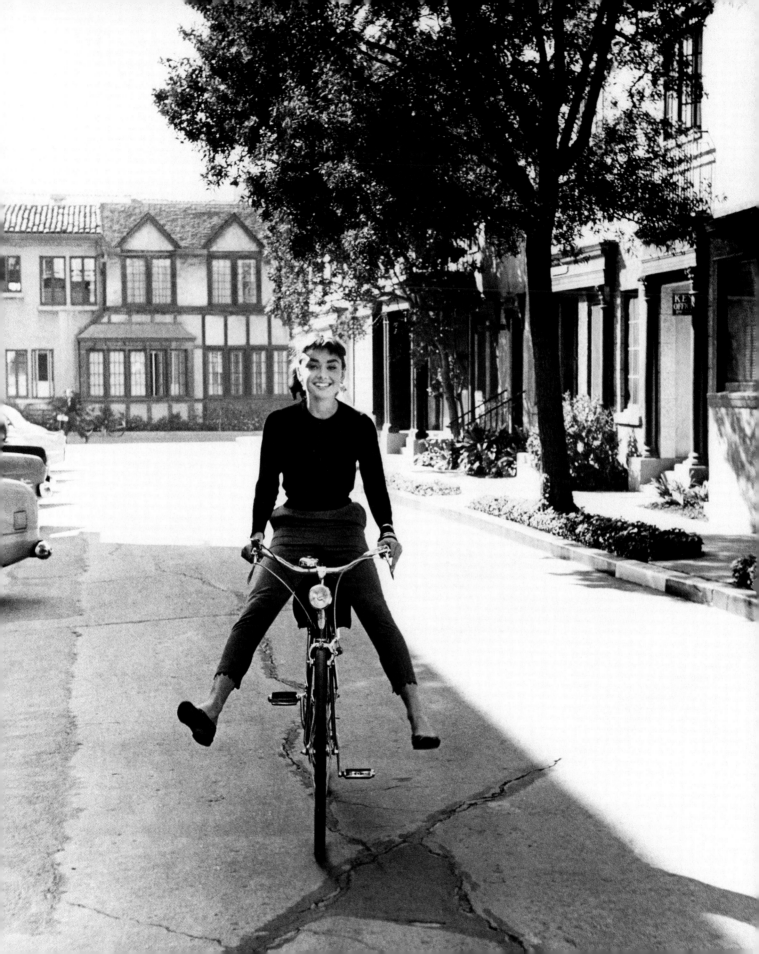

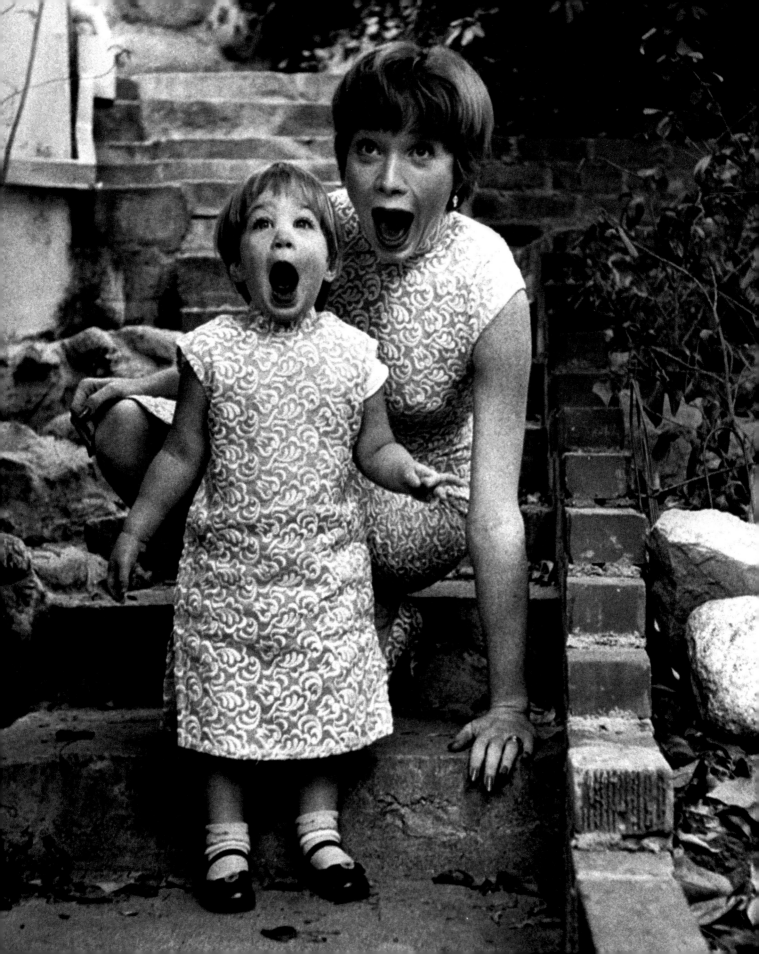

SHIRLEY MACLAINE AND SACHI PARKER | *Allan Grant, 1959*

'WITH
PROFESSIONAL
SCENE-STEALERS,
SHIRLEY CAN
HOLD HER OWN…
BUT AT HOME
WITH SACHI SHE IS
JOYOUSLY HELPLESS'
—*LIFE* MAGAZINE

AT 24, SHIRLEY MACLAINE HAD JUST RECEIVED HER FIRST Academy Award nomination, for her portrayal of a kindhearted floozy in *Some Came Running*. As the final vote approached, she scored a cover story in *Life,* an ideal vehicle to enhance her image. The photo-driven item focused on her real-life role as the mother of an adorable 2½-year-old. Sachi, her daughter with producer Steve Parker, was "a small-size scene-stealer who mimics Mama's every gesture," the magazine observed. It was a classic piece of 1950s celebrity journalism, reflecting a postwar hunger for domestic bliss. Unfortunately it didn't put MacLaine over the top with Oscar voters; she wouldn't win until 1983's *Terms of Endearment.* The actress and writer would go on to appear in more than 65 films and publish more than a dozen memoirs, revealing not only her personal life (including affairs with Robert Mitchum, Yves Montand and Swedish prime minister Olof Palme) but a passion for New Age spiritual pursuits and an obsession with UFOs. Sachi went on to become an actress herself but garnered greater attention in 2013, when she published a tell-all accusing her mother of being alternately neglectful, controlling and delusional. Although MacLaine dismissed the book as "virtually all fiction," the public set-to underscored an enduring truth: Even in our reality-show era, it's impossible to know what goes on behind a seemingly happy family's closed doors.

GOLDFINGER PRESS CONFERENCE | *Paul Popper, 1964*

'A martini. Shaken, not stirred'
—James Bond (Sean Connery) in *Goldfinger*

SHE'S ONSCREEN FOR LESS THAN FIVE MINUTES, and given that the film's leading lady is christened Pussy Galore, you may not remember this ill-fated character's name: Jill Masterson. Sean Connery and Honor Blackman were the stars of *Goldfinger,* the third James Bond film and first blockbuster (and, many still argue, the best) in the series. But the movie's canny publicity team knew just what they were doing when they invited press photographers onto the D stage at England's Pinewood Studios for a peek at actress Shirley Eaton, playing the most seductive of the title villain's minions in little more than a bikini bottom and a lot of gold paint. "It was a nice sensation, being painted all over with this fine brush," Eaton once recalled. In the film she is asphyxiated by the gilding; on the set a doctor monitored the actress's condition. With its release, *Goldfinger* (directed by Guy Hamilton) set the template for every Bond flick to come, from the pre-credits action teaser to Q's array of high-tech gadgets to the way Bond orders his martinis. It helped transform Connery into an enduring sex symbol: The Scottish actor, a veteran of British TV productions of Shakespeare and O'Neill, brought wit to his portrayal of the supernaturally suave, inexhaustibly resourceful, athletically libidinous hero. "Bond, you see, is a kind of present-day survival kit," Connery said, explaining the character's popularity. "Men would like to imitate him...and women are excited by him." There was just one problem: Connery was "fed up to here" with the role. Fortunately for the studio, it was Bond they loved most of all, and when Connery set down the martini glass, there were others—from Roger Moore to Daniel Craig—to pick it up.

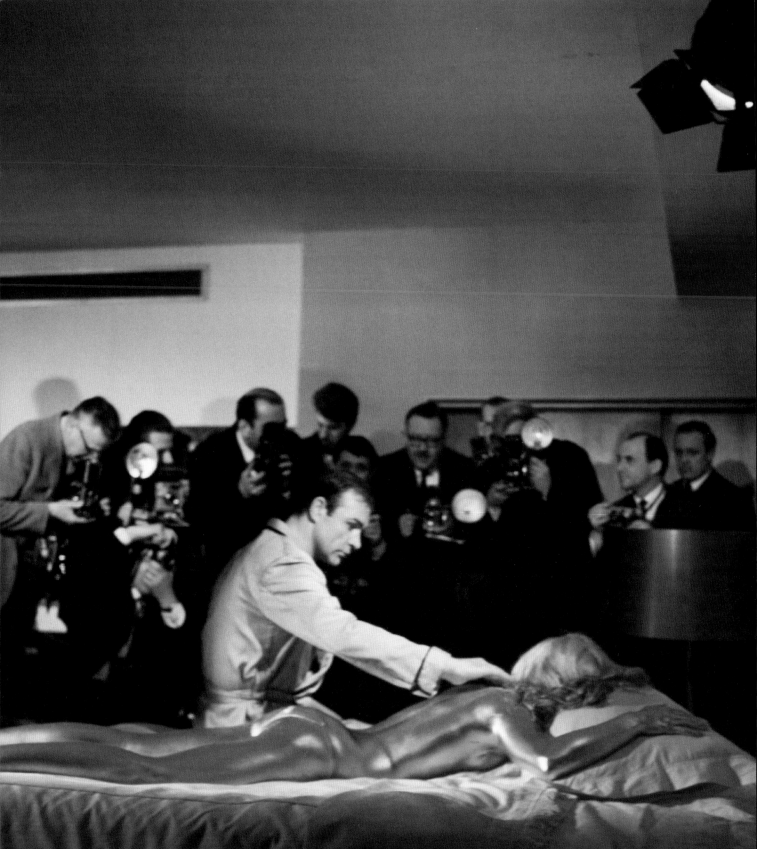

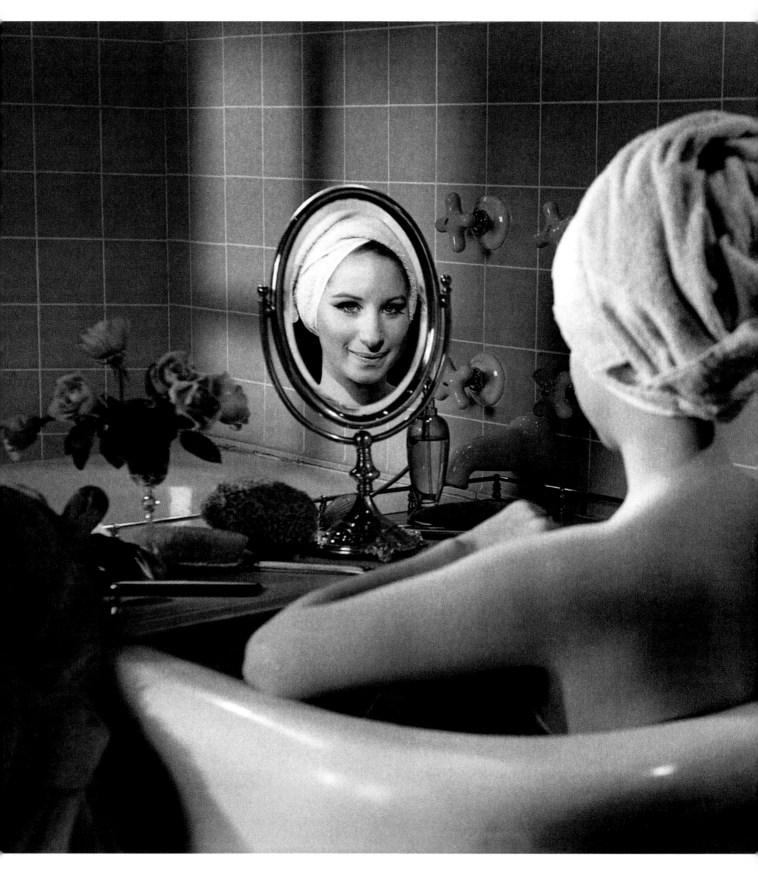

BARBRA STREISAND | *Steve Schapiro, 1967*

'I arrived in Hollywood without
having my nose fixed, my
teeth capped or my name changed.
That is very gratifying to me'
— Barbra Streisand, to columnist
Sidney Skolsky in 1972

SHE WASN'T A CONVENTIONAL beauty, and her accent was straight outta Brooklyn. But her talent and drive were overwhelming. That description applies equally to Barbra Streisand and Fanny Brice, the early-1900s comic chanteuse Streisand portrayed in her first film, the musical *Funny Girl.* (In this photo, shot on the set, she's preparing to sing "Sadie, Sadie," in which Brice marvels at having snagged her dream husband, played by Omar Sharif.) Streisand, 26, was already a star onstage and on TV, with a couple of hit records; her turn as Brice on Broadway landed her on the cover of *Time.* But the movie—a global smash that earned her an Oscar for Best Actress—put her on an unparalleled career trajectory. One of the top-selling female singers of all time (nearly 250 million records worldwide, at last count), she is also the only solo artist to have No. 1 albums in six consecutive decades. She's made a slew of acclaimed films, both as actor (from *Hello, Dolly!* to *The Way We Were* to *Meet the Fockers*) and director (*The Prince of Tides, Yentl, The Mirror Has Two Faces*), and picked up a Best Song Oscar for cowriting "Evergreen," the love theme from *A Star Is Born.* That film, along with 1972's *What's Up, Doc?,* found Streisand back in the bath in increasingly steamier scenes; the Funny Girl was now a leading lady.

MIA FARROW | *Steve Schapiro, 1974*

'When I first saw Mia Farrow on the set,
I thought she was ravishing, just breathtaking'
—Frances Scott Fitzgerald Smith

FOR ITS PREMIERE COVER, DATED MARCH 4, 1974, *People* chose the most-talked-about actress of the moment: Mia Farrow, then appearing opposite Robert Redford in an adaptation of F. Scott Fitzgerald's 1925 novel *The Great Gatsby*. Farrow, 29, had bested several stars (including Ali McGraw, Candace Bergen and Faye Dunaway) for the role of Daisy Buchanan—the wealthy, unhappily married object of Gatsby's obsession. Fitzgerald's daughter Frances endorsed the casting, telling *People*, "She looked just like my father's Daisy Buchanan should look." To convey that look, *People* tapped Steve Schapiro, then known for his searing images of social turmoil. His picture of Farrow—taken at a Newport, R.I., mansion—caught her delicate allure and also the languid intensity of her performance. What the picture didn't show: The actress, then wed to composer-conductor André Previn, was pregnant during filming, her condition concealed by loose dresses and tight close-ups. Schapiro returned to documentary photography; Farrow took other roles and added activism to her résumé; while *People* published thousands more covers (and counting...). But you never forget your first. Neither did our subject. On the magazine's anniversary in 2016 Farrow tweeted the image with a note: "Such an honor to be on your first cover."

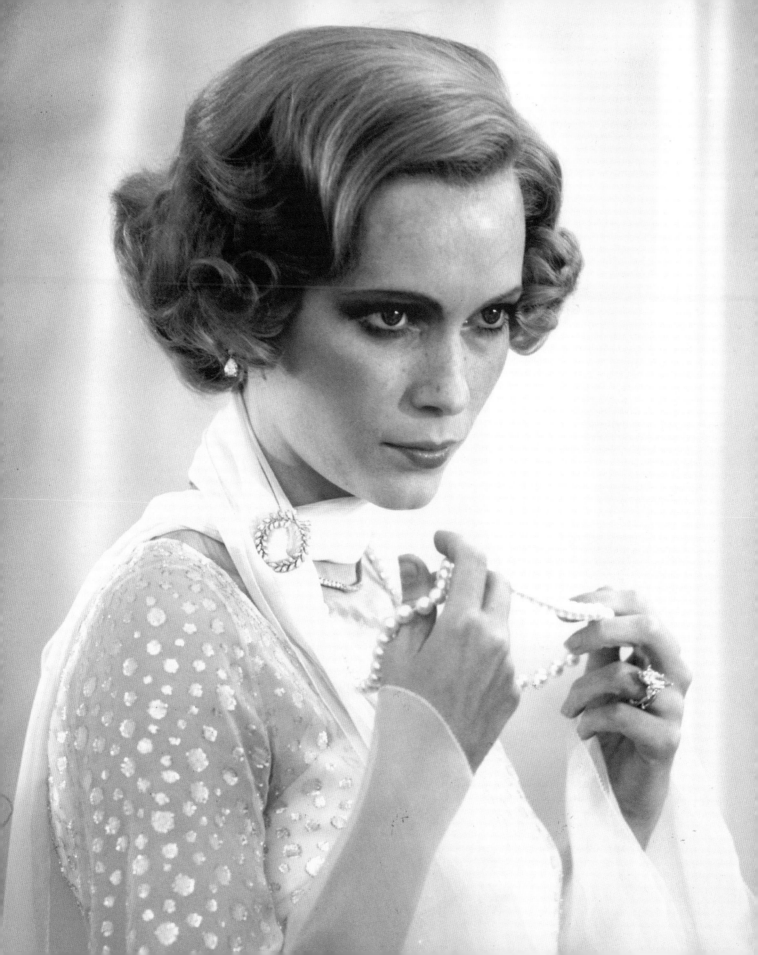

FAYE DUNAWAY | *Terry O'Neill, 1977*

'It's become one of the most Hollywood
pictures of all time' —Terry O'Neill

LONDON-BORN TERRY O'NEILL'S PORTFOLIO SPANS more than half a century—a vast gallery of artists, athletes, Presidents, pop stars and screen idols. But few O'Neill images are more celebrated than the "morning after" photo, shot at dawn on March 29, 1977, after Faye Dunaway won the Academy Award for her performance in *Network*. With her cut-glass cheekbones and edgy grandeur, Dunaway was a defining film actress of the late 1960s and 1970s, and when *People* assigned O'Neill to shoot her, she wasn't hard to get: He was living with Dunaway at the time (they were later married, from 1983 to 1987). "While we were doing the pictures, I said to her, 'I've been to the Oscars before. If you win, they always take the same pictures of you receiving the statue in the press room.' I knew that wasn't the real story," said O'Neill in 2015 to *New York* magazine. "The real story is the next day, when [winners] realize suddenly they're getting all these offers to do films, their value goes from $100,000 to $10 million, and they're just sort of stunned. I wanted to capture that, so I told her my idea, and she was sport enough to do it early in the morning at the Beverly Hills Hotel. She got up at 6 a.m., and we got that great picture."

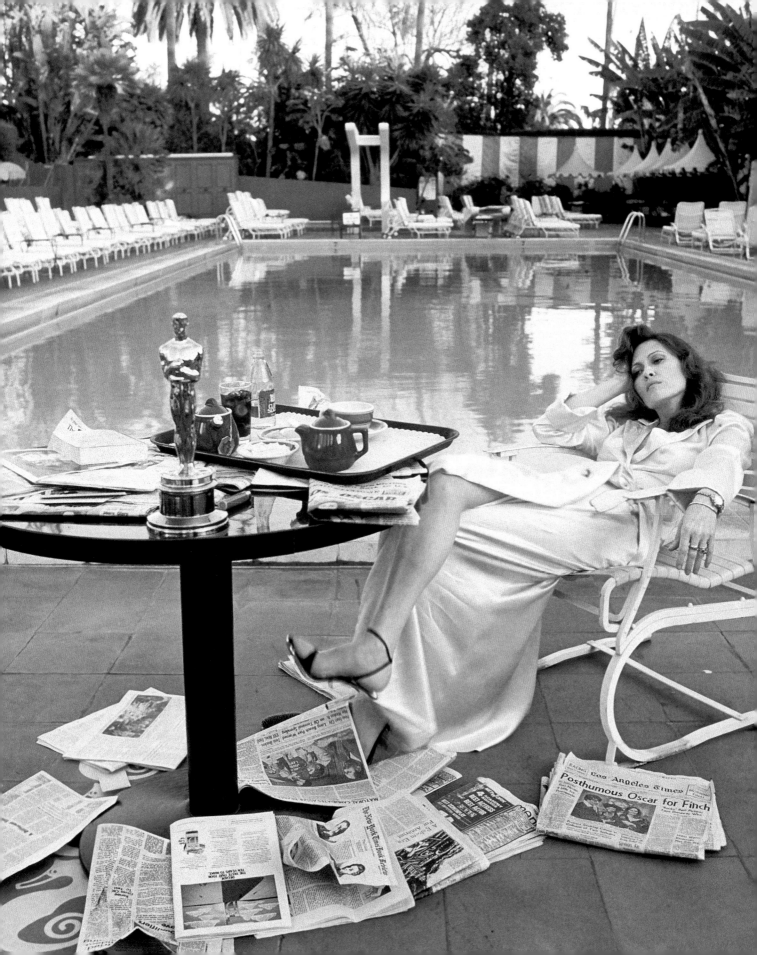

PRINCE | *Robert Whitman, 1977*

'I had a massive ego. Massive. But that's not such a bad thing. Because at least you're aspiring to be something—you consider yourself great because you want to be great'
—Prince, in 1996, to *NME*

IN 1977 ROBERT Whitman was a struggling photographer in Minneapolis when he got a call from a pal, Owen Husney, a novice music manager. Husney's client, a 19-year-old Prince Rogers Nelson, needed some photos for a press kit. "They took me down to the studio," Whitman recalls, "and I thought, this guy is amazing." Nelson, using just his first name for the stage—wrote infectious tunes, sang in a thrillingly funky falsetto, and could play any instrument. Whitman shot him all over town (including in this music-store parking lot), with Prince blowing bubbles, playing with Husney's dog, and posing shirtless with sequins glued to his skin. "I didn't really know what I was doing, and he was somewhat shy," says Whitman, "but he was totally open to everything." Soon Prince had a record contract and was on his way to superstardom. Whitman showed his Prince pictures at galleries, but they were never published until 2016 after Prince had died at age 57. "You rarely see a photo of Prince laughing," Whitman notes. "I made him laugh."

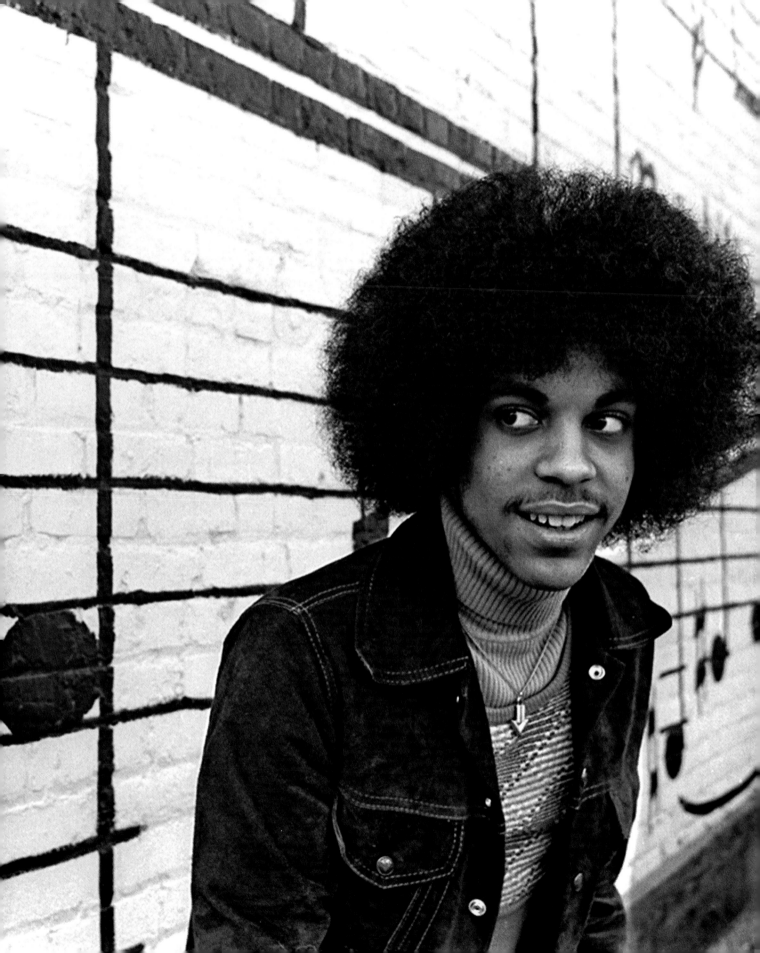

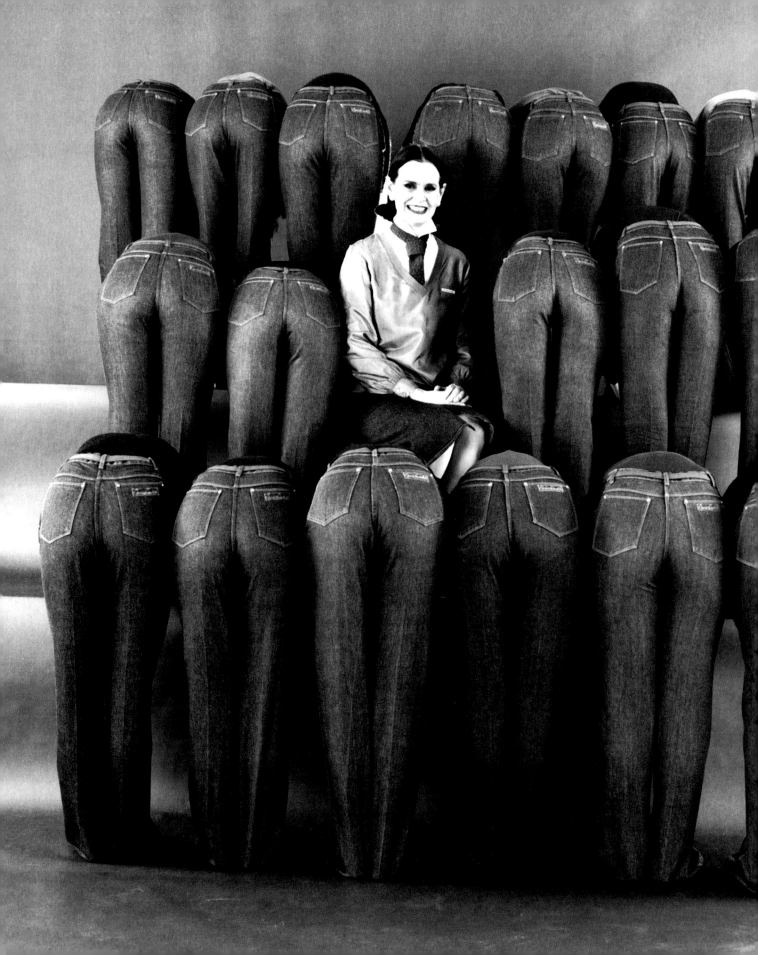

'FASHION IS VERY
MYSTERIOUS.
THINGS GET TO BE
IN THE AIR.
IT'S ALL TIMING'
—GLORIA VANDERBILT

THE GREAT-GREAT-GRANDDAUGHTER of railroad tycoon Cornelius Vanderbilt, she was born into a social stratum in which denim was reserved for the outdoor help. But Gloria Vanderbilt was not your typical blue blood. A baby when her alcoholic father died of liver disease in 1925, she was known in the tabloids as "Poor Little Rich Girl" while her mother and aunt battled over her custody. Three marriages ended in divorce; her fourth, to writer Wyatt Cooper, ended with his death during heart surgery. "I have a very strong impulse to make order out of chaos," she told *People* in 1979. She'd channeled that impulse into painting and sculpture, acting on Broadway and TV, and designing housewares and dresses. In 1976 Murjani International approached her about a clothing line. "Why don't we make a really great-fit jean?" she suggested. The sexed-up dungarees bore Vanderbilt's signature on the rear and a swan (commemorating *The Swan,* a play in which she'd appeared) in front. Although at around $35 they cost twice as much as ordinary jeans, her cachet—and her tireless promotion—helped make them a massive hit. Vanderbilt's 12-year-old son, future CNN host Anderson Cooper, amused himself by counting the pairs he saw daily on the street. For *People*'s 1979 photo, Evelyn Floret surrounded her subject with 18 models in those fancy pants, but as she began shooting, she found their faces distracting. When she proposed a posterior perspective, Vanderbilt seemed startled but didn't object. "She was so gracious and cooperative, and she was truly beautiful," Floret recalls. The image became an emblem of the designer's lasting impact on the world's derrieres.

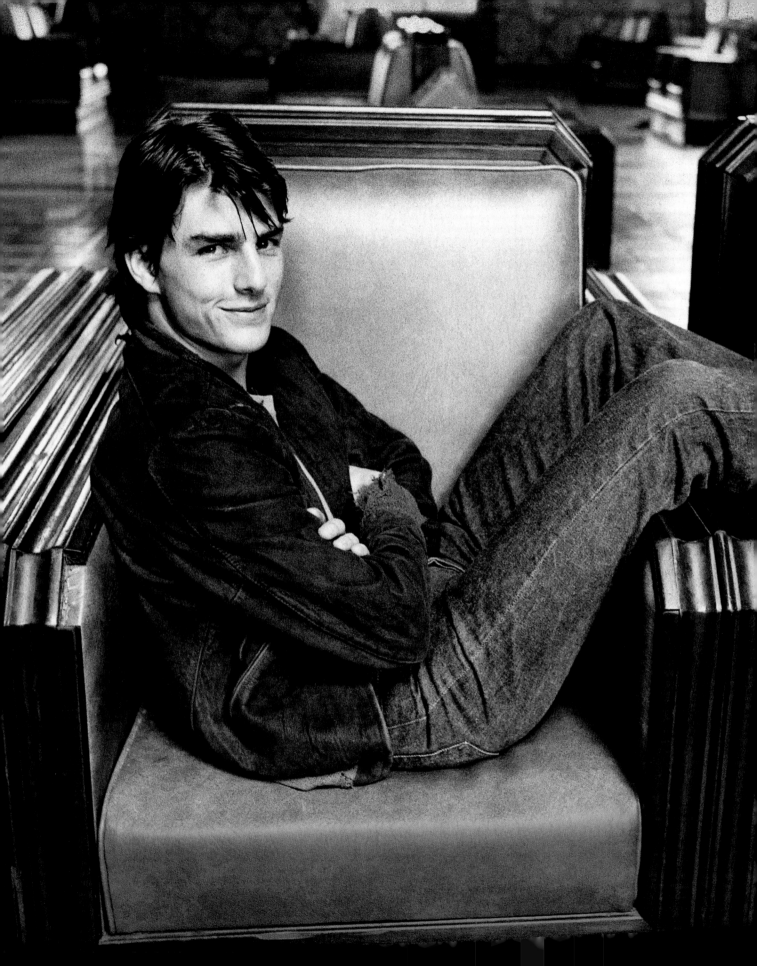

TOM CRUISE | *Neal Preston, 1983*

'I enjoy the pressure of making
a movie. It's like getting
psyched up for a wrestling
match but with higher stakes'
—Tom Cruise, in 1983

IT STARTED WITH a wrestling injury during Thomas Cruise Mapother IV's senior year at a New Jersey high school. Forced to give up sports, he tried out for the school production of *Guys and Dolls* and snagged the lead. Acting "just felt right," he later told *People*. He asked his mother for 10 years to make it in show business, then dropped out and headed for New York City. Soon he landed bit or supporting roles in *Endless Love, Taps* and *The Outsiders*. But with 1983's *Risky Business*, Cruise reached his goal—seven years early. Playing a straight-arrow teenager who falls for a call girl and then leverages her talents to raise cash after wrecking his father's Porsche, Cruise "occupies this movie the way Dustin Hoffman occupied *The Graduate*," raved critic Roger Ebert. Cruise, 21, was suddenly the hottest thing in pictures. Neal Preston (one of *People*'s most-assigned photographers, with more than 700 shoots) took this portrait in L.A.'s Union Station, as a nod to the movie's recurring train scenes. But the setting hinted at something else as well: This young man was going places.

MADONNA | *Ken Regan, 1985*

'I'm tough, ambitious, and I know exactly what I want. If that makes me a bitch, okay'
—Madonna

HER LOOK MAY HAVE seemed trashy to some (see: your parents), but she had no intention of being disposable. Madonna's morning routine said it all: While other pop stars were sleeping off binges, she was hitting the gym. In early 1985, when Ken Regan shot her for *People,* the Material Girl's second album, *Like a Virgin,* had gone triple platinum, and its title single had spent weeks at No. 1. Her videos were in nonstop rotation on MTV. Her first movie, *Desperately Seeking Susan,* was about to hit theaters. Teenage Madonna wannabes were pairing lacy lingerie with crucifixes. Regan (who died in 2012) was the favored photographer of rockers from Dylan to the Rolling Stones and a natural choice to shoot her—although he'd never actually seen her face. As he would recall in *All Access: The Rock 'n' Roll Photography of Ken Regan,* when Madonna walked into the studio, he was shocked to realize she was the same woman he'd shared an elevator with earlier that day and who, he thought, resembled a hooker. Once they got to work, "I found her totally fun, cooperative and charming." The workout photo became a defining image of Madonna—and of the video-star-making, hair-frosting, fitness-mad, sharp-elbowed 1980s.

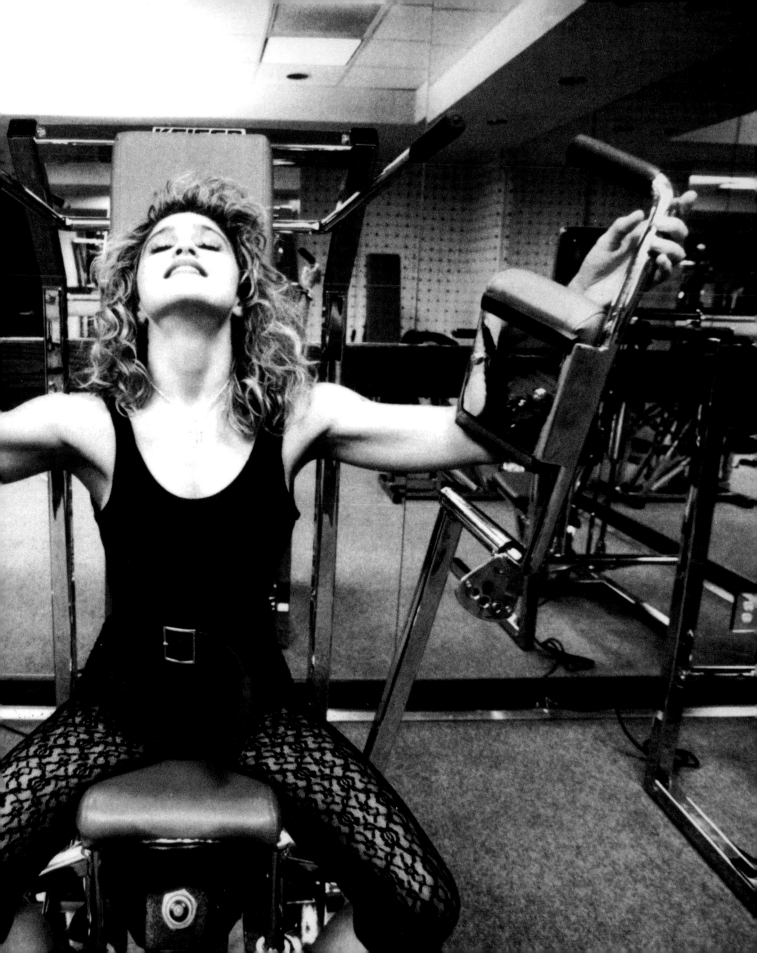

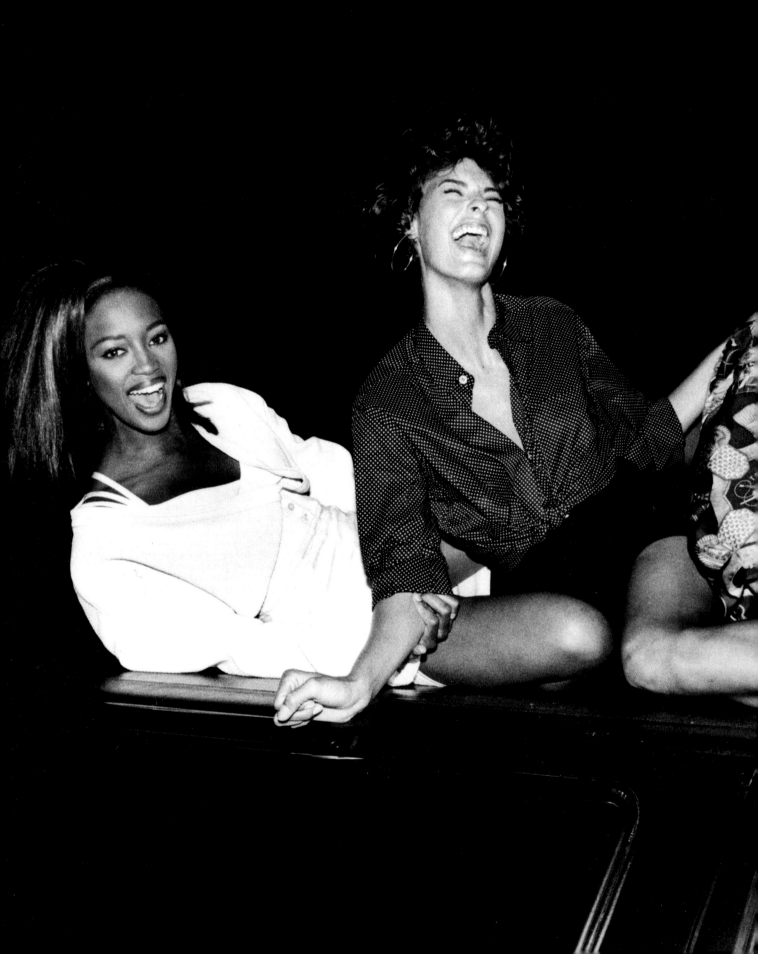

NAOMI CAMPBELL, LINDA EVANGELISTA AND CHRISTY TURLINGTON
Christopher Little, 1990

'They got out and jumped on top of the limo—and drew a crowd instantly like ants to ice cream'
— *People*'s Elizabeth Sporkin

IT WAS THE AGE OF the supermodel, when a handful of preternaturally photogenic women transcended the catwalk to become household names, famous not just for their faces but their lifestyle. With Christopher Little at the camera, *People* writer Elizabeth Sporkin (now an executive editor) spent a Saturday night out in Manhattan with the trinity of Naomi Campbell, Linda Evangelista and Christy Turlington—BFFs all. First stop: Punsch, then a hot spot where tables were at a premium. Despite the models being late for their reservation, "they'll let us in—we *make* their restaurant," Campbell, then 20, chirped with swag. "They ordered everything—tons of entrées and desserts—and ate nothing; the bill was enormous," Sporkin recalls. Afterward they headed to the gritty Hudson Piers to dance with drag queens, then wrapped up at La Palace de Beauté, a club near Andy Warhol's studio the Factory. Little's photo crystallizes the fizzy glitz of a lost era. A quarter century later, when the trio reunite, it's often for a worthy cause—a 2016 event to protect Africa's elephants, for instance. Turlington has become an advocate for global maternal health. And that trendy club? It's now a Petco.

JENNIFER ANISTON | *Robert Trachtenberg, 1995*

'That hairstyle is like a vampire:
It will not die' —Robert Trachtenberg

IT'S IMPOSSIBLE TO IMAGINE now, but Jennifer Aniston wasn't the first choice to play Rachel Green in *Friends*—Téa Leoni was. But Aniston owned the part of the runaway bride turned independent woman, and emerged as the long-running sitcom's breakout star—and America's mid-'90s sweetheart. By the time she posed for Robert Trachtenberg, a year after *Friends* debuted, women could ask their hair stylists for a shaggy, face-framing cut simply by requesting "the Rachel." Despite her 'do being all the rage, Aniston once called it the ugliest she'd ever seen. Known for his witty setups, Trachtenberg sought to capture the phenomenon in a shoot for *Entertainment Weekly*. "The concept came out of my astonishment at the amount of press that haircut was getting," he says. "I had to mock it or address it somehow, and Jennifer was more than happy to play along. We had this unit built, and she had to crawl under it and stick her head through the hole. Not comfortable at all, but since she was pretty much immobilized, it didn't take long to get the shot." As for all the attention the actress and her look were attracting, said Aniston at the time, "I'm a little wigged out by it."

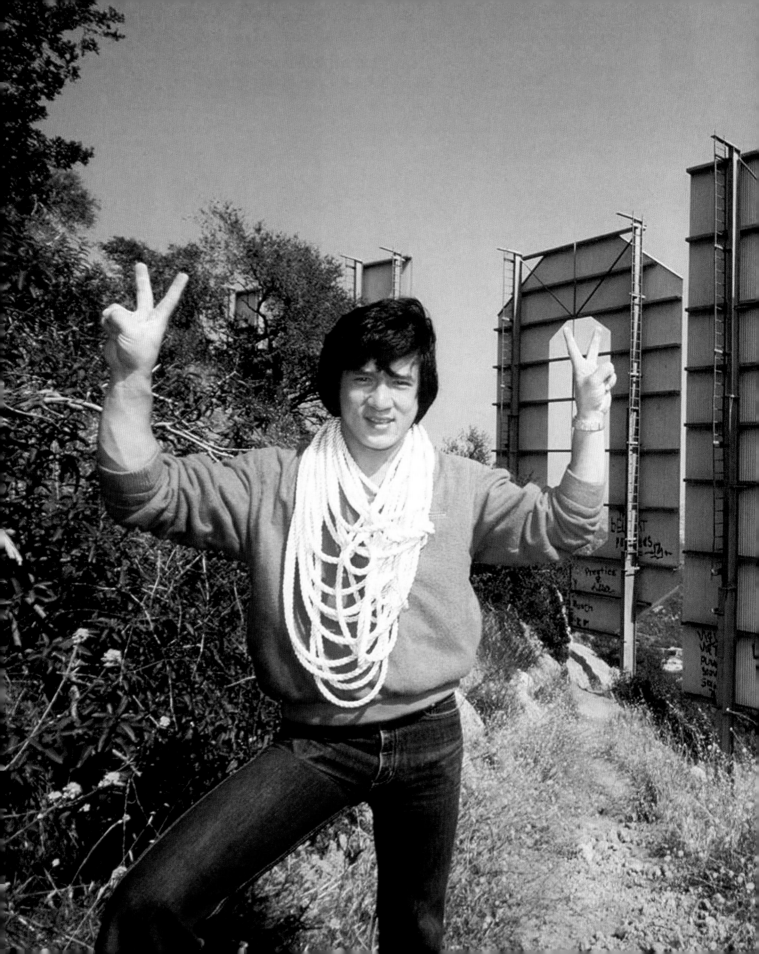

JACKIE CHAN | *Julian Wasser, 1996*

'I never wanted to be the next Bruce Lee. I just wanted to be the first Jackie Chan' —Jackie Chan

WHEN KUNG FU SUPERSTAR Bruce Lee died in 1973, 19-year-old Jackie Chan was expected to succeed him as Hong Kong's action-movie king. But Chan, who'd apprenticed in more than a dozen martial-arts films (including two of Lee's), set out to conquer a realm of his own. Soon he'd won renown throughout Asia for his trademark style of "kung fu comedy"—a blend of spectacular stunts and slapstick laughs. Chan made several attempts at a U.S. hit before succeeding with 1996's *Rumble in the Bronx,* in which he somersaults across rooftops, bridges, pool halls and a hovercraft while battling New York City mobsters. Photojournalist Julian Wasser followed him on a publicity junket to L.A., where they toured local landmarks— including the Hollywood sign, whose "H" Chan clambered up like a kid on a jungle gym. "At that time, there were no security issues," Wasser recalls. "You could go anywhere you wanted." This shot foreshadows a sequence in *Rush Hour* (1998), which proved an even bigger smash than *Rumble.* In that scene Chan dangles from a Hollywood Boulevard street sign, then drops onto, slides over and leaps into various moving vehicles in the space of a few seconds. The sign sent a message, he told *Time*: "It says, 'Hollywood, I've come back.'"

JOAN RIVERS | *Michael Edwards, 2007*

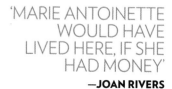

'MARIE ANTOINETTE
WOULD HAVE
LIVED HERE, IF SHE
HAD MONEY'
—JOAN RIVERS

IT WASN'T JUST HER HUMOR THAT WAS OVER-THE-TOP. During her five-decade career—from the early gigs doing stand-up at Greenwich Village dives, to her years helming talk shows, to her reign as red-carpet-fashion arbiter and reality-show star—Joan Rivers was as renowned for her work ethic as she was for her acid-tongued assaults on the boundaries of good taste. She published 12 bestselling books, wrote and starred in two Broadway plays and earned a Tony nod and hawked her own line of bling on QVC. To maintain her personal brand, she had "so much plastic surgery," she quipped, "when I die, they'll donate my body to Tupperware." And she did it all while navigating private turmoil that included her husband's 1987 suicide, which for a time took an awful toll on her relationship with her daughter (and later collaborator) Melissa. With her earnings Rivers built a Versailles on Manhattan's Upper East Side—a gilded triplex penthouse stuffed with precious antiques, which she shared with a ménage of rescue dogs (that's Max in the photo) and a live-in domestic staff of two. When photographer Michael Edwards arrived for the session that produced this portrait, he was bemused to find himself attended to by an aproned butler. "She told me, 'He's my right-hand man. If you're rude to the butler, you'll never get invited back.'" But Rivers was always ready to poke fun at herself. At one point, Edwards recalls, "she was smiling in an awkward way, and I said, 'Why don't we do one with your lips closed?' And she said, 'Oh, honey—my mouth doesn't shut anymore.'"

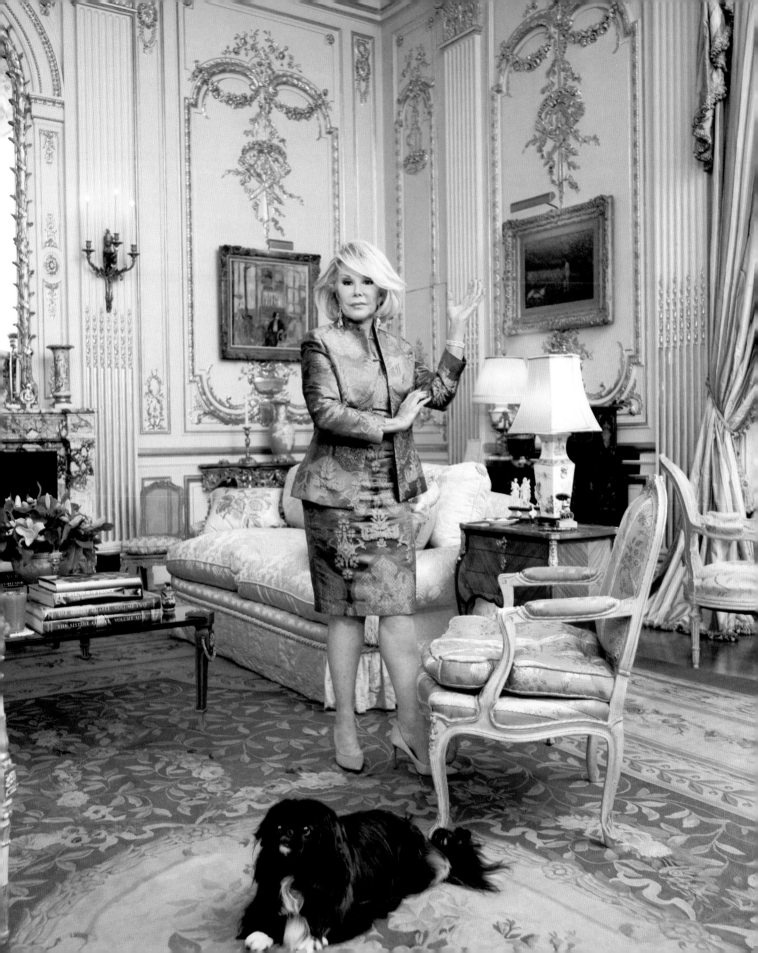

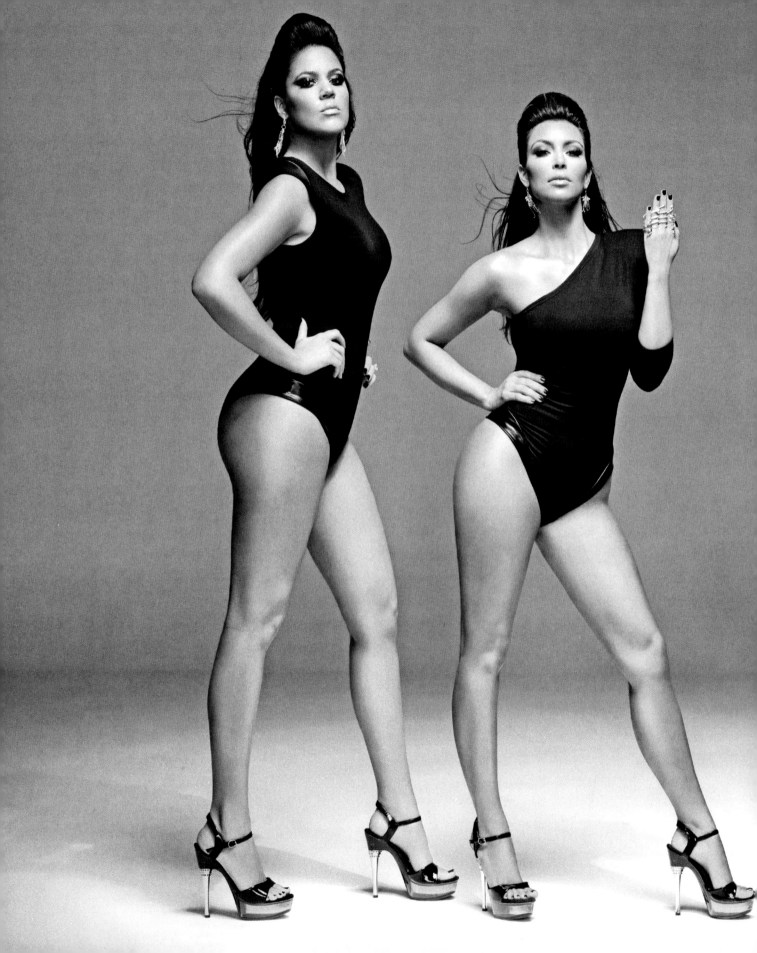

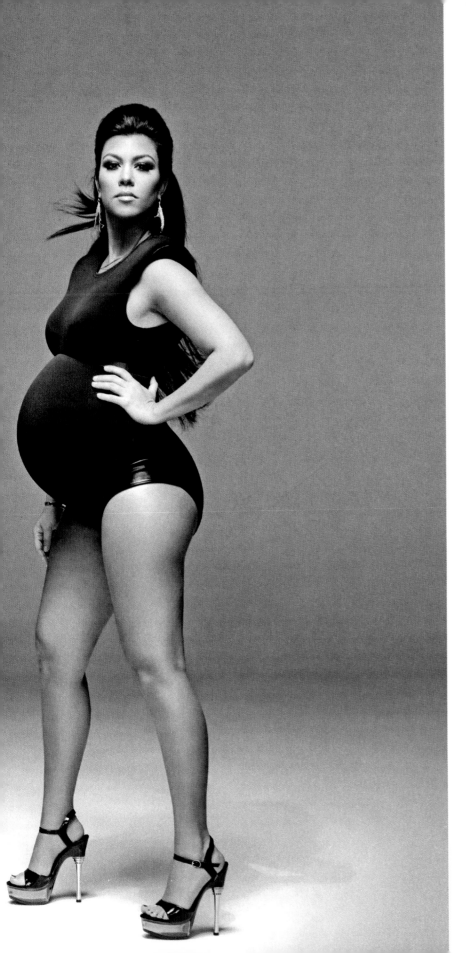

KHLOE, KIM & KOURTNEY KARDASHIAN
Robert Trachtenberg, 2009

'They could not have been
more professional'
—Robert Trachtenberg

IN 2009 BEYONCE'S hit "Single
Ladies" was ubiquitous, but the
most famous real-life single ladies
were the sisters Kardashian, whose
E! series had just spun off a second
show and qualified as a national
guilty pleasure. Happily, when
People's editors brought Kim, Khloé
and Kourtney the idea to re-create
Beyoncé's ring-fingers-up music
video for its Most Intriguing People
issue, the reality stars were all-in. At
the time Kim was dating NFL player
Reggie Bush; Kourtney was preg-
nant with son Mason, her first child
by then-boyfriend Scott Disick; and
Khloé had just wed pro basketballer
Lamar Odom that fall, telling the
magazine, "I'm the happiest I've
ever been." On the set, recalls pho-
tographer Robert Trachtenberg,
"Kim and Khloé were very sweet
looking out for Kourtney, making
sure she felt okay and that the lights
weren't too hot." In the years that
followed, team Kardashian contin-
ued to bring the drama. Kim went on
to marry and divorce NBA player
Kris Humphries, then wed Kanye
West, with whom she has two chil-
dren; Kourtney and Disick had two
more kids together before splitting;
and Khloé's marriage ended in 2016.
Single or not, always intriguing.

ROBERTO MARTINEZ & ALI FEDOTOWSKY OF *THE BACHELORETTE*
Emily Shur, 2010

'I found real, true love, and I'm grateful that I had that experience' —Ali Fedotowsky

WHAT'S REAL? NOT this photo, which looks like it could be a documentary still from the filming of ABC's *The Bachelorette*. In fact, it was (admittedly) staged for *People*'s Most Intriguing People of 2010 issue. No secret: The house is a set, and the cameramen are models. That year *Bachelorette* star Ali Fedotowsky (who had previously left the pool of women on *The Bachelor* when *real* real life intruded: She had to get back to her job as a Facebook account manager) accepted a proposal from her chosen winner, insurance agent Roberto Martinez. "Now that I've found the one for me, I can't wait!" she told *People* as they planned their nuptials. "I feel like, 'I gotta lock that down.'" The latch remained open, however, while the pair got to know each another away from the cameras, and more actual reality set in. A month before this happy picture of domesticity was taken, the couple announced that they were putting the to-be-televised wedding plans on hold. By November 2011 they had separated. "We both deserved more," said Fedotowsky. In 2017 she wed radio host Kevin Manno; they have a daughter, Molly. Martinez still sells insurance—and is single.

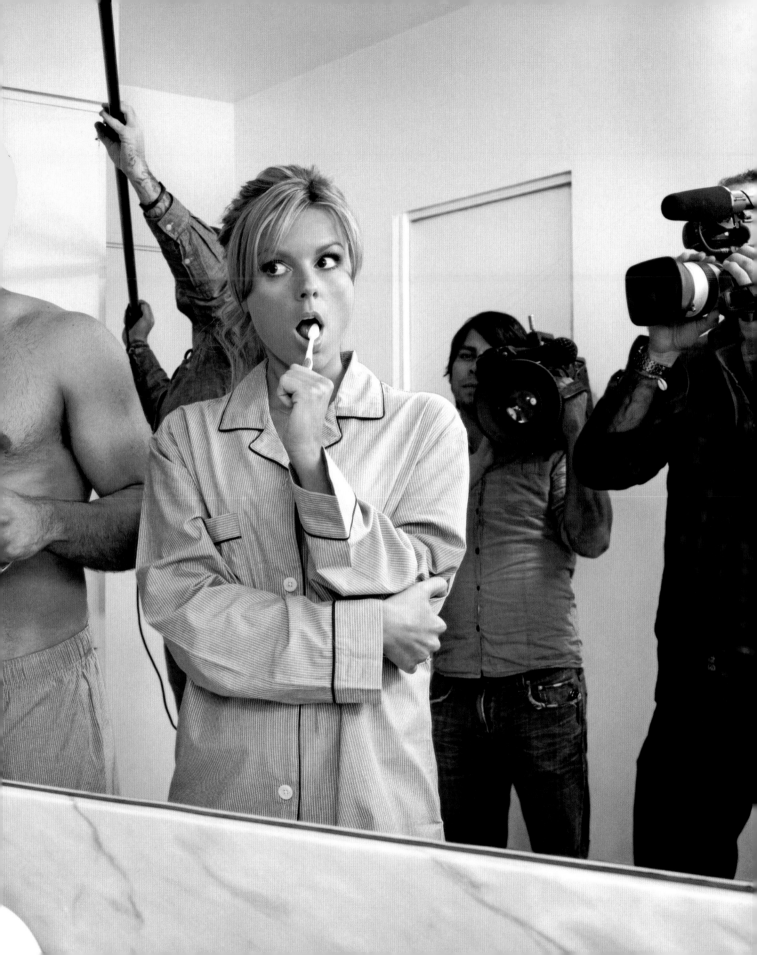

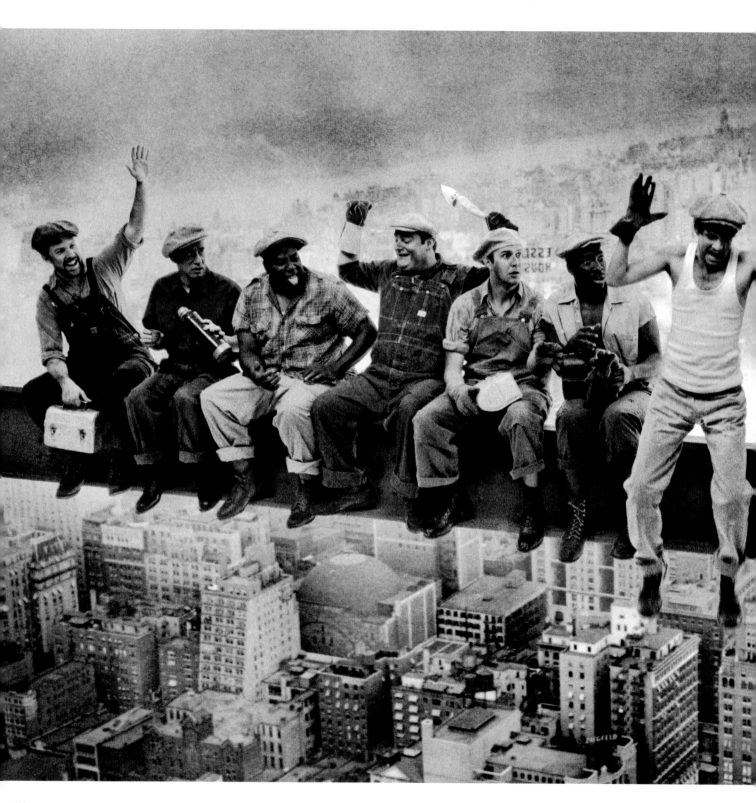

'That was a particularly good period for *Saturday Night Live*. Those guys were all superfunny dudes'
—Jeff Riedel

A FORMER WRITER FOR *Saturday Night Live* called the show "the Empire State Building of satire." So for a portfolio in the 2011 Sexiest Man Alive issue, in which TV's funniest men were transported back in time, editors put the *SNL* guys in an emblematic New York City image: Charles Ebbets's 1932 photo of construction workers lunching above Manhattan. As it happened their perch was in Rockefeller Center—home to *SNL* since its first episode in 1975. For photographer Jeff Riedel the challenge was re-creating the shot in a studio. He had a girder built from wood, then set it about three feet off the floor. Once the actors were seated (from left: Jason Sudeikis, Fred Armisen, Kenan Thompson, Bobby Moynihan, Taran Killam, Jay Pharoah, Paul Brittain, Seth Meyers, Bill Hader and Andy Samberg), Riedel hit another hurdle. When he asked Samberg to leap from the girder, "he looked at me with this bemused expression, saying, 'No, I don't feel like killing myself.'" Brittain, however, took the leap. Afterward, Riedel and a retoucher made a digital composite with the Ebbets image.

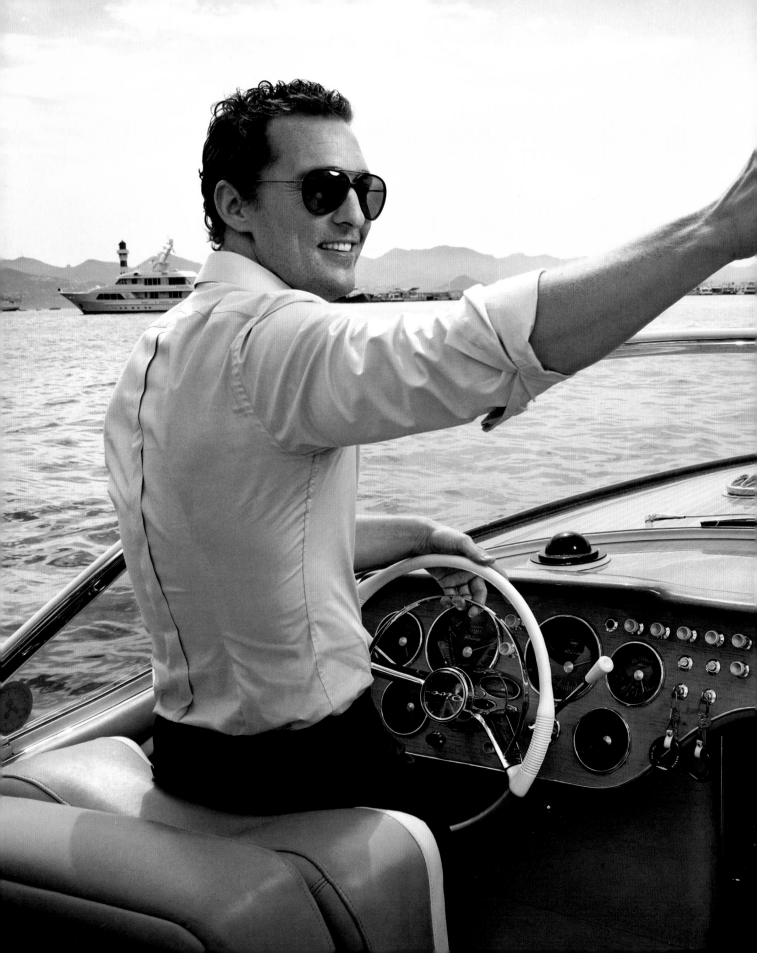

MATTHEW McCONAUGHEY
Art Streiber, 2012

'"Just keep living" is the motto that keeps me moving forward'
—Matthew McConaughey

FOR 12 DAYS EVERY MAY, a sleepy town on the French Riviera becomes the pulsing center of the movie universe. At the Cannes Film Festival, what's onscreen is only part of the show; the action is equally intriguing along the seaside promenade known as La Croisette, where industry heavyweights mingle, cut deals and frolic in the Mediterranean sun. Shooting a portfolio of stars at the 2012 festival, photographer Art Streiber "wanted to give the reader a sense of what it looks like, what it feels like and what a celebrity might do there," he says. Matthew McConaughey, in town to promote *Mud* and *The Paperboy,* illustrated one such activity, taking a spin in a vintage 1965 speedboat. "He was a total natural behind the wheel," recalls Mary Green, who has coordinated nine years of *People* shoots at Cannes. But this image also has a subtler significance. The star, then 42, was just returning to serious films after a decade of lightweight rom-coms. Soon after coming home from France, he married longtime love Camila Alves, who would give birth to their third child that December. By 2014 he'd won his first Oscar, for *Dallas Buyers Club,* playing an HIV-infected electrician who helps other AIDS patients get lifesaving medication. What you see here, in short, is a man taking the helm of his destiny.

TAYLOR SWIFT
Martin Schoeller, 2014

'I'm not looking for anything to complete me. I think that's a nice place to be' —Taylor Swift

ONE OF THE BESTSELLING recording artists of all time, Taylor Swift started as a child-prodigy country singer and songwriter who, as she grew up, eyed more mainstream success. October 2014 marked a fork in her career path: the release of her first undeniably pop album, *1989.* In the cover story of *People'*s 40th-anniversary issue, Swift, then 24, revealed she'd reached a crossroads in her romantic life as well—she was taking a break from boys. "The last couple of years have been about defining life on my own terms," she said. "It's a really liberating and freeing time." Martin Schoeller captured that spirit in this portrait, which also hints at the mix of talent, ambition, charisma and promotional savvy that help lift stars like Swift onto their Olympian pedestals. "What struck me most was her professionalism," the photographer recalls. "She seemed very driven, very focused." In what could be taken as another bit of symbolism, the image echoes the engraving on a U.S. gold bullion coin, with Lady Liberty descending from heaven in a burst of sun rays. But Schoeller insists the resemblance is entirely coincidental.

PINK | *Ruven Afanador, 2014*

'I'm a person who could always lose a couple here and there, but I would rather be strong than bony' —Pink

ASIDE FROM HER powerful pipes, punky hairdos and chart-topping record sales, the singer Pink was known for two distinctive attributes: her boldly soul-baring lyrics and her wildly athletic performing style. She also happened to be 34 years old in 2014—the age, according to a then-just-released study, at which women feel best about their bodies. So when *People* created a portfolio called "Naked at 34" for that year's World's Most Beautiful issue, featuring five stars born between 1979 and 1980, the artist formerly known as Alecia Beth Moore was a natural opening act. Photographer Ruven Afanador shot Pink in a studio near her home in Venice Beach, Calif., rigging up a set of aerial silks like those she used onstage. (Her personal coach was on hand for technical assistance.) "It was amazing that she had the strength and training to be able to pull her weight that way and sing [at the same time]," Afanador recalls. "She was excited and proud of her body, and it was just a very cool experience." Pink was so pleased with the shoot that she used an outtake in an antifur ad for the animal-rights group PETA.

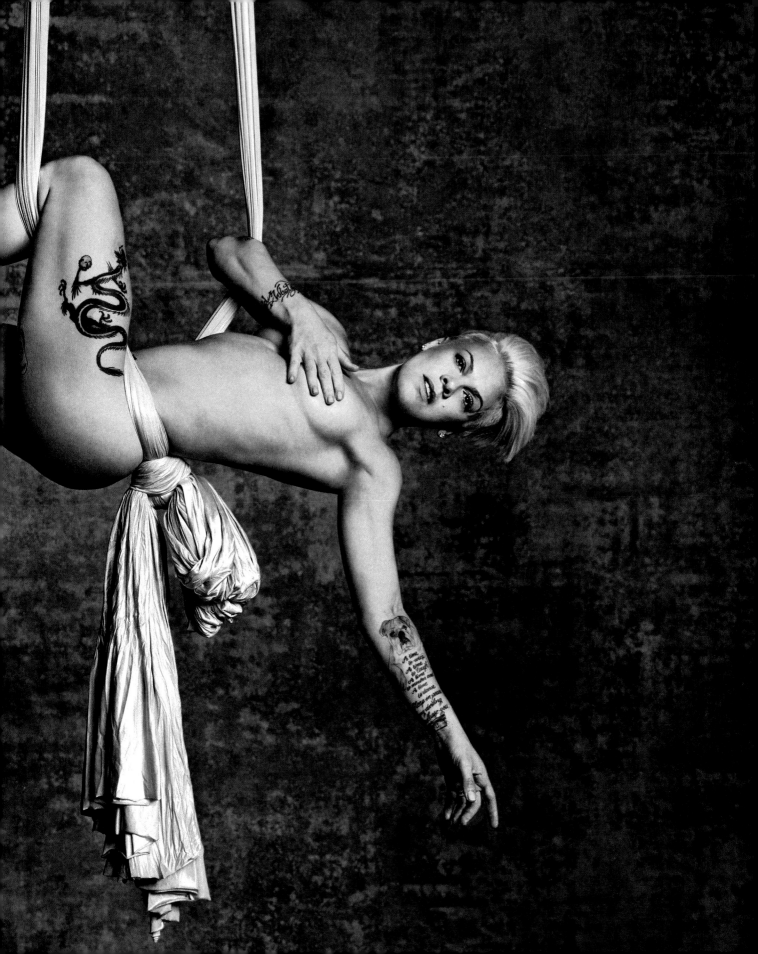

'NOTHING CHANGED MY LIFE AS MUCH AS THAT PICTURE. IT GAVE ME A PLATFORM. I CAN'T HELP EVERY CANCER PATIENT, BUT I HAVE THE ABILITY NOW TO BE THEIR VOICE'

—JOAN LUNDEN

JOAN LUNDEN HAD SELDOM LET FEAR stand in her way. As cohost of *Good Morning America* from 1980 to 1997, she'd climbed an Alaskan glacier and bungee-jumped off a 143-ft. bridge. At age 52, after beginning her second marriage, the mother of three grown children talked publicly about the issue of infertility, then used a surrogate to have twins; two years later, she did it again. When she was diagnosed with breast cancer in 2014, at 64, she went public with the news, then shaved off her hair rather than surrender it to chemotherapy. But when *People* asked her to pose without her wig for a cover story, she agonized over the decision for weeks. Could she bear to shed her glamorous image? Would the Twitterverse accuse her of exploiting her illness? Would her two sets of twins (then 11 and 9) get flak from schoolmates? Lunden was still vacillating when photographer Ruven Afanador arrived at her home outside New York City. "She got more nervous the more we pressed," Afanador recalls. Also present was *People* executive editor Kate Coyne, who suggested breaking the ice by first shooting Lunden with the hairpiece in place, then with just a scarf. When the time came to unveil her head, Lunden suddenly thought of her father, a cancer surgeon who died in a plane crash when she was 13. "Here was an opportunity to carry on his legacy and make a significant difference," she says. Lunden's courageous gesture inspired countless cancer patients. After the issue hit newsstands, she recalls, "one woman who was undergoing chemo told me, 'What struck me was the smile on your face.' In that instant I knew I could do this."

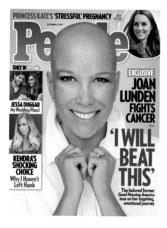

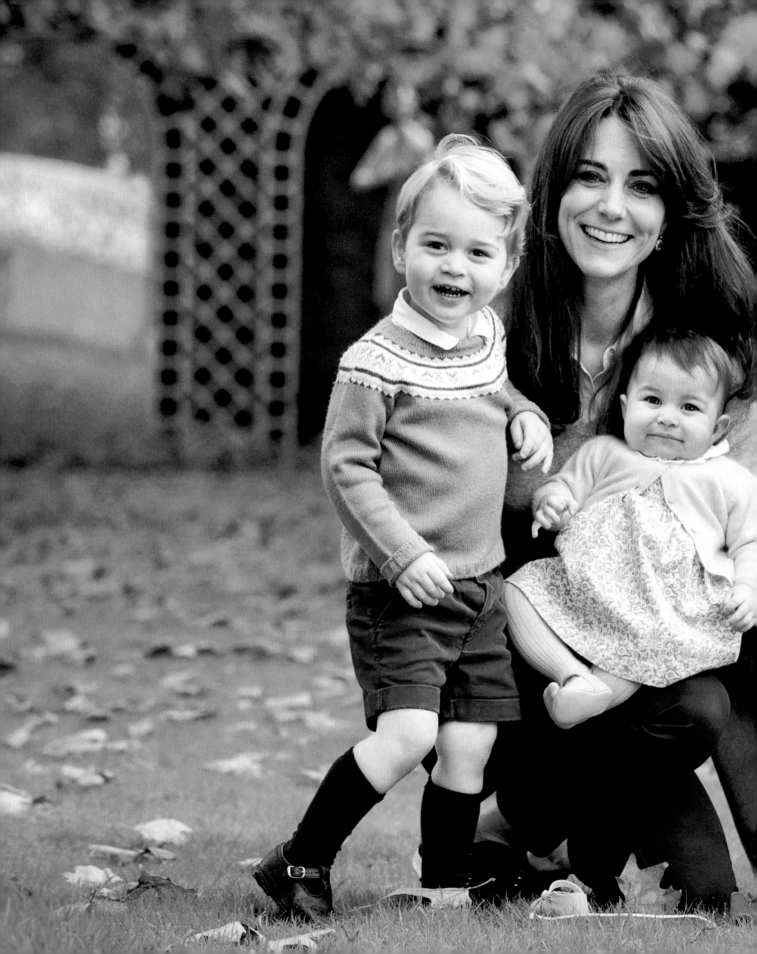

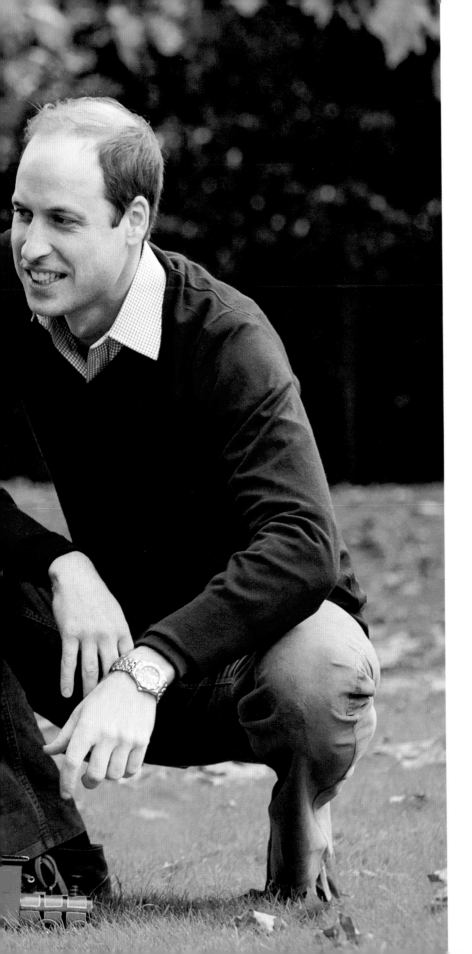

PRINCE GEORGE, PRINCESS KATE, PRINCESS CHARLOTTE & PRINCE WILLIAM
Chris Jelf, 2015

'It reflects the way the monarchy has changed. They didn't want the puffed-up, sitting-up-straight sort of picture that would have been traditional' —Chris Jelf

THE CALL CAME ON a Friday evening: "Are you free on Monday? We need a family picture taken." For Chris Jelf, a commercial photographer, the request was unusual in only one respect—it came from an aide to Prince William, Duke of Cambridge. Jelf doesn't know why he was offered the gig, though it might have helped that he had served in the British Army (including a tour as a tank captain in Iraq) before switching careers. "Maybe they needed someone with a relatively decent security clearance," he guesses. His assignment: a Christmas card photo. To calm his nerves, Jelf reminded himself that the couple's children—Prince George, 2, and Princess Charlotte, 5 months—were about the same age as his own kids. Arriving at Kensington Palace at 9 a.m., he learned that he had just half an hour; adding to the pressure, the little princess was on a crying jag. (Jelf had wisely packed a hand puppet.) But it was her parents who put him at ease. "They were very genuine, very relaxed. After a while, you forgot you were photographing the future king."

TRACEE ELLIS ROSS | *Art Streiber, 2016*

'"Just pinch me" is all I can say'
—Tracee Ellis Ross

FOR ANY TV ACTOR, BEING NOMINATED FOR AN EMMY IS a thrill. But for Tracee Ellis Ross, the moment was especially intense. Ross, then 43—family matriarch Dr. Rainbow Johnson on ABC's *Black-ish*—was one of just five black women ever to get the nod for Outstanding Lead Actress in a Comedy Series, and the first since Phylicia Rashad (*The Cosby Show*'s Clair Huxtable) 30 years earlier. When she got the news, she told *People,* "I ran around my dining room table and out to the courtyard yelling to myself, 'Where am I going? You need to call someone. Call someone!'" So she dialed her mom, Motown legend Diana Ross. "We screamed together for a bit." With her sense of humor unflustered, she agreed to a little selfie shtick. In this image, employing the suddenly ubiquitous tourist tool, she spoofs her own excitement—and the self-absorption for which her profession is famous—in photographer Art Streiber's portfolio depicting the year's Emmy-nominated funnywomen prepping for the ceremony. The biggest technical challenge, he recalls, involved Ross's outfit: "She was wearing one of those bustiers that stays in place while the body moves, because it's got all kinds of infrastructure. A couple of times I had to say, 'Tracee, don't shift that far!' We were inches away from a wardrobe malfunction."

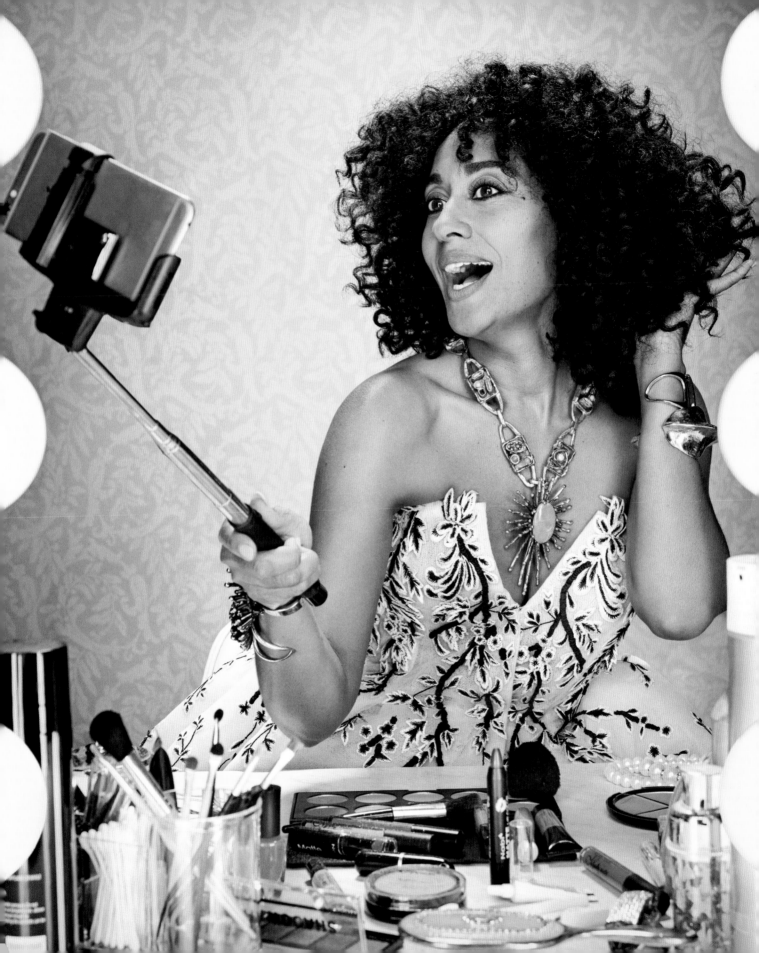

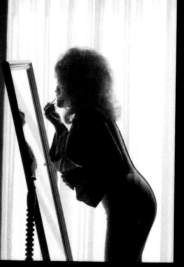

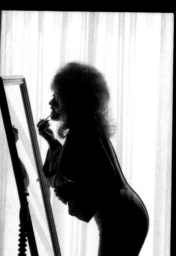
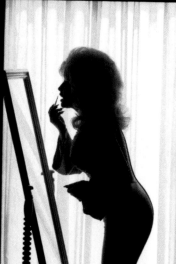

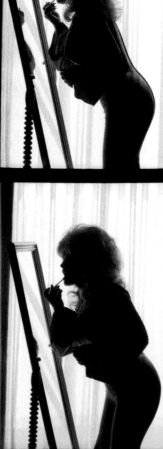

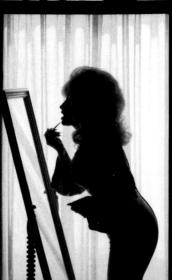

➡️|

PRIVATE WORLDS

BY DAN WAKEFORD

DICK STOLLEY, ONE OF THE MAGAZINE'S FOUNDING EDITORS, said *People* is about "ordinary people doing extraordinary things and extraordinary people doing ordinary things," and there's nothing more normal than seeing a star hang out at home or chill out at work when the cameras aren't rolling. It comes as some relief, even after so many years, to see Glenn Close and Michael Douglas palling around in the *Fatal Attraction* bathtub between takes of trying to kill one another.

Four decades later an editor's eyes will still light up when a reporter utters the words "I think they'll be photographed at home." Looking into a star's private world gets us closer to finding out the truth about these seemingly higher beings. These photos humanize their subjects and make them relatable. Who knew Katharine Hepburn did her own laundry? Elizabeth Taylor cooked fried chicken and Meryl Streep uses the New York subway? As evidenced by Harry Benson's contact sheet, Dolly Parton touches up her own makeup.

Sometimes candid and sometimes staged, these pictures are as delightful as they are revealing. No one ever looked as good and perfectly posed as Rock Hudson reading his newspaper.

Wakeford is a deputy editor of People.

I◄─ PREVIOUS SPREAD
CARY GRANT & RANDOLPH SCOTT | *Jerome Zerbe, 1935*

'Any sense that there might be a personal relationship between two guys, it wasn't that it was forbidden—Hollywood's position was that it didn't exist' —Hollywood photo archivist Robert Dance

DEBONAIR BRITISH IMPORT CARY GRANT became one of cinema's inimitable leading men, while rugged Randolph Scott is a revered hero of American westerns. Both were Paramount contract players when Jerome Zerbe took a series of publicity shots at the Santa Monica house the two men shared during the nearly 12 years they lived together on and off in the 1930s and '40s. The photos were "unprecedented in the history of Hollywood publicity," says Robert Dance, curator of the John Kobal Collection. It was rare, he notes, to see "two men doing anything without having a woman between them." Had Zerbe documented more than a friendship between the two stars, who, between them, were married to seven women? The rumors are as enduring as the images. In 2011 Grant's daughter Jennifer, with Dyan Cannon, addressed them in a memoir, *Good Stuff,* this way: "Did Dad ever experiment sexually? I don't know. Have I ever experimented sexually? Have you? If experimentation makes one gay, then my guess is that most of the world is gay."

MARLON BRANDO | *photographer unknown, ca. 1950*

'If I hadn't had the good luck to be an actor, I don't know what I would have been. I probably would have been a good con man' —Marlon Brando

BY 1950 MARLON BRANDO, 26, HAVING electrified Broadway in *A Streetcar Named Desire,* was about to conquer film as a paralyzed veteran in *The Men,* for which the method actor prepared by spending weeks in a military hospital. Early on, Brando established himself as an enigma, and even a sly smile in a candid photo (or was it?) could intrigue. Noted *Time*: "Hollywood began to believe Brando's extravagant advance publicity. His personal eccentricities, as well as his acting skill, had the film colony agog. He appeared to be the first genuine 'character' since Garbo.... The $150 weekly allowance from his father (who invested the rest of Brando's earnings in Nebraska cattle) was always gone in a few days, much of it handed out in fistfuls to friends, shoeshine boys and waitresses." Soon after this photo was made, Brando cemented his legend in Elia Kazan's film of *Streetcar.* But by 1960 he telegraphed a future retreat from fame: "Acting is an empty and useless profession. It's a bum's life."

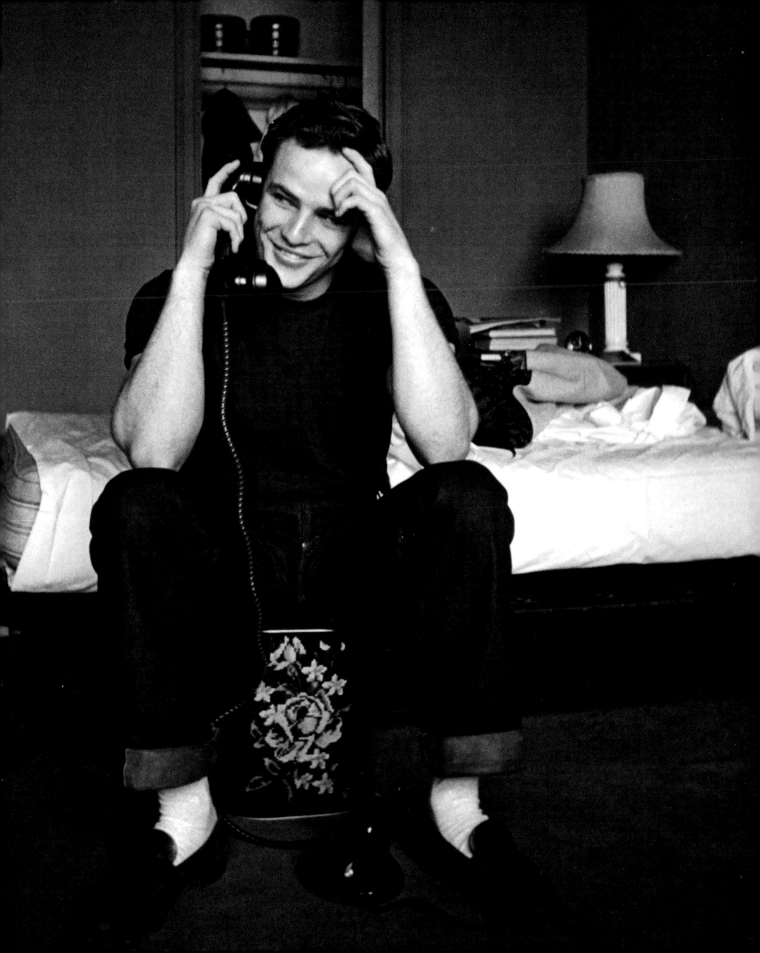

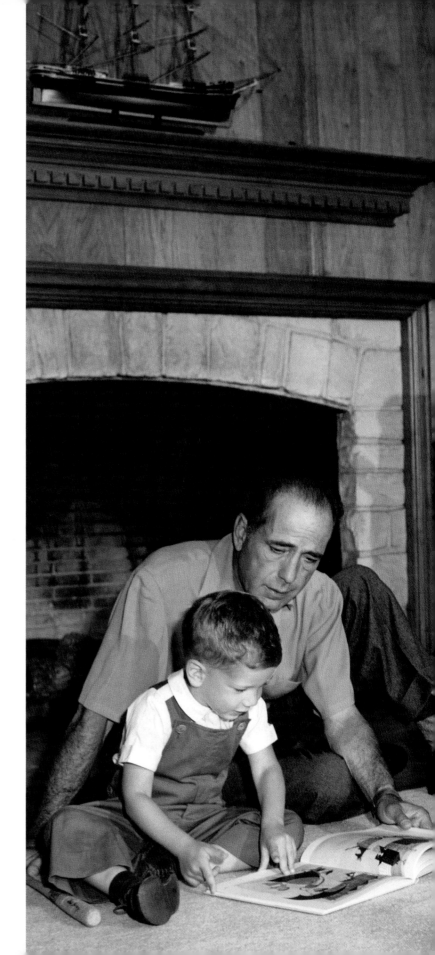

HUMPHREY BOGART & LAUREN BACALL WITH SON STEPHEN
Sid Avery, 1952

'[My father] treated these stars as people, and as a result, they treated him in kind' —Ron Avery

KNOWN FOR SEEMINGLY candid but, in fact, carefully staged photos of postwar celebs with their families, Sid Avery had a knack for soothing difficult sitters. But Humphrey Bogart, whose combativeness was not limited to roles in films like *The Maltese Falcon,* presented a special challenge. The request to shoot him with wife Lauren Bacall and their son was turned down first by Bogart's agent, then by his publicist. Avery phoned the movie lot, and the star himself hung up on him. The next day Avery asked if he could have just five minutes. "Be there at 8 a.m.," Bogart responded grudgingly. When Avery arrived, Bogart growled, "Okay, kid, come on in," and, according to Avery's account in his son Ron's book *The Art of the Hollywood Snapshot,* poured them both tumblers of whiskey. Then Bogart left to finish dressing, and Avery dumped his drink in a potted plant. After Avery snapped him hanging a picture, Bogart said, "'Do you want another shot?' I said, 'Well, I've already used up my time.' He says, 'No, no, what else would you like?'" Avery captured this cozy tableau, and Bogart wound up taking him sailing that afternoon, then to dinner. "For a tough guy on the screen," Avery once reflected, "he turned out to be a real pussycat."

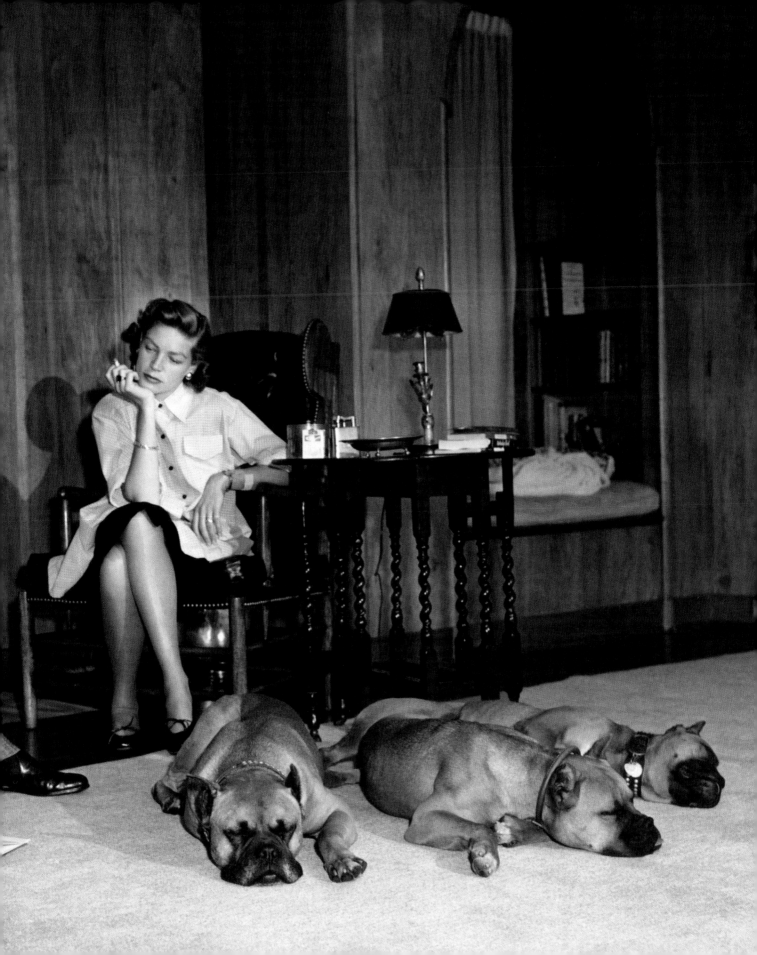

ROCK HUDSON | *Sid Avery, 1952*

'He was always cooperative and very thoughtful' —Sid Avery

AT 26, ROY SCHERER JR.—rechristened Rock Hudson—was a new actor when Sid Avery shot him for the *Saturday Evening Post.* A "tousle-haired, loose-muscled bucko," as they wrote, Hudson had yet to film *Magnificent Obsession, Giant* or those last-gasp-of-innocence Doris Day comedies. "I was always fond of him," Avery once said. "He loved the most popular recording stars of the time, and we shared the same likes in many of his choices." Hudson was also charmingly modest. "I don't like myself on the screen," he told the *Post.* "I get embarrassed in the projection room. I can't make love very well." Hudson was gay but scrupulously secretive about it. A few years later a *Life* article noted that devotees were vested in pairing him off: "Their complaints, expressed in fan magazine articles, range from a shrill 'Scared of Marriage?' to a more understanding 'Don't Rush Rock.' ... He enjoys taking out girls, but likes his bachelorhood more than ever." In 1955 he wed his agent's secretary, a union that lasted three years. "Nobody in their right mind came out—it was career suicide," Lee Garlington, his boyfriend from 1962 to 1965, told *People* in 2015. Only after Hudson's death from AIDS-related illness at 59 in 1985 did Garlington and others speak of the truth of his life: "He was a romantic."

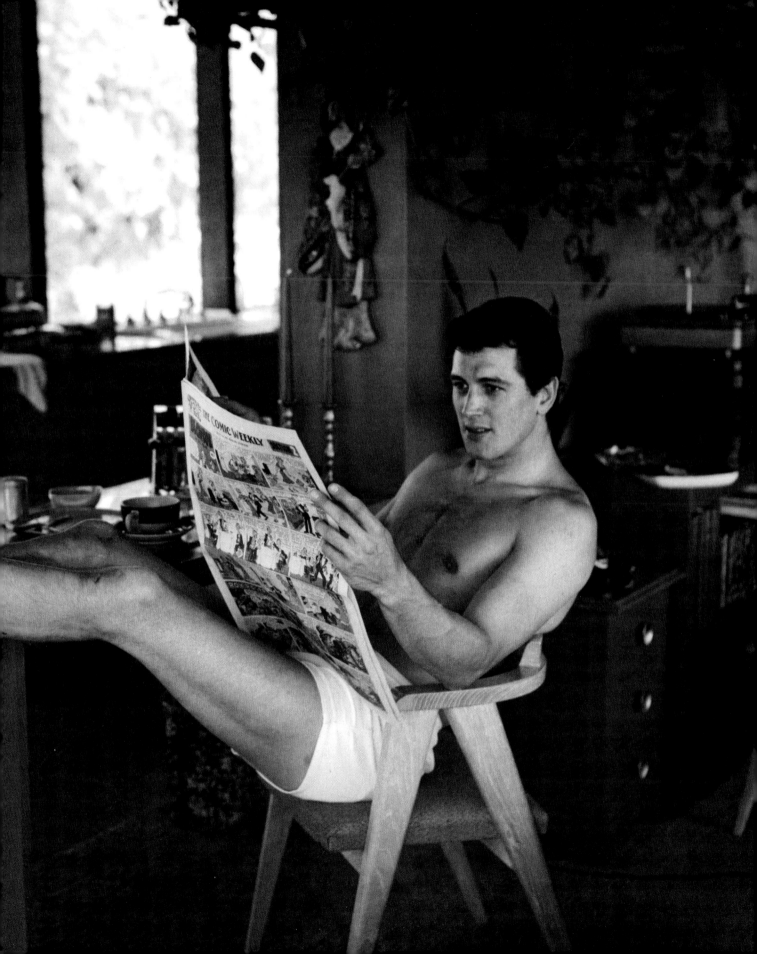

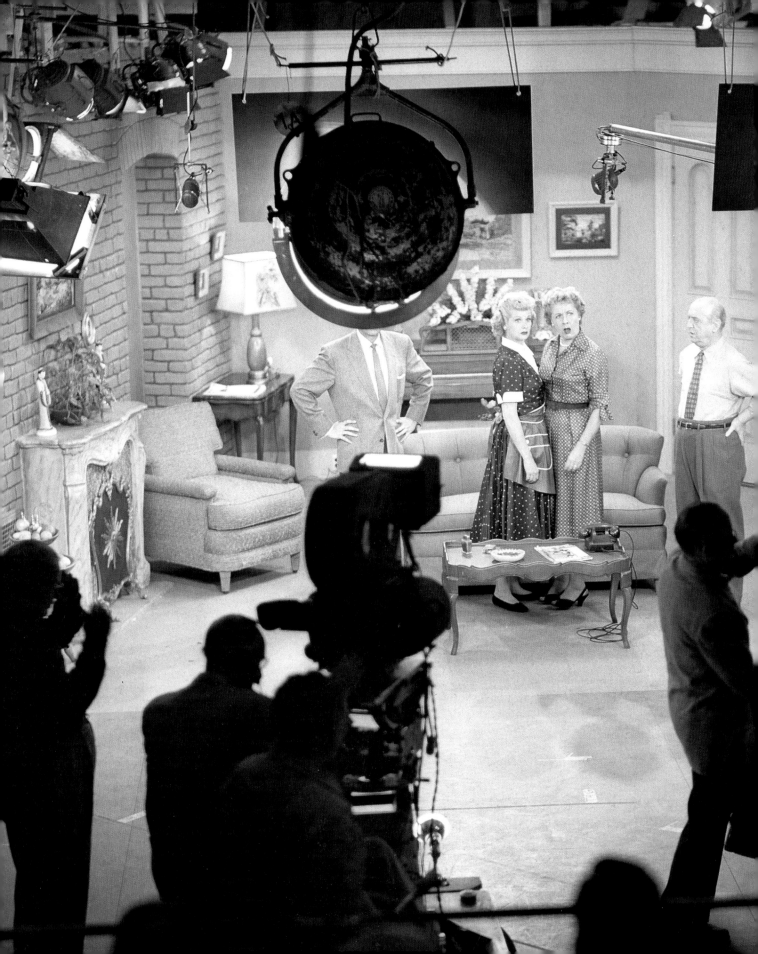

THE SET OF *I LOVE LUCY*
studio photographer, 1953

'This is fun, not work'
—Lucille Ball

623 EAST 68TH Street isn't a real building in New York City. In fact the Ricardos' apartment was in a Los Angeles TV studio, where Lucille Ball, Desi Arnaz & co. filmed *I Love Lucy* from 1951 to 1957. The show, with audiences upward of 20 million, was an obsession: Even the apartment's simple mid-century furnishings, from the bedroom set to Little Ricky's layette, inspired replicas for sale. The series also transformed a onetime B-movie glamour-puss into one of America's great clowns—somewhat to her own surprise. "I sure as hell didn't know what I was doing when I started," Lucy told *People* in 1980. "TV started for me just as a means of keeping my husband, Desi, off the road. He'd been on tour with his band since he got out of the Army, and we were in our 11th year of marriage and wanted to have children." Off-camera it wasn't one big happy family. William Frawley and Vivian Vance (who played landlords and neighbors Fred and Ethel Mertz) loathed each other. And Lucy and Desi's real-life marriage was tempestuous—when they eventually divorced in 1960, it "disappointed millions of people," Ball lamented. But they remained close, and Lucy had fond memories of their collaboration. "We enjoyed it so much. We didn't want to go home at night."

JAMES DEAN & NATALIE WOOD | *Warner Brothers, studio photographer, 1955*

'JIMMY APPROACHED
ALL HUMAN BEINGS
WITH THE SAME URGENT,
PROBING CURIOSITY'
— **DIRECTOR NICHOLAS RAY**

NOT ONLY WAS MAVERICK DIRECTOR NICHOLAS RAY'S *Rebel Without a Cause* American cinema's seminal study of white middle-class teenage angst, it launched the legend of a slouching, brooding, screen supernova named James Dean. Trained at New York City's storied Actors Studio, the slightly built Indiana farmer's son punched his ticket to movie stardom after impressive work on Broadway and television. Dean brought to the screen an unfiltered emotion that could be almost painful to watch. But you'd never know it from his zany mugging with costar Natalie Wood in this Warner Brothers promotional still on the *Rebel* set. A saucer-eyed child star of the studio-era— memorably in the Christmas classic *Miracle on 34th Street*—Wood campaigned ardently for her role and then, at 16, carried on an incalculably risky affair with the 43-year-old director. She and Dean enjoyed a warm working relationship. "He was so inspiring, always so patient and kind," Wood recalled. Both young stars met famously tragic ends. After considerable adult success, Wood drowned at 43 in a mysterious 1981 boating accident. Dean was killed in the crash of his Porsche Spyder on Sept. 30, 1955, less than a month before *Rebel Without a Cause* premiered. Just 24, he'd made only three films—the others were *Giant* and *East of Eden*—but endures as a mythic symbol of youthful disillusionment. Still, as actress Liz Sheridan, whom he dated in the early 1950s, told *People*, "Jimmy wasn't a rebel, and he had no cause. I think he was just shy."

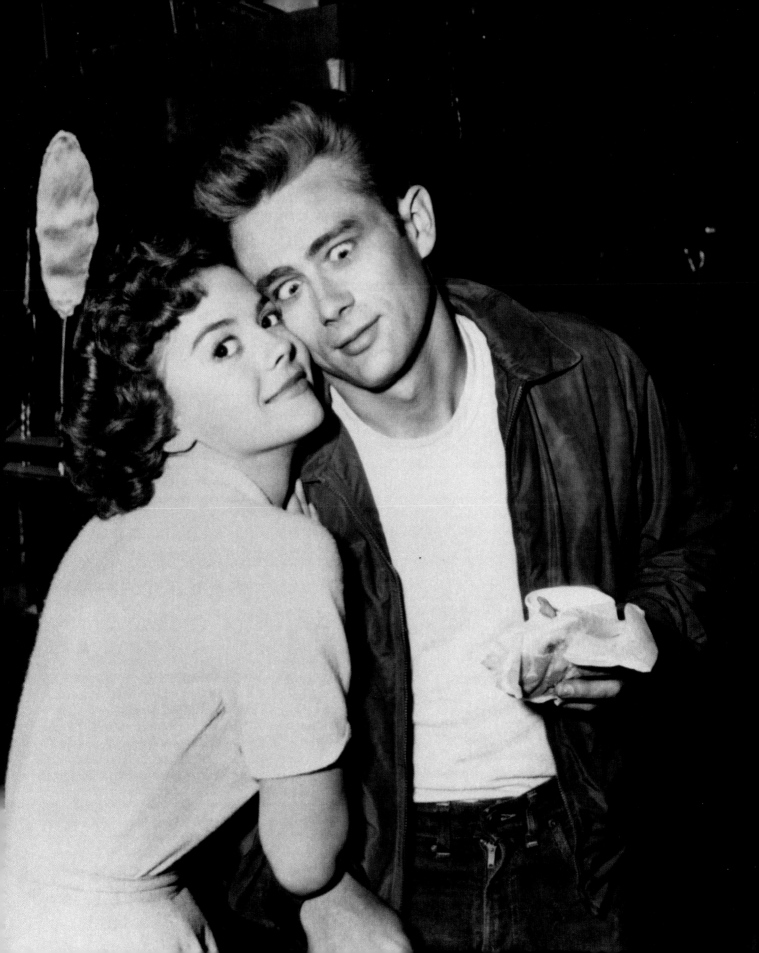

CLARK GABLE, VAN HEFLIN, GARY COOPER & JAMES STEWART
Slim Aarons, 1957

'Cooper is telling [them] how I flubbed my one and only line' —Slim Aarons

GEORGE "SLIM" Aarons said his stock-in-trade was "attractive people in attractive places doing attractive things." This may be Aarons's most celebrated work. Dubbed "the Kings of Hollywood," it captures a moment in time (New Year's Eve, 1957), a storied setting (Romanoff's restaurant) and a joke between four pals who happened to be screen giants: Clark Gable, Van Heflin, Gary Cooper and James Stewart. Gable and Cooper were already legends, while craggy character actor Heflin hit his peak that year in *3:10 to Yuma*; as for Stewart, he was enjoying a golden decade in Anthony Mann westerns and a string of Hitchcock classics. (His voyeuristic photographer in *Rear Window* lived in an apartment modeled on Aarons's.) Novelist Louis Auchincloss called the photo "the very image of American he-men." Lanky 6´4˝ Aarons was no slouch in that department: He won a Purple Heart as a World War II battle photographer. He also managed a few movie cameos, with questionable results. "That's what they're laughing about," Aarons recalled in 2001. "Gary Cooper is telling Clark Gable, Van Heflin and Jimmy Stewart how I flubbed my one and only line."

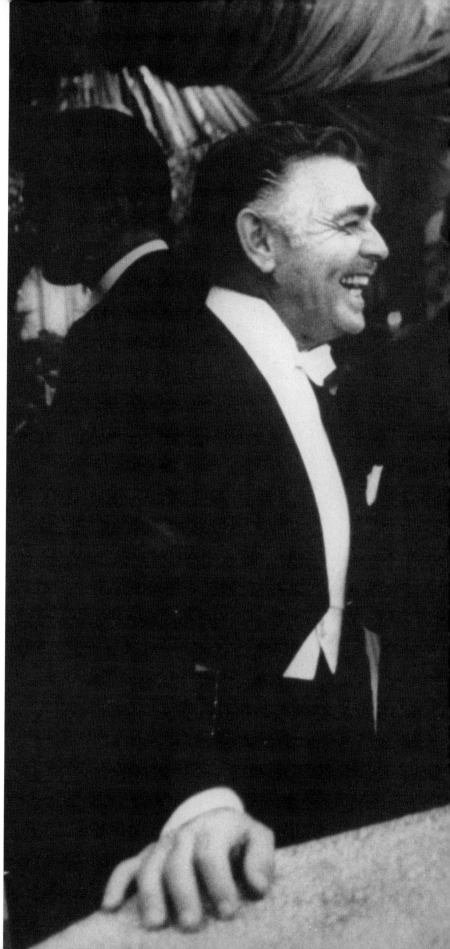

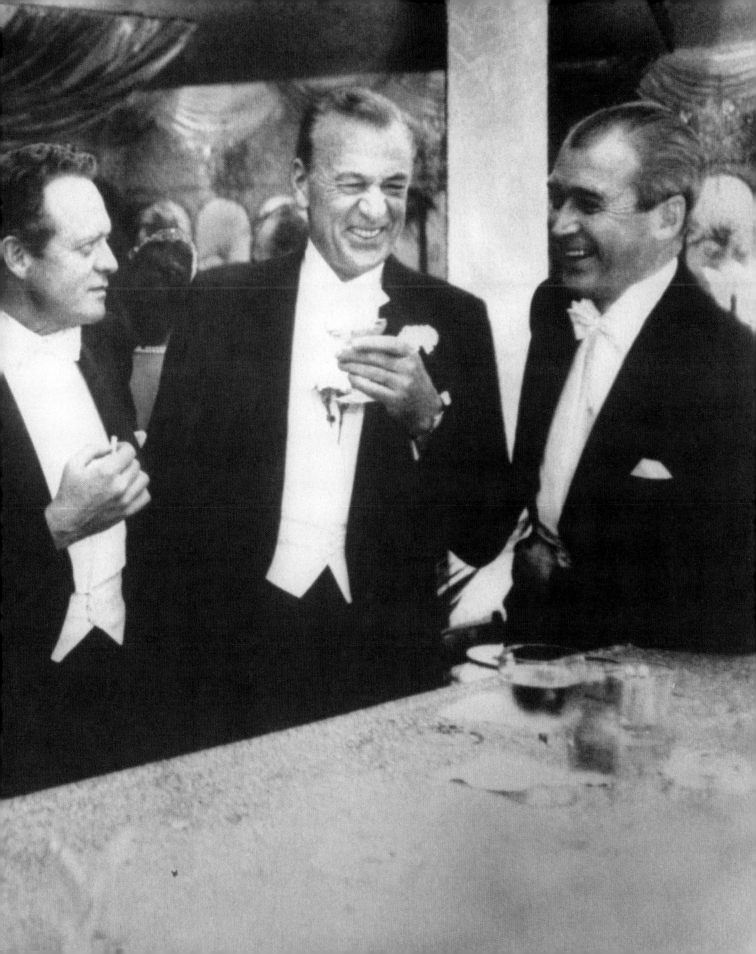

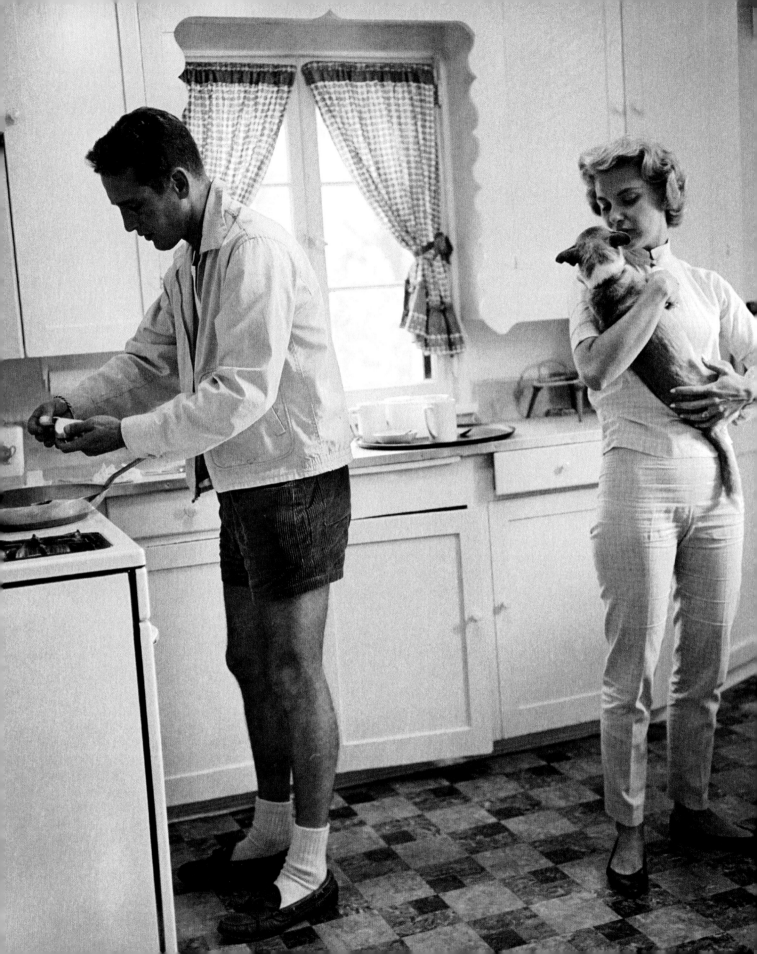

PAUL NEWMAN & JOANNE WOODWARD | *Sid Avery, 1958*

'THEY WERE SO WARM
AND SO RELAXED
AND SO EASYGOING—
"HERE, HAVE SOME
POPCORN…"'
—SID AVERY

THE DAYS OF GLOSSY, STATIC STUDIO PORTRAITS WERE ending as Sid Avery brought film fans into the stars' kitchens and backyards, revealing that glamorous screen idols were just flesh-and-blood folks after all—like us, but with bigger budgets and better lighting. Newlyweds Paul Newman and Joanne Woodward made it easy for him. "It was like being invited into some old friend's home," said Avery, who died at 83 in 2002. "They were so warm and so relaxed and so easygoing—'Here, have some popcorn, get yourself a beer, open up the refrigerator.' Absolutely no star ego at all, real people," he said in his son's book *The Art of the Hollywood Snapshot*. At the time Newman and Woodward—who had recently won an Oscar for *The Three Faces of Eve*—were working together on *Rally 'Round the Flag, Boys!,* a fluffy service comedy. "I love this picture because he's there, cracking eggs and making breakfast while she's standing there with her favorite dog," Avery said. "The cupboards are open, and the drawers are pulled. In the background there's a washing machine, and there's a lot of clothes thrown on top." The couple's union endured for another half century (ending only with Newman's death in 2008), producing three daughters and a charitable packaged-foods empire, offering salad dressing, cookies and, yes, popcorn.

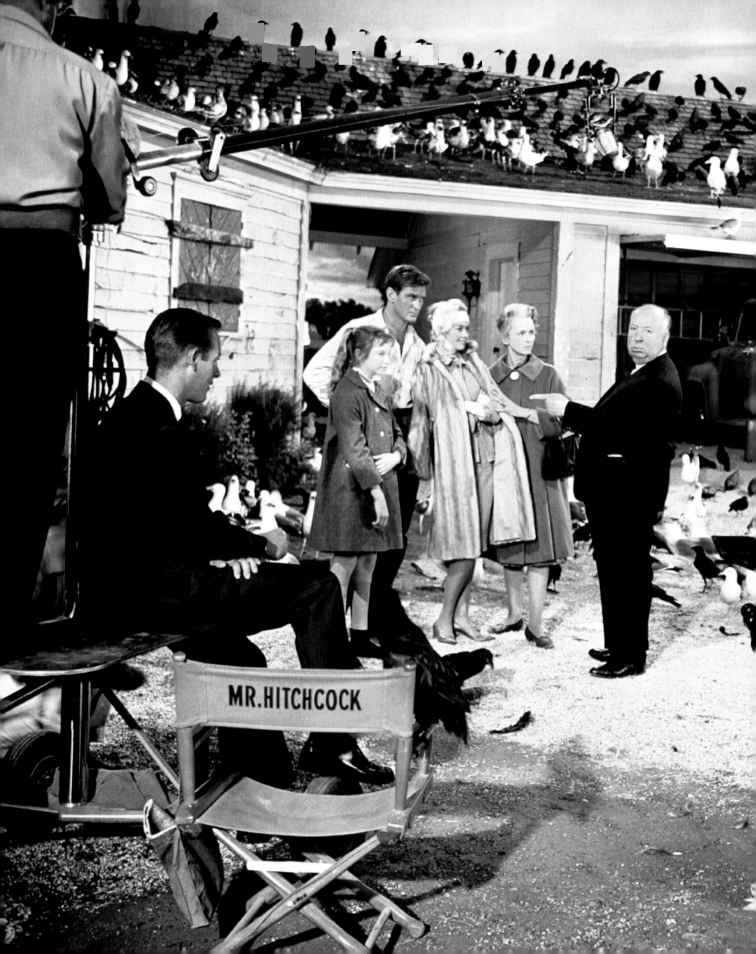

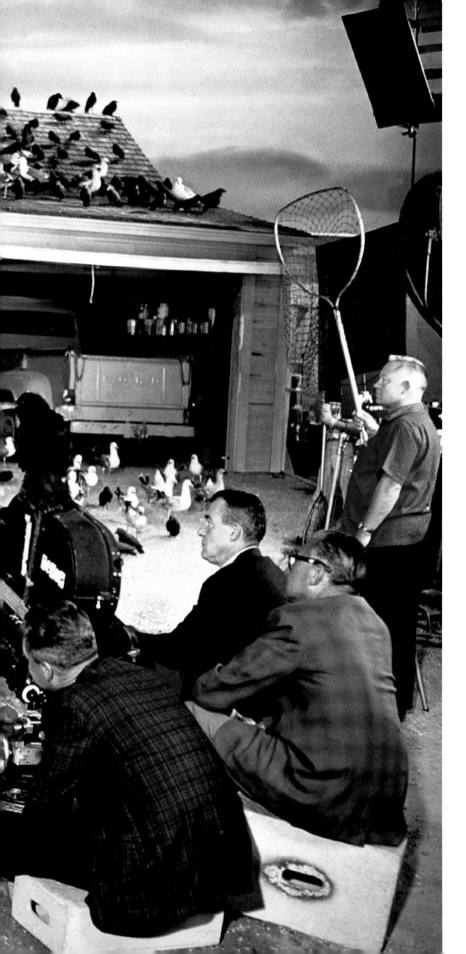

VERONICA CARTWRIGHT, ROD TAYLOR, TIPPI HEDREN, JESSICA TANDY & ALFRED HITCHCOCK
photographer unknown, 1963

'Cary Grant happened to be visiting the set one day and told me between takes, "You're the bravest woman I've ever seen"' —Tippi Hedren

THIS PLACID production still notwithstanding, Hitchcock's avian-invasion thriller was a harrowing experience for audiences—and its stars. In the climactic scene—when Tippi Hedren's character is pecked within an inch of her life—Hitchcock had promised to use mechanical birds. But at the last minute she was told technical difficulties meant they needed live ones, and for days handlers hurled ravens, doves and pigeons at her. "It was brutal, ugly and relentless," Hedren wrote in her 2016 memoir *Tippi*. Her working relationship with Hitchcock (she also appeared in his 1964 film *Marnie*) wasn't much better. She claims that the Master of Suspense (who died in 1980) punished her for rejecting his advances. "He said, 'I'll ruin your career,'" Hedren told Fox News. "And he did. He kept me under contract. . . . It was just one of those Hollywood nightmares."

DEBBIE REYNOLDS & CARRIE FISHER | *Lawrence Schiller, 1963*

'She was mesmerized'
—Lawrence Schiller

IN 1963 THE SINGULARLY EFFERVESCENT DEBBIE REYNOLDS was at a career peak, working steadily onscreen and on the Las Vegas stage (here, at the Riviera Hotel). She had rebounded after a scandalous divorce from singer Eddie Fisher—who had dumped her for her pal Elizabeth Taylor—and married wealthy shoe magnate Harry Karl. "I was shooting a magazine story on her and Karl," recalls Schiller, who stood in the wings one night as Reynolds's daughter Carrie Fisher looked on. "I photographed them at their home on Sunset Boulevard, where the walls were lined with Picassos, Renoirs, Chagalls and other great art. She was leaving to go to Vegas, and I asked if I could tag along." When Reynolds arrived in Sin City, with 6-year-old Carrie and her younger brother Todd in tow, "the first thing she did was put little teeny pictures—the kids' own drawings—on the walls," Schiller says. "She wanted them to feel at home. The next day, when Debbie took the stage, the family housekeeper set up a stool so Carrie could watch her. She was just mesmerized." Within a decade Reynolds had divorced Karl, who gambled away much of their fortune; she would continue delighting audiences into the 21st century. Fisher, of course, grew up to make cinema history of her own as *Star Wars*' Princess Leia and win acclaim as a writer—often chronicling her battles with addiction. Schiller went on to become a respected producer-director but found himself discussing this image again at the end of 2016 when Fisher died suddenly at age 60 after a medical emergency on a flight from London, and Reynolds, 84, died the next day. Reynolds and Fisher's relationship was a turbulent one, but they were close at the end—so much so, Todd Fisher told *People,* that Reynolds's last words were "I want to be with Carrie."

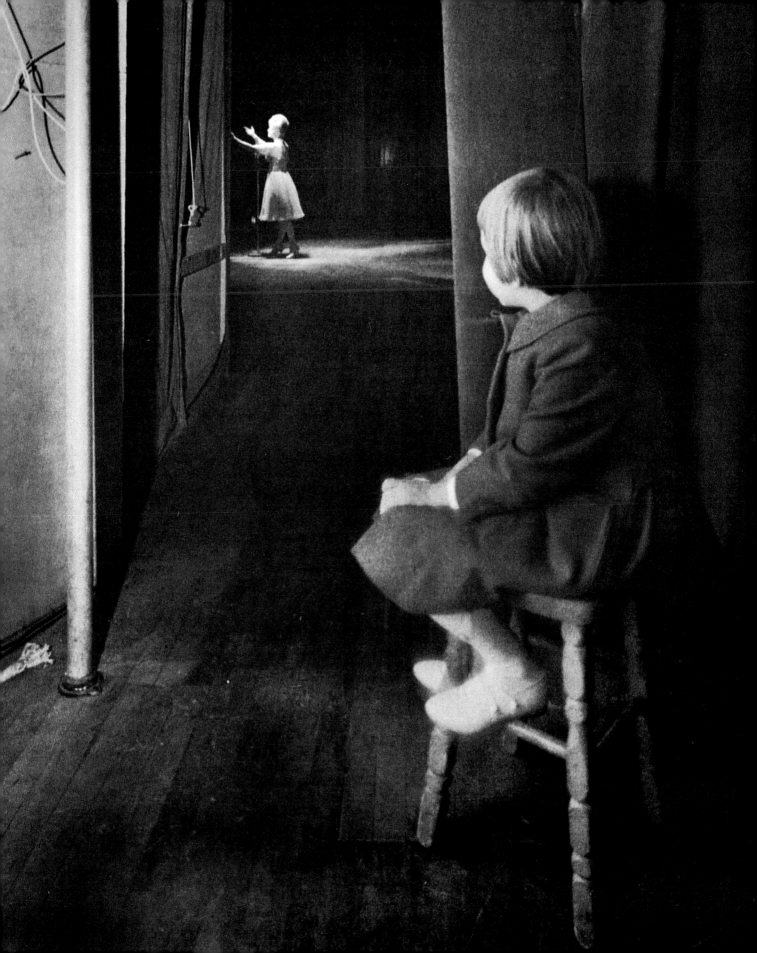

LEONARD NIMOY
Gene Trindl, 1967

'It's tedious. It's painful,
and it's confining'
—Leonard Nimoy

LEONARD NIMOY enjoyed a 60-year career as an actor, director, photographer, author and political activist. But the Bostonian barber's son is inextricably linked to Mr. Spock, the half-Vulcan science officer of *Star Trek's* USS *Enterprise*. Nimoy's relationship with Spock was complicated: He titled his 1975 autobiography *I Am Not Spock* and his second, two decades later, *I Am Spock*. What never varied was Nimoy's impatience for the two hours Spock kept him in the makeup chair, a process documented by Gene Trindl, a prolific cover photographer for *TV Guide* and regular visitor to the *Trek* set. It wasn't all about the ears; Trindl noted that Spock's eyebrows "must be laid on hair by hair and cut fresh every morning. They are not one piece. If they were, you would not get mobility." Ultimately Nimoy, who died at 83 in 2015, embraced his alter ego. "A lot of people will tell me they're in the sciences because of Spock," he told *People* in 2009, or "during adolescence they used Spock as a role model on how to function with some dignity and equilibrium, dealing with the logic versus the emotional issues." Spock also made Nimoy an unlikely sex symbol. "I didn't see that coming," he said. "I *really* didn't see that coming."

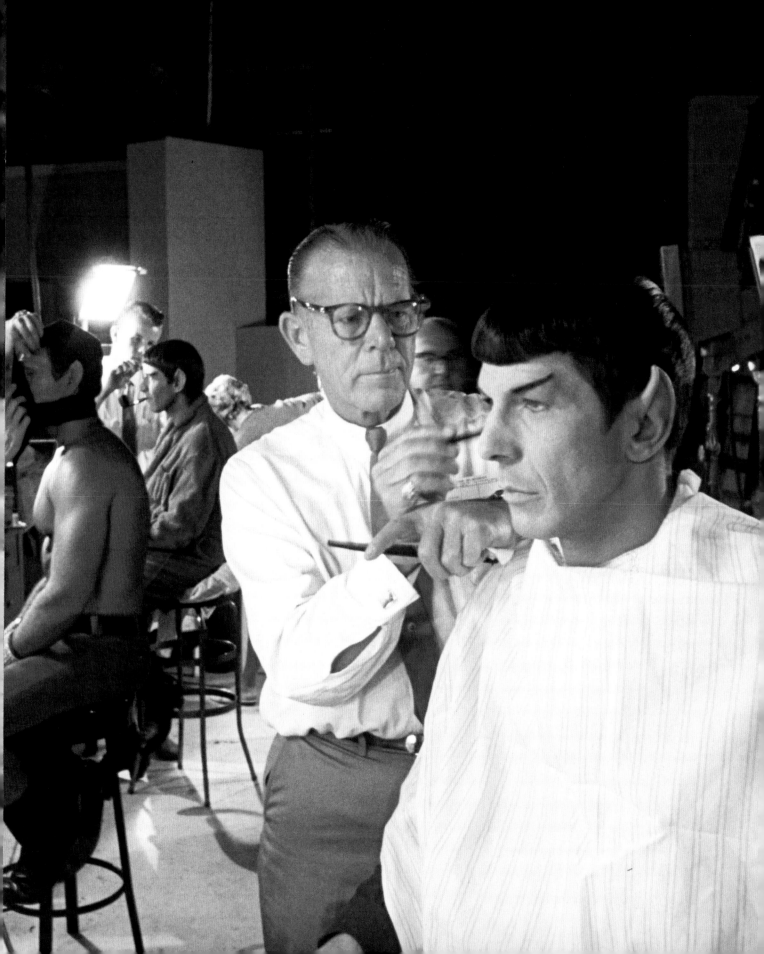

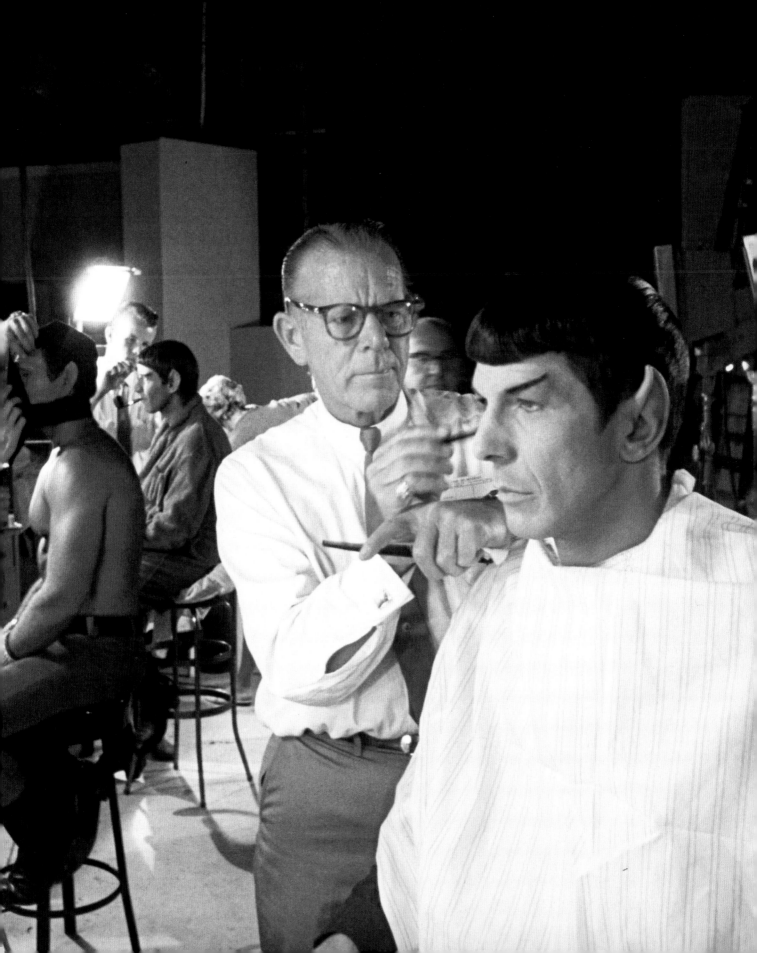

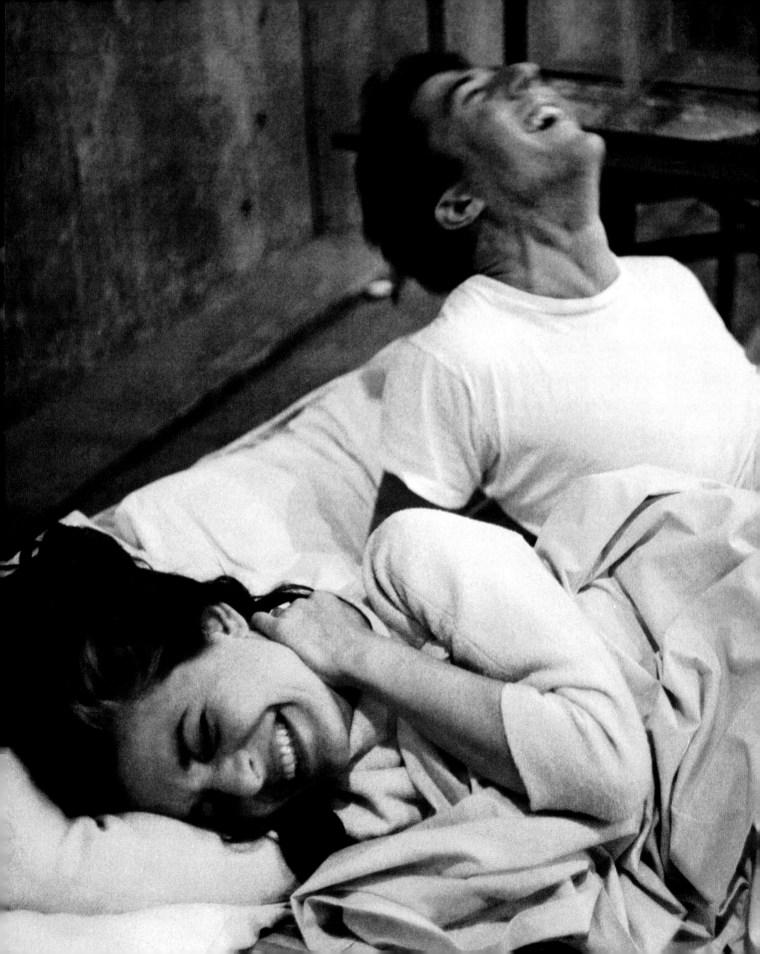

'I was an unemployed actor at 29, and Anne Bancroft was only six years older. Her husband, Mel Brooks, was very jealous. He would call her and ask, "Did he kiss you yet?"' —Dustin Hoffman

DURING HIS FIRST job on a movie set—shooting a spread about 1954's *A Star Is Born*—self-taught photographer Bob Willoughby bonded with a notoriously volatile Judy Garland. She became a lifelong friend, as did Audrey Hepburn, among other screen luminaries. By the time Willoughby showed up on the *Graduate* set in 1967, he knew most anyone who was anyone in Hollywood, including Anne Bancroft, who played mother-of-all-cougars Mrs. Robinson. "But he was meeting newcomer Dustin Hoffman for the first time," film editor Christopher Willoughby says of his father, who died at 82 in 2009. "Suddenly Dad was like, 'Was your mom's name Lillian? And your dad's Harry?' And Dustin went, 'Um, yeah.' And Dad said, 'I used to babysit you when you lived on Orange Avenue in L.A.!'" This particular shot was taken on a closed set during a rehearsal. "They were hard at work, and director Mike Nichols said, 'Hey, let's play this for laughs,'" Christopher says. "Dad caught them as they were goofing around, changing the whole vibe of the scene."

JOHNNY CASH
& JUNE CARTER
Ken Regan, 1970

'I didn't know what to expect. I had heard all the stories about Johnny Cash, drugs and the sometimes wild behavior, like driving his truck off a hillside into a lake' —Ken Regan

KEN REGAN COVERED a wide range of topics, but he's best known as a chronicler of the rock era, producing intimate images of the Beatles, the Rolling Stones, Bob Dylan and other heavyweights. When *Time* sent Regan to Hendersonville, Tenn., for a story on Johnny Cash and wife June Carter, however, he felt a measure of trepidation. The Man in Black was a formidable figure. "The shoot was both a challenge and a thrill," Regan, who died in 2012, recalled in his book *All Access.* But Johnny and June, he wrote, "graciously opened themselves and their home to me. We'd be in the living room when Johnny would pick up his guitar and start singing. It was so special—sitting there, hearing that incredible voice of Johnny Cash . . . in such a private setting." The next day Cash invited Regan back for a dinner party—with his camera. "I got there as Johnny and June were making dinner." They were joined by Kris Kristofferson, actor Jack Palance and Shel Silverstein, who wrote Cash's 1969 hit "A Boy Named Sue." "That evening turned into quite a treat."

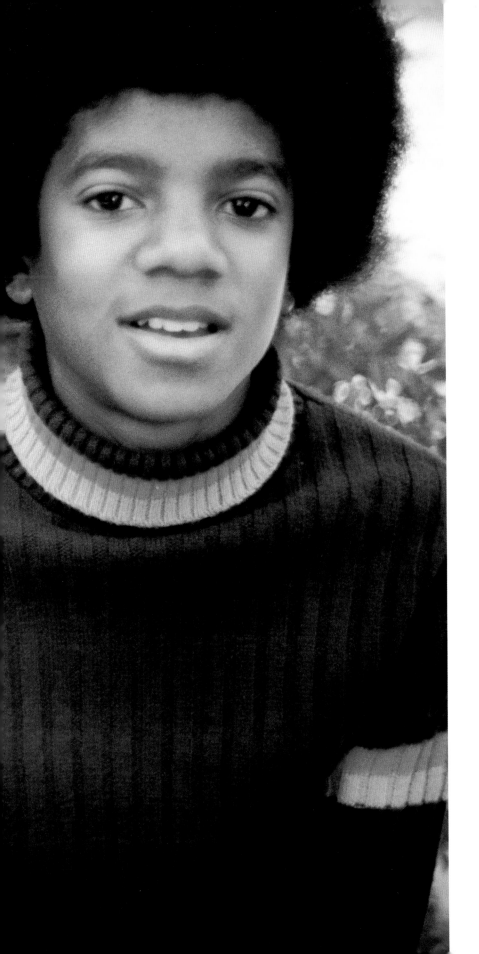

JANET & MICHAEL JACKSON
Michael Ochs, 1972

'It was not a normal childhood'
—Michael Jackson, 1993

WHEN MICHAEL and Janet Jackson posed in their Hollywood Hills backyard, he—a 14-year-old chart-topper with the Jackson Five—was already making his first solo steps toward becoming King of Pop. His 6-year-old sister would soon join the family business, from which she would later break free to achieve her own dreams. This photo betrays no hint of their turbulent childhood, allegedly marred by psychological abuse from dad Joe. "My childhood was completely taken away from me; there was no Christmas, there were no birthdays," Michael said in a 1993 Grammy acceptance speech. "Those were exchanged for hard work, struggle and pain and eventually material and professional success." Janet has said her siblings teased her about her looks and that she became intensely self-critical. "I would literally bang my head up against the wall because I didn't feel attractive," she told NBC's Meredith Vieira in 2011. Janet altered her appearance as she grew up, though to a far lesser extent than her brother. When he died at age 50 from a 2009 drug overdose, Michael was barely recognizable as the adult version of this cherubic boy. But close your eyes and listen to him sing, and you can hear that kid was still inside.

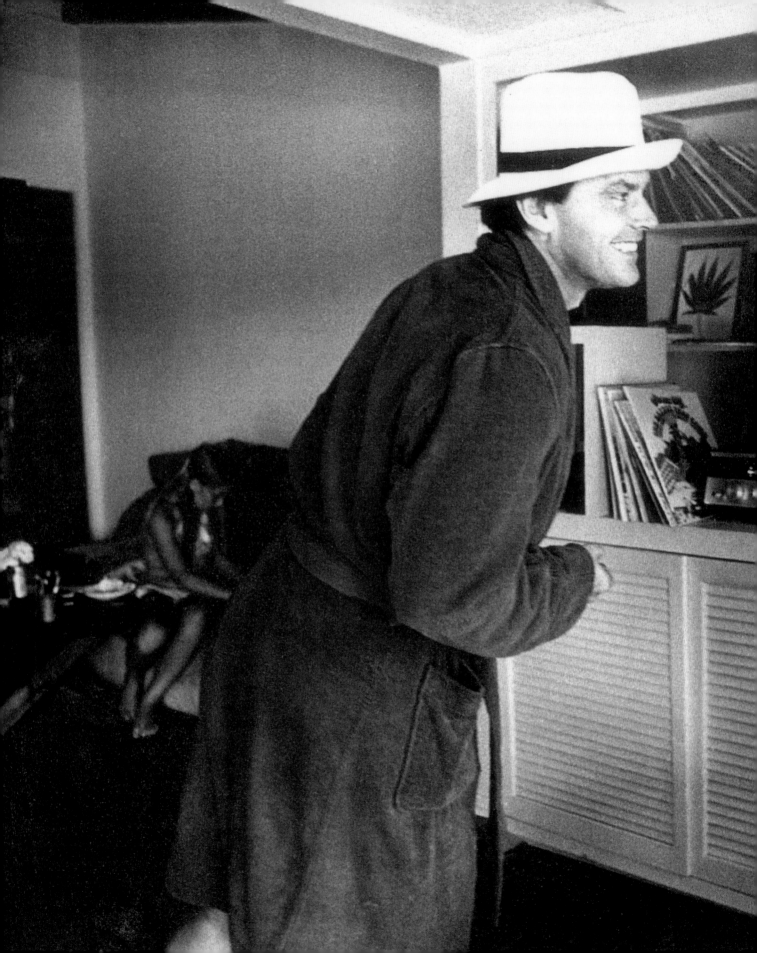

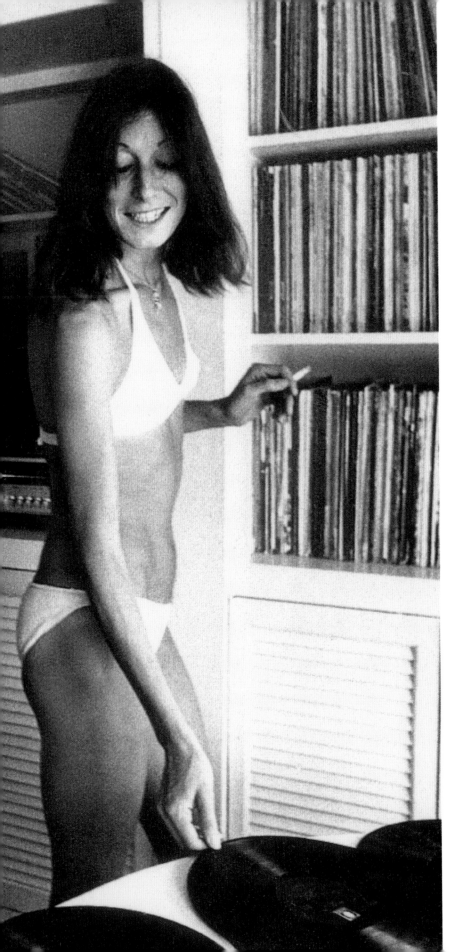

JACK NICHOLSON & ANJELICA HUSTON
Julian Wasser, 1974

'This was at his house up in Mulholland Drive. We were first together here. We were so free' —Anjelica Huston, 2013

HE WAS 37, A FORMER studio gofer who'd drifted into acting. She was 23, an heiress to film royalty. Jack and Anjelica—no last names needed, as a knowing mention in *Annie Hall* proved—had been together about a year when photojournalist Julian Wasser visited them at home above L.A. Nicholson, after a run of three Oscar nods, had critics swooning over his turn in *Chinatown*. (The film was inspired by the story of water engineer William Mulholland, whose name is immortalized in the hilltop road where Nicholson perched.) The daughter of director John Huston, Anjelica was then a model; she'd recently returned from Cannes, where she bought this bikini. What struck Wasser was the ambient scruffiness. "It was a very low-key house," he recalls. (It is also where, in 1977, Huston came home to find *Chinatown* director Roman Polanski with the 13-year-old girl he was charged with raping.) "Nicholson was driving a VW convertible. He didn't really understand what a big star he was for years." By the time they broke up in 1989, Huston had her own Oscar, and her ex—who's won three of those trophies—had bought a scad of fancier homes. But he always kept the place on Mulholland Drive.

CHER & CHAZ BONO
Douglas Kirkland, 1975

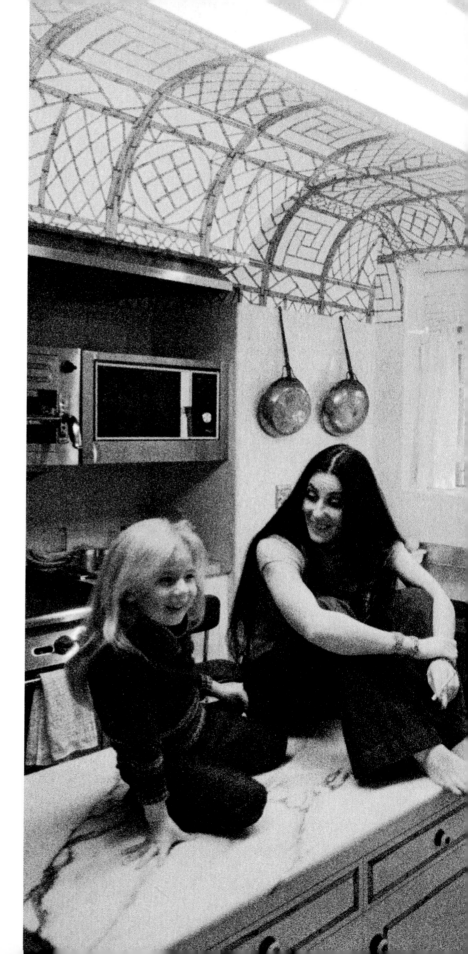

'From a young age
I thought I was a little boy'
—Chaz Bono

DOUGLAS KIRKLAND snapped Cher at a moment of renewal—recently divorced, she had found new love with Gregg Allman and begun a solo TV show. But the center of her life was Chaz, 5 (then called Chastity), her child with Sonny Bono. "They had a very good relationship, and I think it shows in a very lovable way," says Kirkland, a veteran of *Life* and *Look* in the 1960s. "Chastity was delighted with her mother, and it wasn't because she was a star. She was her mom." Alone or with Sonny, Cher often ended her show by bringing out Chaz to say good night, sometimes in a little-girl version of Mom's Mackie couture. Chaz had a different memory of that time: "I especially liked it when they put me in clothes that matched my father's." In 2009 Chaz came out as transgender and became an important LGBT voice. While his mom admitted some initial misgivings, Chaz told *People*, "She's started to see how happy I am, and that's her biggest concern."

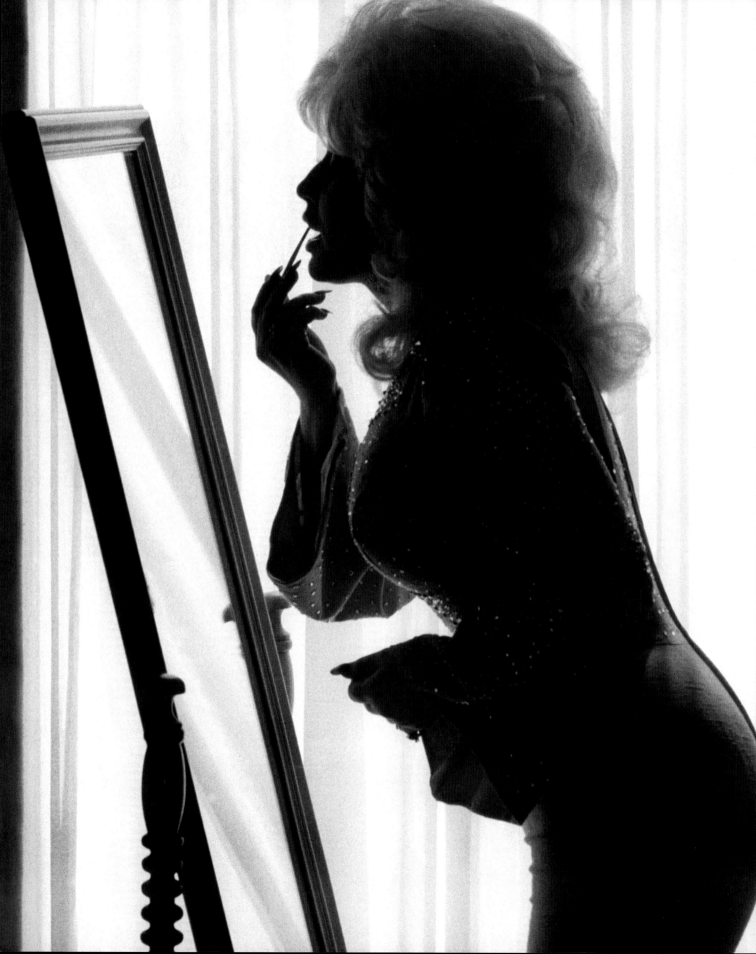

'I'M AWARE THAT
I'M NOT IN STYLE,
BUT IT DON'T
BOTHER ME. I LIKE
LOOKING AS
IF I CAME OUT OF
A FAIRY TALE'
—DOLLY PARTON

THERE HAD NEVER BEEN A COUNTRY SINGER LIKE HER. Just five feet tall ("6′4″ with wigs and heels," she joked), Dolly Parton packed more firepower than a barn full of skyrockets. As if her songwriting chops and vocal virtuosity weren't enough, her outsize persona—down-home sass crossed with bombshell sizzle, accented by plunging necklines and towering hairdos—put her in a class of her own. This image, taken at Parton's Nashville home, captures that intensity in a quiet moment. Photographer Harry Benson had gone to fetch some equipment and returned to find her doing a touch-up in her bedroom mirror. "I said, 'Just stay as you are, Dolly,'" he recalls. "There's such elegance in the hands and the pose—and a lot of energy. This is, in some ways, an athlete." At the time, Parton was executing a career pivot. One of 12 children of a dirt farmer in Tennessee's Great Smoky Mountains, she'd made her Grand Ole Opry debut at 13. In her 20s she'd formed a successful duo with Opry eminence Porter Wagoner; then, after topping the country charts with solo efforts like "Joshua" and "Jolene," she'd struck out on her own. By 1977, when Benson's photo appeared in *People*, she was 31, and her music was edging toward crossover territory. She'd just fired her old band (including four of her siblings, an uncle and a cousin) and replaced her manager with the firm that represented Joan Rivers and Cher. Still, she insisted, she hadn't forgotten her roots: "I'm Dolly Parton from the mountains, and that's what I'll remain." Though she soon added pop diva and movie star to her portfolio, she kept her word.

GILDA RADNER & JOHN BELUSHI | *Edie Baskin, 1976*

'Nobody knew what was happening. It was all very new, and I said [to Lorne Michaels], "Hey, do you think I can be the photographer?"'
—Edie Baskin, in 2015, to NPR

GILDA RADNER WAS ONE OF THE PEOPLE WHO urged *Saturday Night Live* creator Lorne Michaels to audition John Belushi, her friend and fellow veteran of the Second City comedy troupe. Radner and Belushi were among the most prodigiously talented of *SNL's* inaugural cast, each with a steamer trunk of comic characters: her endearingly dim commentator Emily Litella; his manic Samurai. Also there at the creation was photographer Baskin, who landed the gig after meeting Michaels in a poker game, she told NPR in 2015, and went on to document cast members until leaving in 2000. Besides capturing the backstage antics, Baskin created the hand-colored portraits viewers saw when the show came back from commercial. While many of her images are humorous (see: Land Shark at Table Read) she also caught moments of affection, like this one between two pals who couldn't have differed more. Petite Radner radiated sweet vulnerability. "Gilda always had a pocketbook filled with candy," castmate Chevy Chase told *People* in 2015. "That's all she ate; she loved it. She was loved by many." Belushi was burly—and surly. "John was fired a couple of times for behaving badly—hurting someone's feelings," Michaels told the magazine. "Then other people would come in and say, 'You can't fire John!'" A man of epic, self-destructive appetites, Belushi died from cocaine and heroin in 1982 at just 33. Radner was also gone far too soon, struck down by ovarian cancer at 42 in 1989. "I think about the loss of Gilda and…John," Chase told *People,* "and think, 'That's it, you're never going to find them again, anything like them.'"

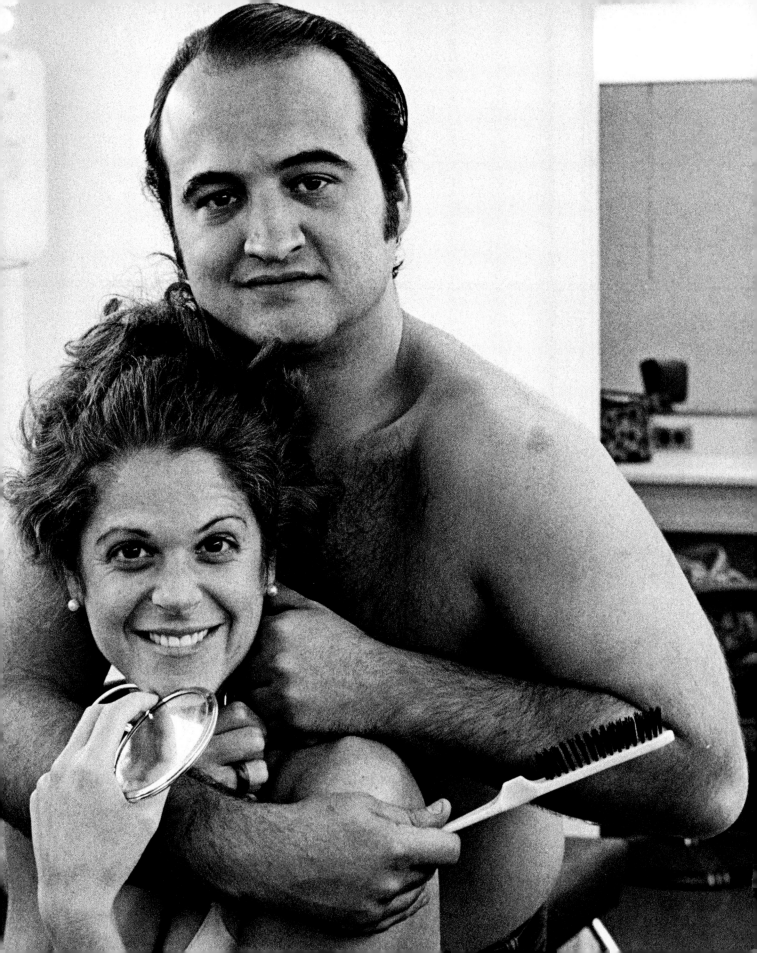

JACLYN SMITH, DAVID DOYLE, FARRAH FAWCETT & KATE JACKSON
Julian Wasser, 1976

'We started out as strangers, but now there's a real warmth and fondness between us'
—Jaclyn Smith, 1976

CHARLIE'S ANGELS' success with its 1976 debut can largely be explained by its winning combination of female empowerment for the girls and ample on-the-job bikini scenes for the guys. Rarely discussed when parsing producer Aaron Spelling's "jiggle TV" hit is the chemistry of the show's stars. As a trio of private eyes who toiled for a never-seen tycoon named Charlie, Jaclyn Smith, Kate Jackson and Farrah Fawcett (here with David Doyle as Detective Bosley) bonded on the high-pressure set. "He worked them like dogs," photographer Julian Wasser says of Spelling. "He wouldn't give them time off for the shoot, so I had to do it on their lunch hour." The stress fostered camaraderie: "If somebody is late or irritable," Jackson told *People* in 1976, "the others say, 'It's not her fault.'" But by season 2 Fawcett quit, to be replaced by Cheryl Ladd; then Jackson left, succeeded by Shelley Hack. But in the early days, Smith told *People* in 2016, "we were three girls from the South, and it was like being in college again."

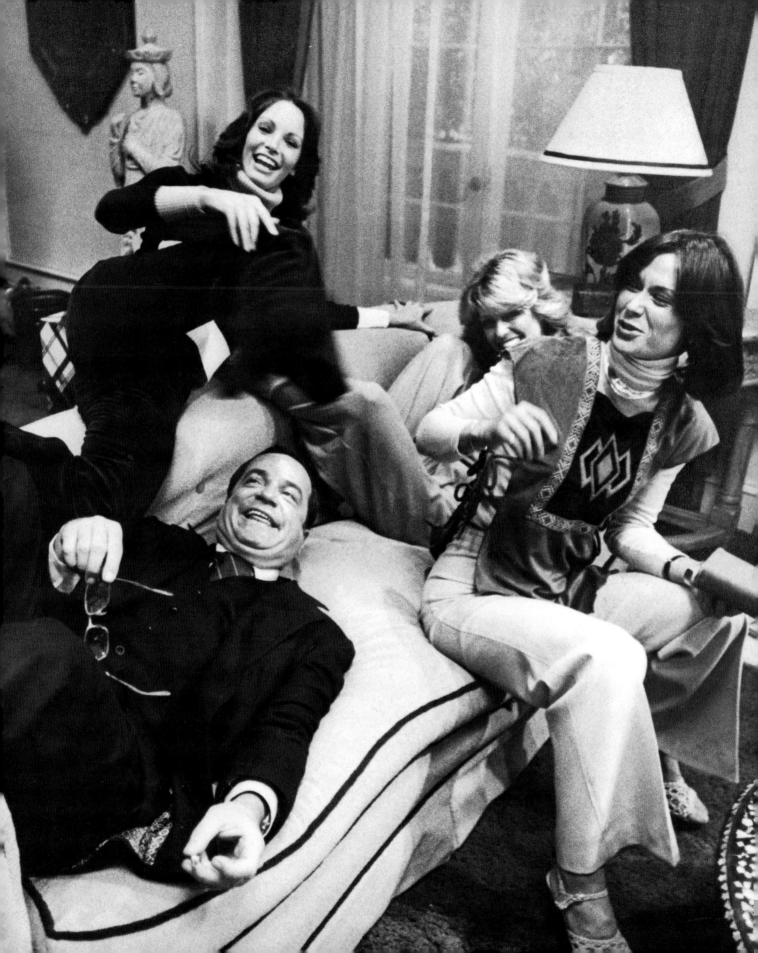

CAST OF *STAR WARS*
John Jay, 1976

'When it began, it was just another film' —Peter Mayhew

THE CREW OF THE *Millennium Falcon* had no idea what lay ahead. Asteroids. Space slugs. Imperial tractor beams. Likewise, the actors at England's Elstree Studios couldn't have guessed what was coming. Harrison Ford, 33, had been in George Lucas's *American Graffiti* but still took carpentry jobs. Carrie Fisher, 19, had two famous parents—Eddie Fisher and *Singin' in the Rain*'s Debbie Reynolds—but had not experienced firsthand the impact of a landmark movie. Mark Hamill, 25, was the wide-eyed newcomer, and 7'2" Peter Mayhew was the fellow in the Wookiee suit. If the set was as relaxed as it appears, it was because expectations were low. No one knew they were launching one of cinema's most influential and lucrative franchises. During rehearsals, those with blasters provided their own "bang bang" sound effects. The motion of the *Falcon* came from stagehands rocking it. And at least two cast members, it was revealed decades later, had a hot location affair. "It was Han and Leia during the week, and Carrie and Harrison during the weekend," Fisher wrote in 2016's *The Princess Diarist*. Five weeks after its publication, she died at age 60. She was, Ford recalled to *People*, "funny and emotionally fearless."

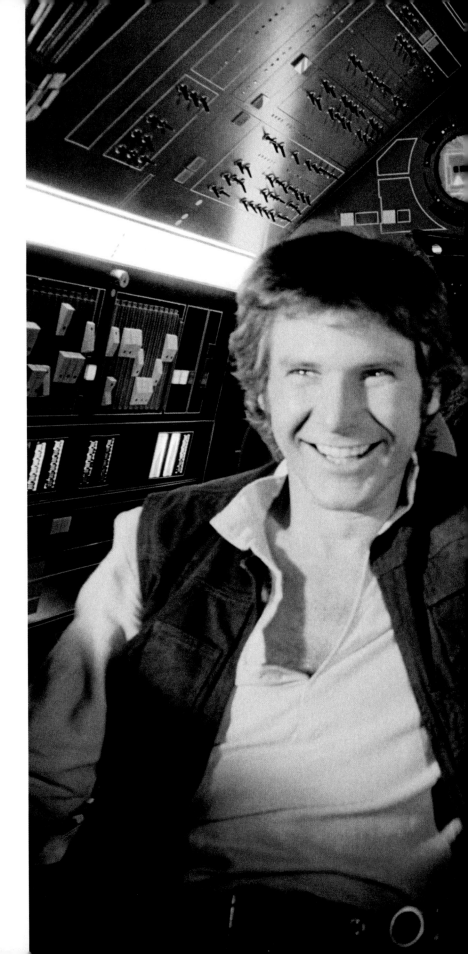

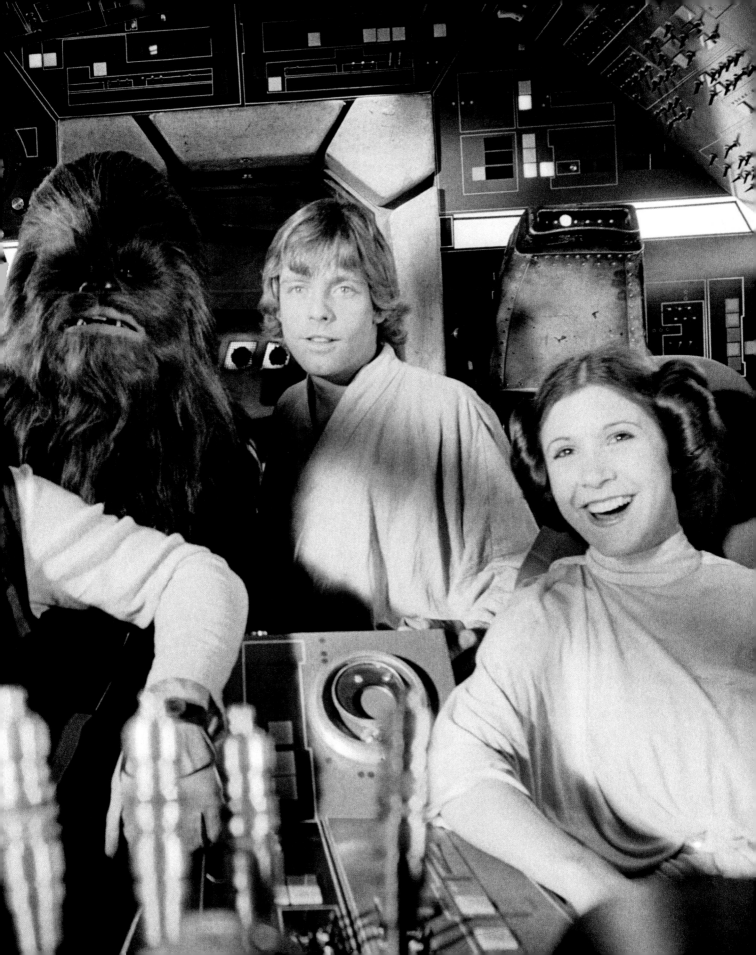

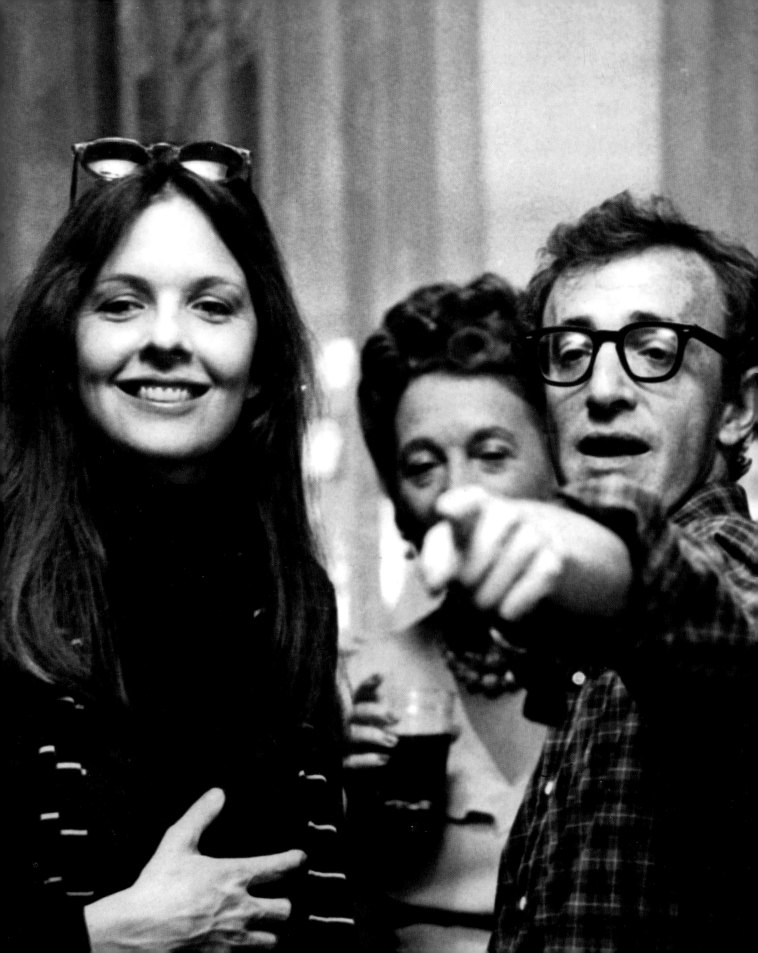

DIANE KEATON, WOODY ALLEN & TONY ROBERTS
Brian Hamill, 1976

'I did 77 movies, and of all the people I worked for, Woody was my favorite guy. He's so loyal' —Brian Hamill

IT WAS BRIAN HAMILL'S brother Pete, the legendary New York newspaper columnist, who introduced him to Woody Allen at the director's regular haunt, Elaine's on Manhattan's Upper East Side. Allen hired Hamill to shoot on the set of a film he was making in 1976—a New York romance loosely based on his relationship with costar Diane Keaton. In one scene Allen's character brings his girlfriend (Keaton) and pal (Tony Roberts) to his childhood home in Coney Island and they witness, in flashback, a 1945 homecoming party. (The fourth actor in this photo plays a guest.) The photographer and the filmmaker bonded over their shared roots. "You know," says Hamill, "*old* Brooklyn"— the brawling borough of egg creams and Ebbets Field, not today's man-bun mecca. Hamill says Allen's nebbish persona is an invention; he describes the real man as street-smart with "a cool, confident, urban-boppin' walk." Their friendship has endured for 26 films. "We still have lunch, we go for walks, we exchange texts, we bull----. You know, he's a Brooklyn guy." One who hung back in New York while that film, *Annie Hall*, picked up Oscars for Best Picture, Director, Original Screenplay and Actress.

ELIZABETH TAYLOR
Firooz Zahedi, 1977

'[She was] like your fantasy mother, the one who lets you do fun things' —Firooz Zahedi

WHEN FIROOZ ZAHEDI met Elizabeth Taylor in 1976, he was a recent art-school graduate shooting for Andy Warhol's *Interview* magazine and she was recently divorced for the second time from Richard Burton and dating Zahedi's cousin, Iran's ambassador to the U.S. That romance didn't last—she would soon meet the sixth of her seven husbands, Republican Sen. John Warner of Virginia. But the union with the photographer endured for more than three decades. Their first collaboration took Taylor to Iran, where Zahedi had been born. The next year he photographed Taylor fixing fried chicken in the kitchen of the Middleburg, Va., farm she shared with Senator Warner during their five-year marriage. Fans raised on images of a bejeweled film goddess could rightly have been shocked by this image. But Zahedi, who commemorated his friendship with Taylor in a 2016 book, *My Elizabeth*, said that under all the glamour Taylor was quite down-to-earth. "She was very low-key, very hippie, very sweet," he told *People.* On the other hand Taylor was not terribly domestic but was capable with her mom's fried chicken recipe—"Elizabeth's favorite food next to caviar."

DIANA, PRINCESS OF WALES, WITH BRIDESMAIDS
Patrick Lichfield, 1981

'My recollections … are of achingly tired legs, of desperately wanting to sit down … and of doggedly staring at my little gold shoes as they walked up the aisle and down it again, determined not to step on that magnificent train' —Clementine Hambro

AROUND THE WORLD, a TV audience of 750 million watched as 32-year-old Charles, Prince of Wales and heir to the British throne, wed Lady Diana Spencer, 20, a former kindergarten teacher, at St. Paul's Cathedral. Hundreds of thousands of spectators lined the streets as the couple rode in a procession of ornate carriages. For one bridesmaid, however, the day was not entirely glorious. Clementine Hambro, age 5 (a great-granddaughter of Winston Churchill and Diana's former pupil), tripped and fell in a palace corridor. The new princess picked her up and soothed her, murmuring, "Did you bump your bottom?" Hambro, weeping, responded indignantly, "No, I bumped my head!" Queen Elizabeth gave her a consoling pat. Fashion photographer Patrick Lichfield, there to shoot formal portraits, slipped a small camera from his pocket and captured the scene— a bit of ordinary human drama behind the pomp. He caught something else as well: the kind spirit that enthralled Diana's fans.

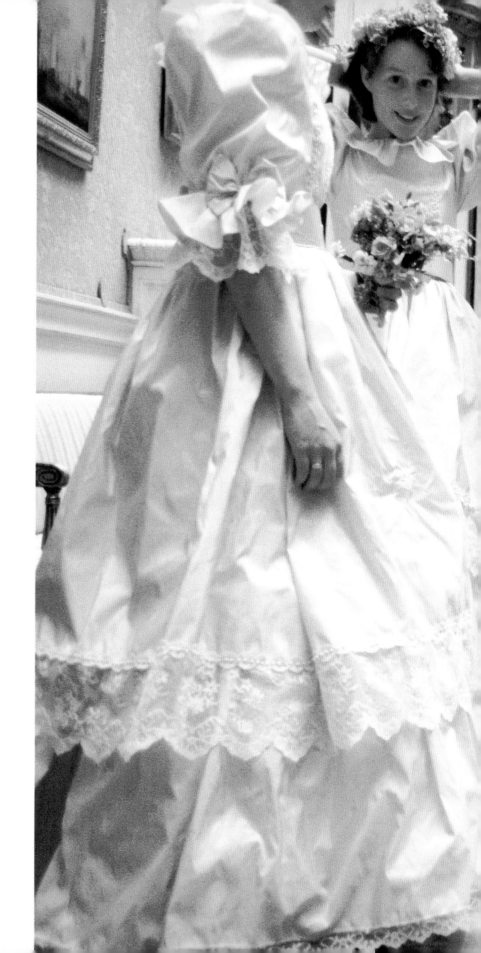

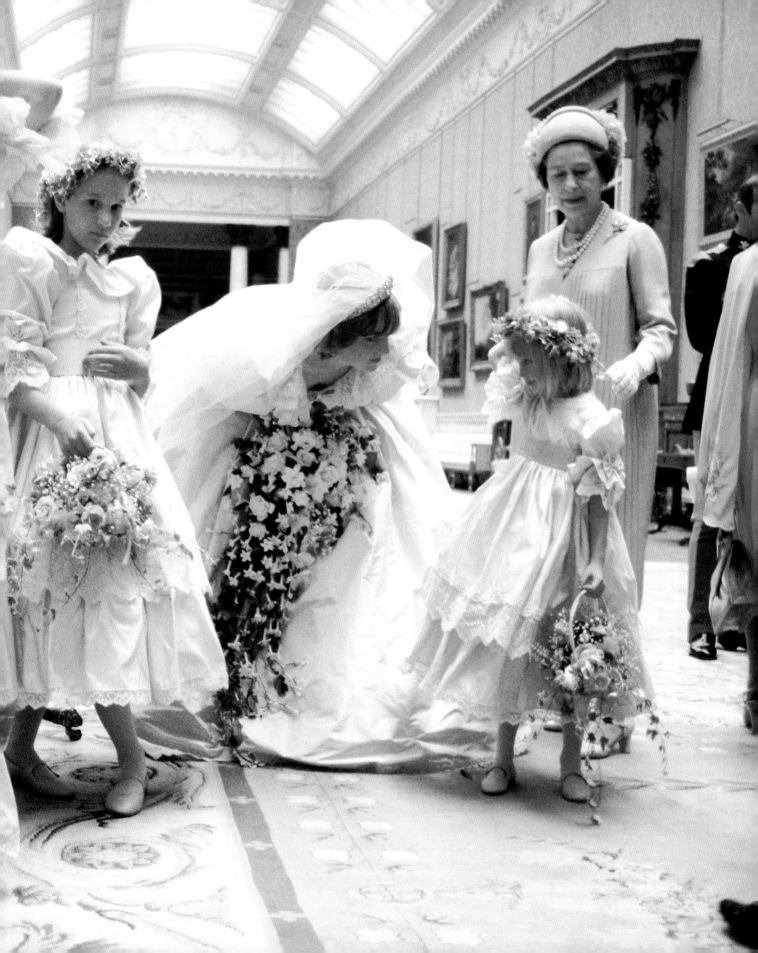

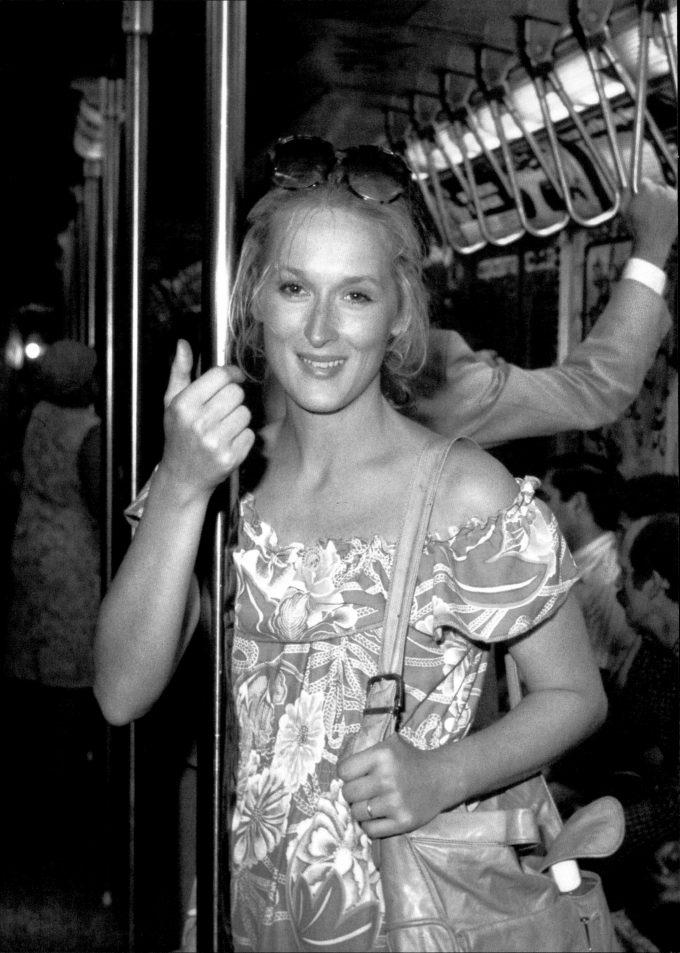

MERYL STREEP | *Ted Thai, 1981*

'It was unbelievable:
She was so famous, but
you can see, nobody
disturbs us' —Ted Thai

WHEN *TIME* CHOSE Meryl Streep for a cover story timed to her upcoming 1981 film *The French Lieutenant's Woman*, she was already a singular star known for disappearing into her roles. So it should have come as little surprise that, virtually at will, she could disappear into a New York City subway crowd. "I was told to meet her at this restaurant, and she was very nice," recalls *Time* lensman Ted Thai. "I'd photographed her before, while shooting *The Deer Hunter* in Pittsburgh in 1977, and she remembered me. Anyway, Meryl was living downtown, about five blocks from my place, and I said, 'Well, let's take the subway.' I thought it was a nice idea to photograph her there—because she was so very approachable." They boarded the train—a canvas of 1980s graffiti—and Thai got his picture. "When we got off at Canal Street and Broadway, she said, 'You have to try this egg cream place on the corner.' Now it's some terrible Chinese restaurant. So we had an egg cream. I've never met her again."

GOLDIE HAWN WITH OLIVER & KATE HUDSON | *photographer unknown, 1982*

'FOR JUST A
LITTLE LONGER,
I DON'T WANT
TO BE ANYTHING
OTHER THAN
THE NAMELESS
MOM OF TWO
SMALL KIDS'
—**GOLDIE HAWN**

GOLDIE HAWN FIRST CARVED OUT HER PLACE IN SHOW BUSINESS with an infectious giggle, a ditzy persona and the memorable image of her bikinied, graffitied go-go dancing body on *Laugh-In*. She parlayed that sunny spirit into an Oscar in her first major film role, in 1969's *Cactus Flower*. "I never feared the ding-a-ling image," she said to *People* in 1976. Perhaps because, from early on, she made a point to show the public another side of herself: a joyful mom who took care to balance work and family. "I can't wait for this baby!" she told the magazine when she was pregnant with her first child, Oliver, with second husband, musician Bill Hudson. She opened up again about the frightening days following his birth, when he suffered pneumonia. "He had a will to live. He's a very special little boy." Daughter Kate followed in 1979, just before Hawn's triumph in *Private Benjamin*. During the making of that film she split from Hudson. In 1983 she began a romance with Kurt Russell that is one of Hollywood's most enduring. "What really got me was when I watched my kids when they'd come to the set and how he was with them," she told *People* of Russell, who came to the relationship with a son, Boston, and with Hawn had another, Wyatt. Those kids in the photo? Oliver is an actor (*Nashville, Scream Queens*). Kate followed in Mom's footsteps as a bubbly princess of rom-coms (and earned an Oscar nomination for her breakthrough role in *Almost Famous*). Hawn's still known for her comic chops, appearing opposite Amy Schumer in 2017's *Snatched*. But at home the grandmother of five is known as Glam-Ma.

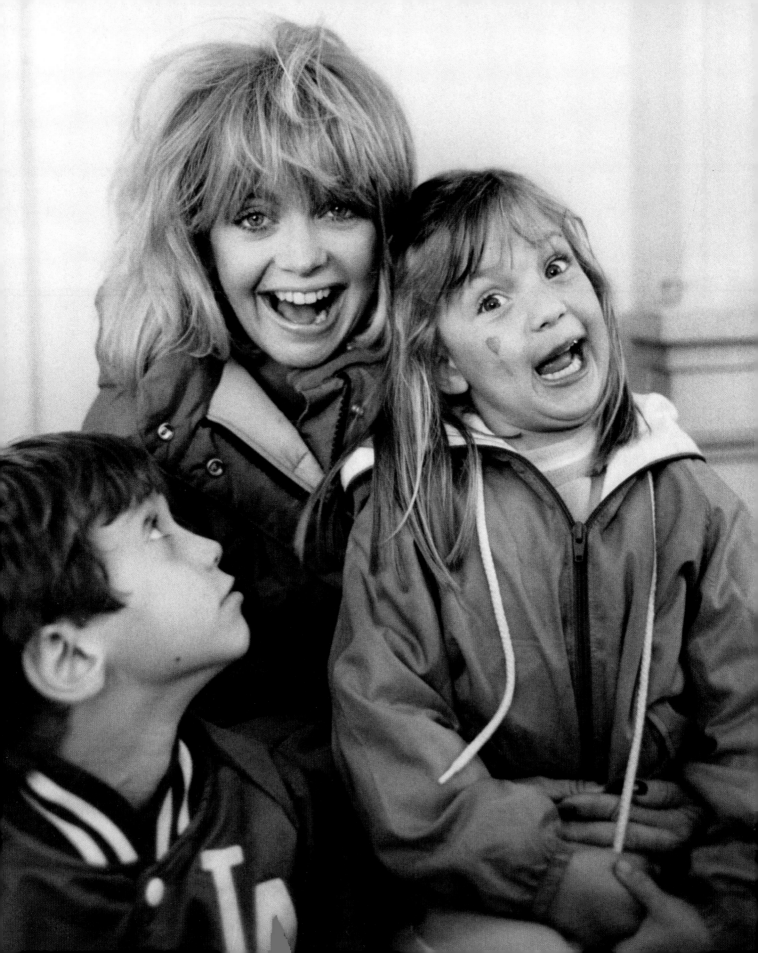

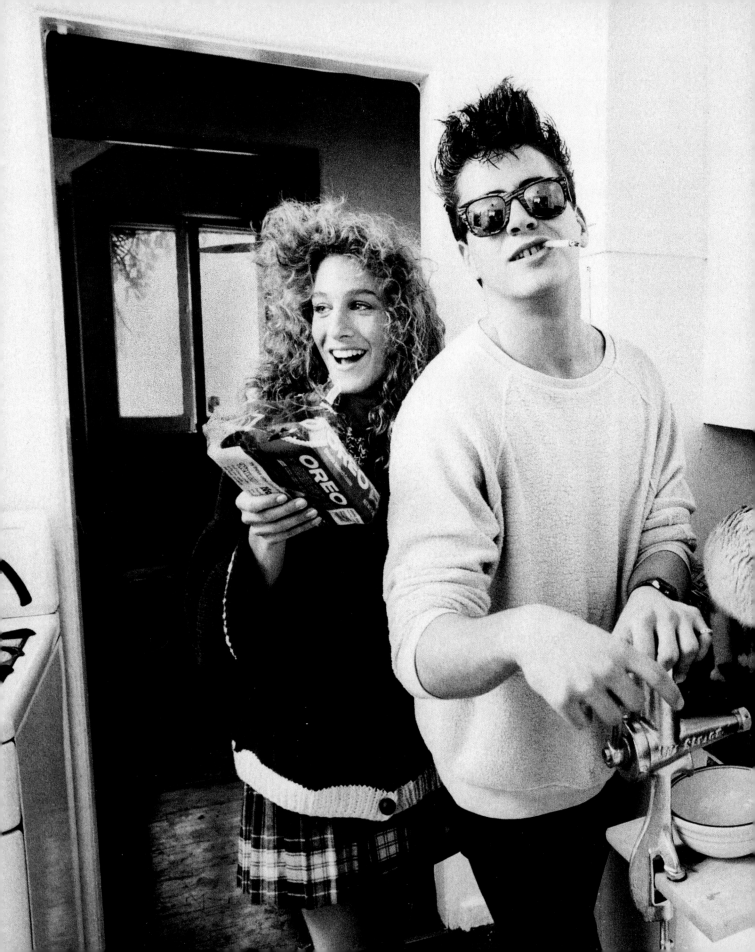

SARAH JESSICA PARKER & ROBERT DOWNEY JR.
Steve Smith, 1985

'They seemed very happy
to be in each other's
presence' —Steve Smith

SARAH JESSICA PARKER and Robert Downey Jr., then both 20, were mutually smitten when Steve Smith shot them for *People*. The future Carrie Bradshaw and Iron Man met filming a 1984 thriller, *Firstborn,* in New York. Eight weeks later Downey moved into her apartment. It was, said Parker, "so impetuous, we were almost embarrassed for anyone to know." They set up home in Hollywood (where this picture was taken), and Downey said, "marriage looks like where we're headed." But his substance abuse strained the relationship; they split in 1991. Parker wed Matthew Broderick. Downey, who did time for violating his probation on drug charges in 2000, got sober and is now married to producer Susan Levin. More recently he and Parker had a friendly reunion. "It was really cool," he told Howard Stern in 2015. "I saw the way she and Matthew live, and I respect both of them so much." Said Parker, affectionately: "It was surprisingly not weird."

GLENN CLOSE
& MICHAEL DOUGLAS
Andrew Schwartz, 1986

'What can I say? I love this shot. Two pros at work'
—Andrew Schwartz

FATAL ATTRACTION was an instant classic, a neo-noir thriller about sexual obsession with a rivetingly unhinged performance by Glenn Close as the mother of all spurned lovers. She plays Alex, a sultry Manhattan book editor jilted after a weekend fling with married lawyer Dan (Michael Douglas). Rejection transforms her into a vengeful Medusa who is "not gonna be ignored," stalking Dan and his family and at one point boiling his daughter's pet rabbit. The original ending called for Alex to commit suicide but was revised—over objections from the cast and director Adrian Lyne—to have her gunned down after a climactic struggle in a bathtub. "This shot was on a New York stage during the reshoots for the new ending," says photographer Andrew Schwartz. "Glenn didn't like being underwater, but she was great about it, a real trouper." Indeed, with retakes Close had her head dunked some 50 times, sustaining eye and ear infections. Nonetheless, it was a happy set. "Michael and Glenn got along famously, and it was a great shoot," Schwartz recalls. "They were so good, and so prepared that everyone suspected the film would be good, but nobody could've guessed how iconic it would become."

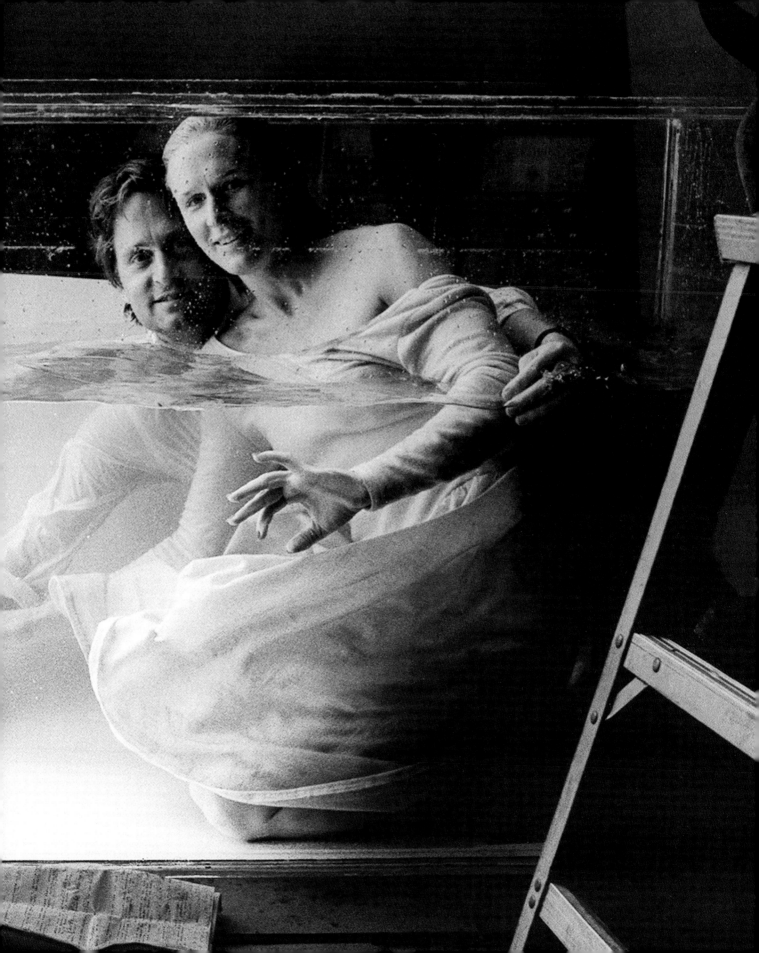

'JOHN HAS BEEN
FOLLOWING
ME AROUND...AND
IT FINALLY GETS
TO BE KIND OF FUN'
—KATHARINE HEPBURN

KATHARINE HEPBURN WAS FAMOUSLY PROTECTIVE OF HER PRIVACY, shunning at-home tête-à-têtes with the press. But she made an exception for John Bryson, who first photographed her in 1974, for *Life*, when she was filming *Rooster Cogburn* with John Wayne in the Oregon woods. Bryson (whose previous subjects included five Presidents) so charmed Hepburn that she allowed him to shoot her at her various homes over the next 15 years. He became a friend—and a frequent guest at the retreat in Fenwick, Conn., that her physician father had purchased around 1910. "The me I know is the person at Fenwick," said Hepburn, who spent most weekends at the rambling house on Long Island Sound. There, Bryson learned that the self-reliant Yankee of films like *Woman of the Year* and *The African Queen* was no act: "She is all that she appears to be," he wrote, "with a face for Mount Rushmore." In his intimate images (collected in his 1990 book, *The Private World of Katharine Hepburn*), he showed the actress rising before dawn, climbing a tree to prune the branches and taking an ocean dip in freezing weather. "This is the great movie star doing the laundry," she told him as she laid her garments on the lawn to dry. When *Life*'s editor asked Hepburn why she'd opened up to Bryson, her reply was succinct: "I just like him. I trust him." To which Bryson responded: "That might make me a hell of an epitaph."

ANTHONY HOPKINS & JONATHAN DEMME
Ken Regan, 1989

'I played Lecter with great relish. You can't play evil to portray evil'
—Anthony Hopkins

THE SILENCE OF THE LAMBS was one of those epochal films that transcend the horror-thriller genre to enter the cultural bloodstream. The story, adapted from a novel by Thomas Harris, is operatically gruesome: Pursuing a murderer who skins his female victims, feisty FBI trainee Clarice Starling (Jodie Foster) consults—and spars with—Hannibal Lecter (Anthony Hopkins), a brilliant psychiatrist who also happens to be an incarcerated cannibalistic serial killer. Aside from sweeping five major Academy Awards, Demme's dark masterwork invaded the national psyche, turned Hopkins into a global superstar—and cast fava beans and Chianti in a whole new light. This publicity still shows Demme, who died in 2017 at 73, as he checked Hopkins's signature muzzle and straitjacket. As if to counterbalance the film's ghoulish subject matter, the mood on the set was genial. Hopkins, especially, kept everyone loose. "Not a shooting day went by without Tony gliding up behind Jodie or myself, baring his fangs and going, 'Good *mooorning,*'" Demme told *People*. "Or he'd look round with these gigantic eyes at the whole crew and go, 'You know Jonathan's the mad one. He never blinks. He's quite insane.' His lightness made it easy for everybody else."

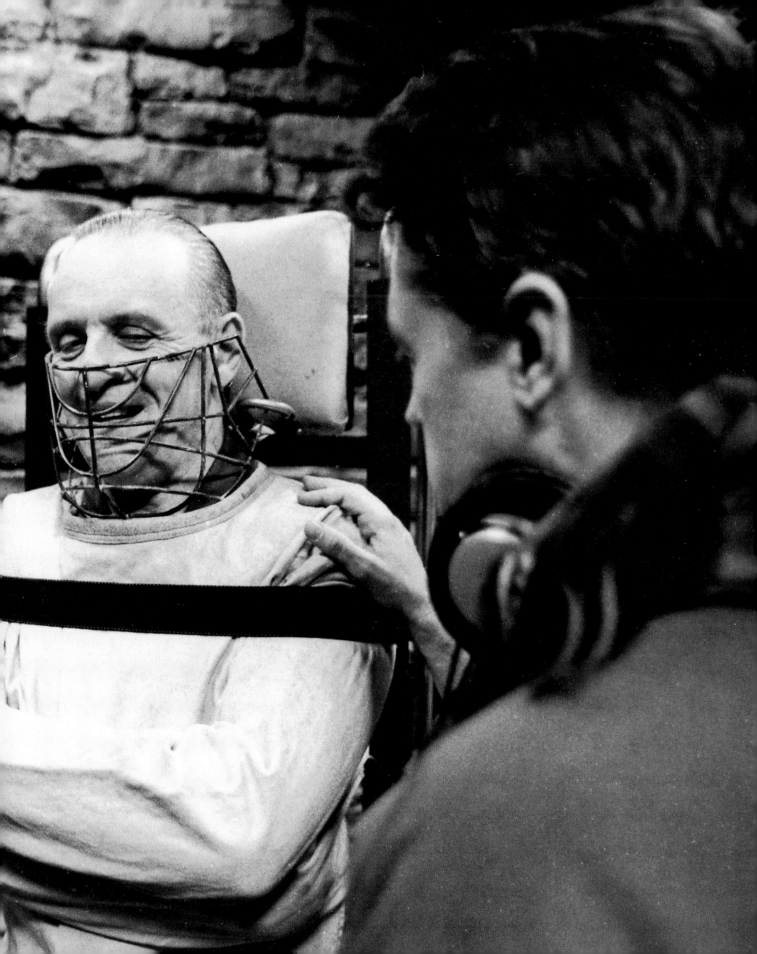

JULIA ROBERTS & GARRY MARSHALL | *Ron Batzdorff, 1989*

'We're a business who loves to discover a star. She was absolutely delightful and charming. It wasn't just good acting— she was magical'
—Garry Marshall

BEFORE JULIA ROBERTS DID A SCREEN TEST FOR *PRETTY WOMAN*, director Garry Marshall (seen with her on the set) had considered several better-known actresses to play the streetwalker who steals a tycoon's heart. The 21-year-old novice erased all doubt. "We're going to make it with this girl," Marshall told his studio chief. "She's got it." Roberts had left Smyrna, Ga., after high school and moved to New York to join her sister Lisa, also an aspiring actor. (Brother Eric had already picked up an Oscar nod for 1985's *Runaway Train*.) With virtually no formal training, she'd won kudos for her first major movie, *Mystic Pizza* (1988), and earned an Oscar nomination as Best Supporting Actress for her third, *Steel Magnolias* (1989). But Marshall's 1990 blockbuster, with Richard Gere as the mogul, sent her career into the stratosphere. By year's end, she would pick up a Best Actress nod for *Pretty Woman* and soon joined the million-dollar-a-picture club. The star and the director would make four films together, and when he died in 2016, Roberts had nothing but fond memories dating back before their first collaboration. "I was 7 years old when *Happy Days* came on TV," she told *People* of Marshall's pre-film career. "Followed a couple of years later by *Laverne & Shirley* and then *Mork & Mindy*. I have said before that Garry Marshall raised me, and it is rather true.... It is my great fortune that there were only a few short years between *Happy Days* going off the air and Garry Marshall walking into my life and changing it in so many ways."

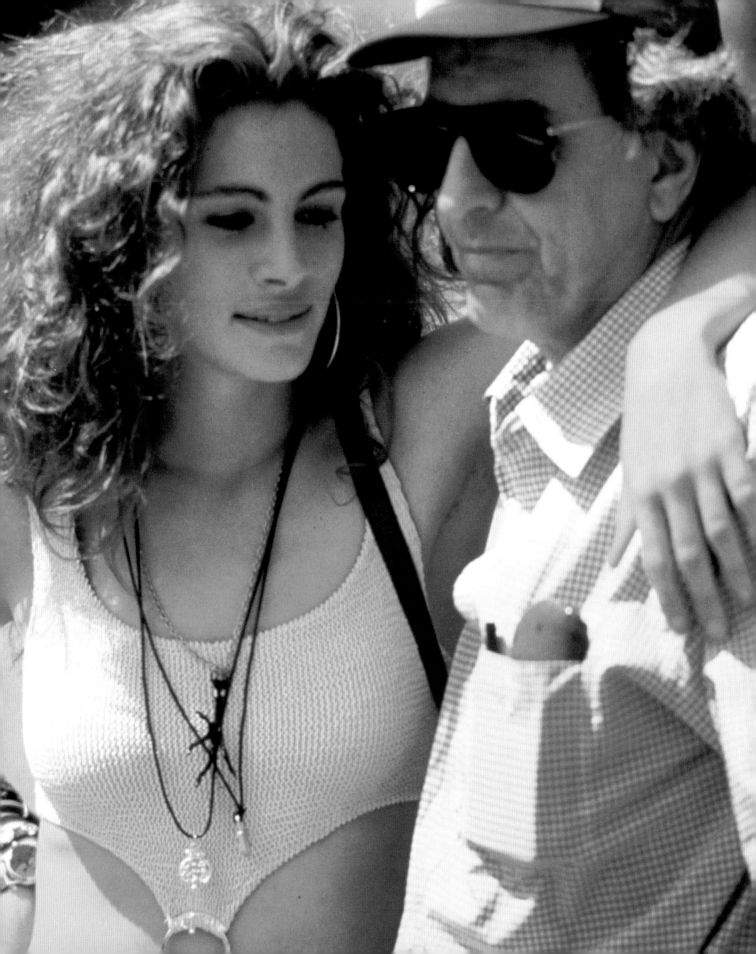

JESSICA SIMPSON & NICK LACHEY
Neal Preston, 2003

'It's a setup within a setup within a setup. And therein lies the irony of the whole thing'
—Neal Preston

NEWLYWEDS: NICK and Jessica was one of the first hits of the reality-TV era, purporting to offer an inside look at the marriage of singers Jessica Simpson and Nick Lachey. When Neal Preston accepted *People*'s assignment to photograph the couple at their Calabasas, Calif., home, it was with a healthy dose of skepticism. "I don't allow reality TV to be watched in my house—it's beyond bogus," he says. Like the show, his shoot was "posed to feign realism." Preston recalls waiting with Lachey while Simpson readied herself: "I told Nick a little bit about what I do, and he yelled up, 'Jess, the photographer guy, he worked for Led Zeppelin!' And she did not know who Led Zeppelin was." But it was Simpson's acted—or real—cluelessness that hooked viewers: Her line about Chicken of the Sea tuna— "Is this chicken what I have, or is this fish?"—is the show's "Rosebud." *Newlyweds* ended in 2005, along with the marriage. (She's now wed to ex-NFL player Eric Johnson, and Lachey to former MTV veejay Vanessa Minnillo.) That year the canny Simpson launched her own fashion line and now runs a business worth an estimated $1 billion.

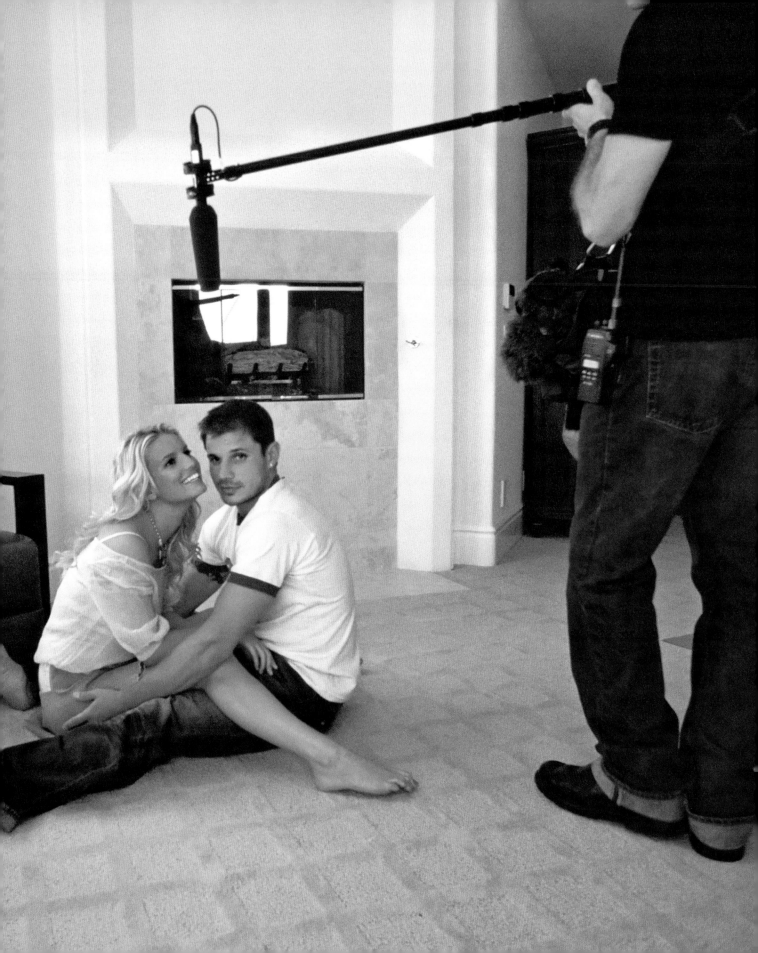

DAVID BURTKA &
NEIL PATRICK HARRIS
Danielle Levitt, 2014

'The fireworks that
night were both
metaphoric and literal'
—Neil Patrick Harris

WHEN NEW YORK became the sixth state to legalize same-sex marriage in 2011, Neil Patrick Harris shared his joy on Twitter: "It PASSED!.... Yes!! Progress!!" The *How I Met Your Mother* star had a personal reason to celebrate: He and chef/actor David Burtka had proposed to each other five years earlier. "We've been wearing engagement rings for ages, waiting for an available date," Harris told *People*. On Sept. 6, 2014, after a decade as a couple, they finally moved those rings to their left hands. The wedding took place at a castle in Italy, and though it was intimate, with about 50 guests—including the couple's 3½-year-old twins, Harper Grace and Gideon Scott—it was hardly understated. The ceremony was followed by fireworks and a private concert by a friend, Elton John. "Everyone was freaking out, like, 'Oh, my God, this wedding couldn't get any better,'" recalls photographer Danielle Levitt, who attended as a guest. "And then *another* set of fireworks goes off." The moment she captured symbolized the uncontainable force of the newlyweds' love, she said. Harris agreed. "Epic," he says, looking at the picture again. "It was a night I'll never forget."

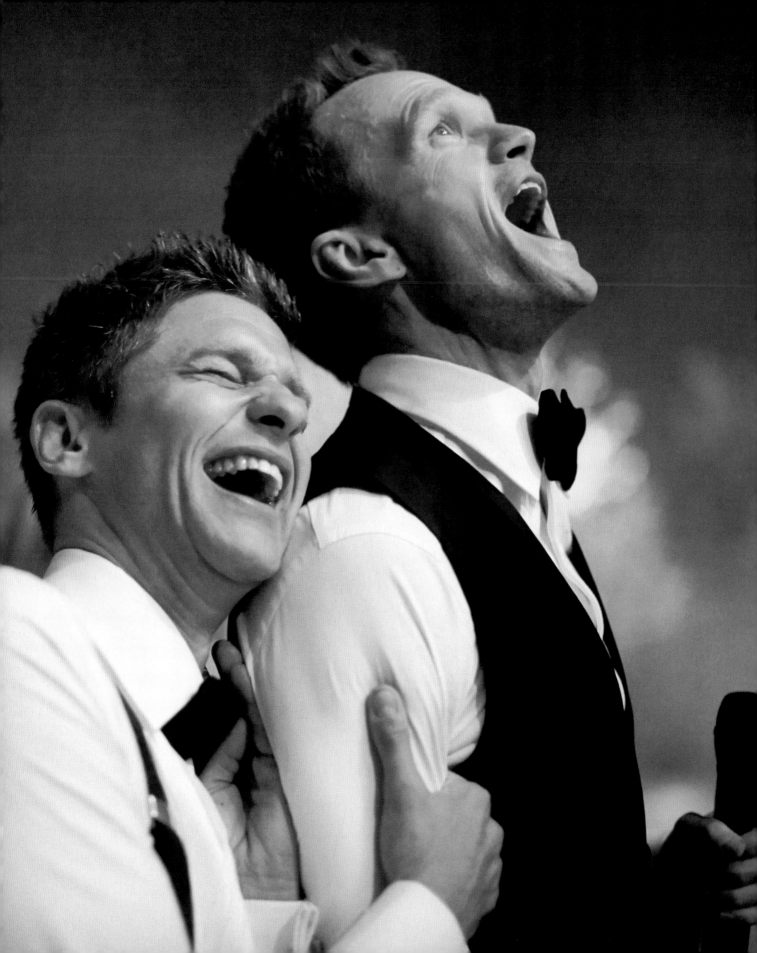

ALEC BALDWIN
Mary Ellen Matthews, 2016

'Totally biased, not funny and
the Baldwin impersonation
just can't get any worse. Sad'
—President Donald J. Trump

ALEC BALDWIN IS hardly the first
performer to impersonate a Presi-
dent on *Saturday Night Live.* The
show has lampooned every Com-
mander in Chief since Gerald Ford,
and though they have it down to a
science, there is still a rush in the
moments before they go live. "This
was taken right before the show,"
recalls *SNL* staff shooter Mary Ellen
Matthews, who caught Baldwin run-
ning lines as Donald Trump and get-
ting touch-ups from makeup
department head Louie Zakarian
and head hair designer Jodi Man-
cuso. When the actor comes in, "he's
himself, and as that paint is laid on,
and he's getting orange, there's more
Trump-isms coming out," says
Zakarian (left). Trump has been an
SNL target since Phil Hartman
played him in 1988, when he was
known only as a gold-leaf-loving real
estate mogul. Trump had never pub-
licly objected; indeed, he'd hosted
the show on two occasions, most
recently in 2015, as his campaign for
the White House was just taking off.
Despite the mockery, Trump won
and became the first President-elect
to poke back at the show. "A com-
plete hit job," he tweeted in January.
"Really bad television." Viewers dis-
agreed: That season's ratings were
the highest in two decades.

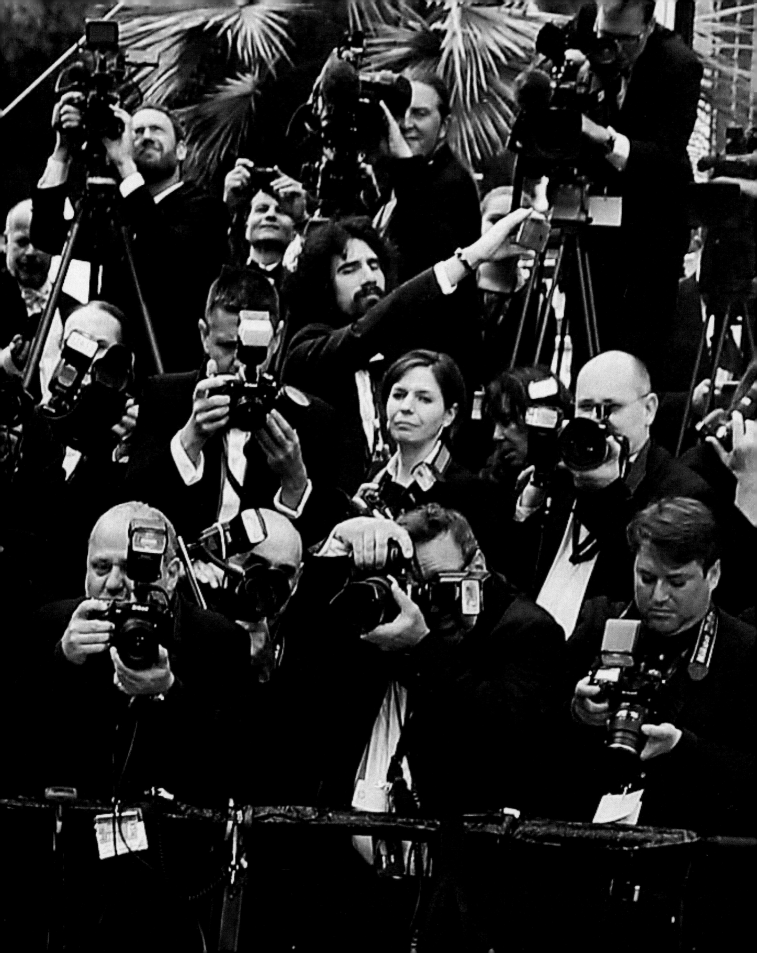

RED CARPET
MOMENTS

BY ANDREA LAVINTHAL

JENNIFER LOPEZ WAS INDISPUTABLY FAMOUS IN 2000. She had already won over fans with her leading role in the biopic *Selena* and followed up with smart turns in films directed by Steven Soderbergh and Oliver Stone. Somehow she also found time to record what became an instant hit debut album, *On the 6,* and to enjoy a social life, which, at that moment, included a relationship with Sean Combs, then known as "Puffy." She was doing everything right. And yet Lopez wasn't yet the superstar she would become. That all changed on a February night in Los Angeles.

Lopez arrived at the 42nd annual Grammy Awards in a sheer, tropical-print Versace gown with a neckline so plunging, it fell several inches below her navel. Then—in the time it took flashbulbs to pop—the artist soon to be known as J.Lo solidified her place in pop-culture history.

That's exactly what a great red carpet dress should do. Its purpose is to capture the world's attention and get people talking—even if just to say, "What was she thinking?" (We're still looking at you, Björk.) Here we've chosen 10 moments beginning in the "Who are you wearing?" era of televised awards preshows, an arena the goddesses of early Hollywood glamour never had to navigate. Success there is more than alchemy between a star and a designer: Their collaboration still has to slay an army of photographers. (At left: a close-up of the battalion at Cannes.) Because at the end of the day, it doesn't matter if you win the award. It just matters what you were wearing.

Lavinthal is People's *style and beauty director.*

KIM BASINGER | *Reed Saxon, 1990*

'It was a surprise to all of us when we saw it—we did not make it for her. Prince is all half-and-half, though: male/female, Gemini. I'm sure Kim thought it was a really great representation'
—Helen Hiatt, then costume supervisor for Prince

IN HER HAND-ILLUSTRATED MEMOIR *LOVE, Loss, and What I Wore*, author Ilene Beckerman tells her life story through clothes. If you ever doubt that what we wear is who we are in that instant, one glance back to Kim Basinger's 1990 Oscar night outfit should change your mind. The actress, who had before and would again exhibit classic awards-show elegance, had been hanging out with Prince, who provided songs for the film *Batman,* in which Basinger played Vicki Vale. The actress and the rock star never confirmed a relationship, though she did visit him at Paisley Park to add her voice to a remix of the single "Scandalous," and he produced her only album, *Hollywood Affair.* "He's a brilliant talent. . . . It was a really special moment in time," Basinger later said. No doubt. But perhaps better to commemorate in a scrapbook of scribbled lyrics than in a ball gown of her own design. Because, while shiny asymmetry and *Lovesexy*-era sleeve lettering worked for Prince, they looked out of place on the statuesque Southern beauty. By year's end she had met Alec Baldwin (whom she would marry), and the couple would be spotted out in matching tuxedos.

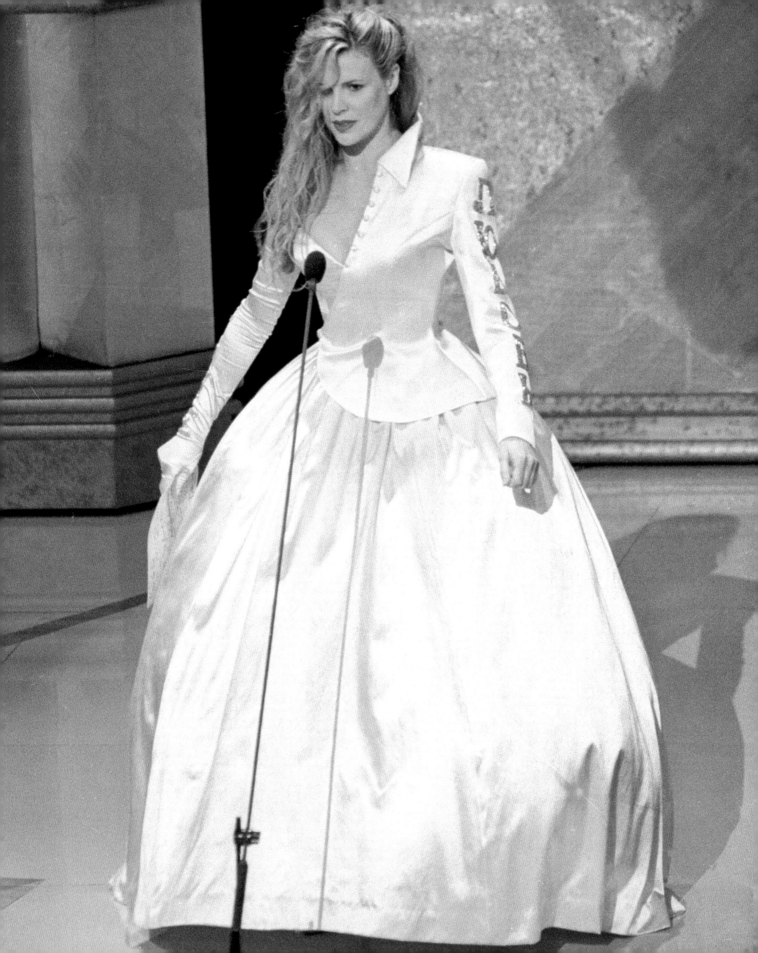

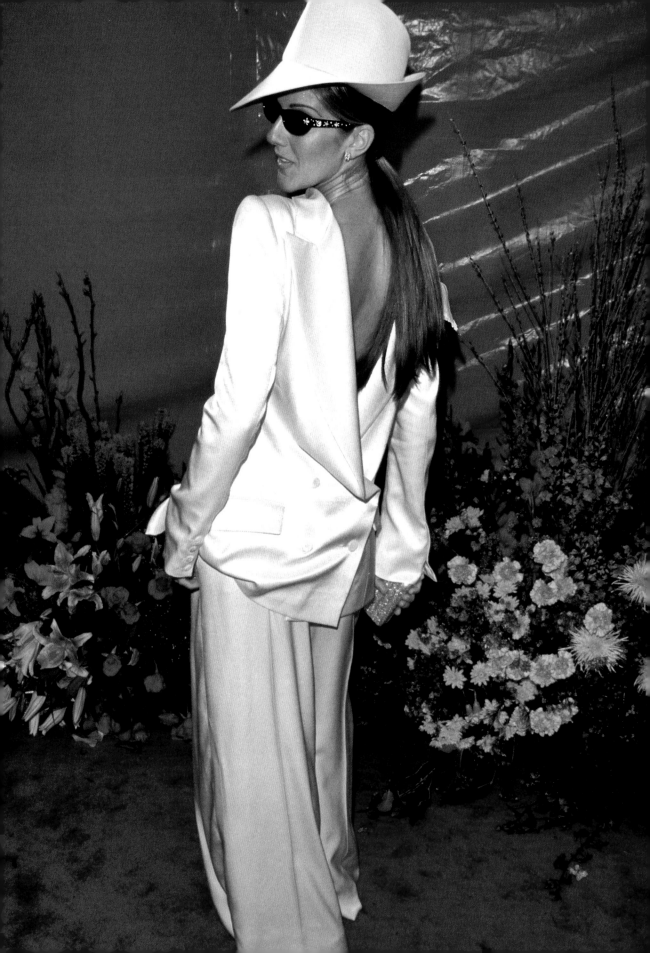

'I was the only one with pants
in a backward suit from Galliano,
and if I would do this today, it
would work…. You just have to assume
what you wear, you wear, and I did'
—Céline Dion, to *People*, 2017

"I WAS SO EXCITED WHEN I SAW HER ON TV BECAUSE I DIDN'T know if she'd actually do it," said a Dior publicist after Céline Dion had been seen around the world in a white tuxedo, opened in the back, by John Galliano, then a Dior designer. In his 1999 Paris Haute Couture summer collection, Galliano had shown several backward men's suits for women, and Dion had gone in for the whole look, including a Dior hat by Stephen Jones. What makes sense on the avant-garde runways of Europe, however, doesn't always translate to Hollywood, which, for all its embrace of difference, has a fairly narrow bandwidth for interpretations of glamour. Dion, despite a reputation for big, commercial pop, has long shown a renegade streak when it comes to dressing. (In 2017, at age 49, she romped through a *Vogue* video in new couture, and demonstrated both humor and a deftness for pulling off an out-there look.) In 1999—a year after her performance of "My Heart Will Go On," from the motion picture *Titanic,* wowed the Oscar crowd—a relaxed Dion showed up in pants as virtually every other woman worked a gown. Critics sharpened their barbs ("female Al Capone," "dyslexic pimp outfit"), but many others were cheering. Completing her outfit were Ray-Ban shades, studded with diamonds by jeweler Martin Katz, which Dion wore on the condition that the eyewear company make a $50,000 donation to the Canadian Cystic Fibrosis Foundation. Said the star's stylist, who otherwise loved the ensemble: "I wish I could have given $50,000 for her not to wear those glasses. They looked pretty ridiculous."

JENNIFER LOPEZ | *Scott Gries, 2000*

'IT WAS THE
MOST POPULAR
SEARCH
QUERY WE HAD
EVER SEEN'
**—GOOGLE EXEC
ERIC SCHMIDT**

THE EFFECT OF THE JUNGLE-GREEN VERSACE DRESS on Jennifer Lopez's career is well documented. But its power isn't limited to turning a rising star into a style icon. The bamboo-printed silk, fastened below the navel with citrine quartz details, also elevated the profile of its designer, Donatella Versace, who had taken over the top creative role in the company after her brother Gianni's 1997 murder and needed to demonstrate her distinct vision to the fashion world. Of course, as Versace has admitted, it wasn't the dress alone that boosted her reputation, but the pairing of the garment, the event and the star. (As if to offer proof of this equation, Versace noted that she had worn the dress herself to the 1999 Met Gala and no one blinked. Well, no one except Lopez, who said, "I saw Donatella with it, and I had to have it.") Also owing its very existence to Lopez's outfit that night: Google Images. The Google website was originally designed to run text-based searches only. A record number of people were typing "Lopez Grammys dress," but back in 2000 "we had no surefire way of getting users exactly what they wanted," noted Google executive chairman Eric Schmidt. Engineers tackled the problem, and soon, Schmidt said, "Google Images was born." Let others take off their clothes and break the Internet; by putting on just the right thing, J.Lo helped to make it.

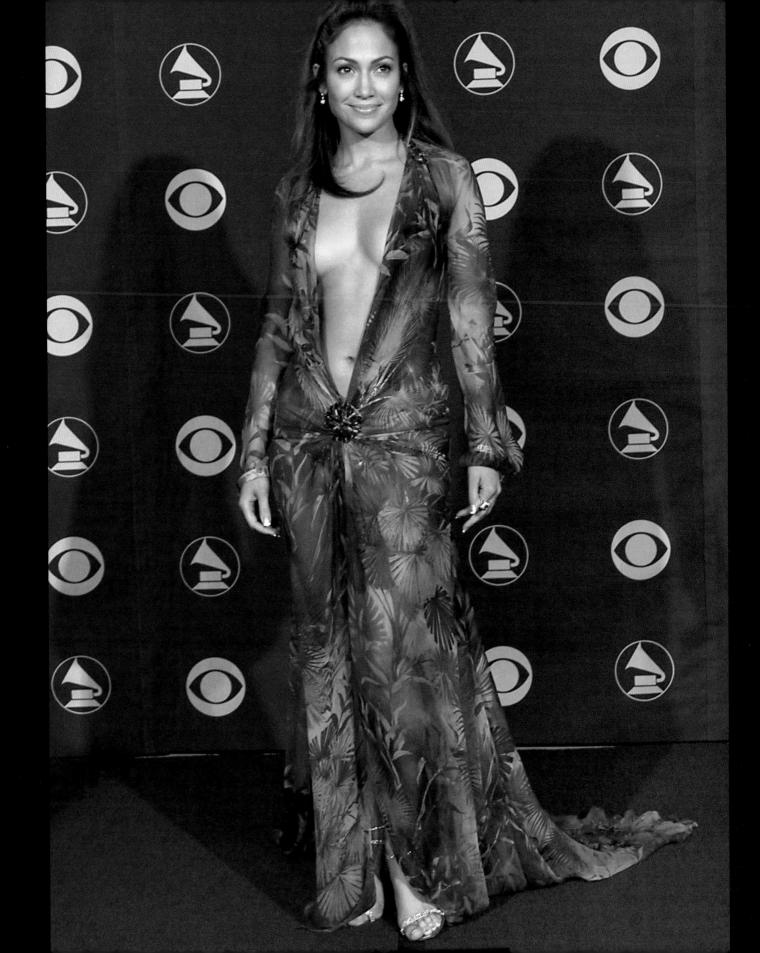

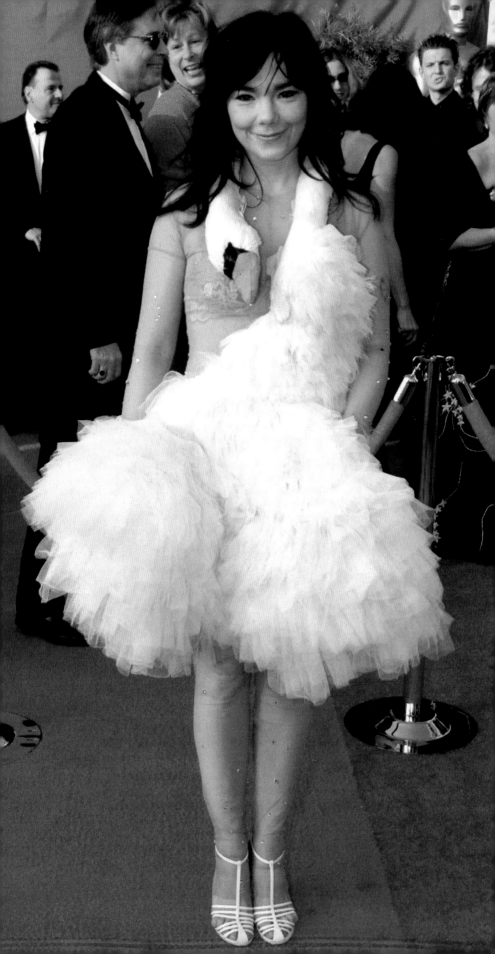

'Probably everybody can see it
but me. I just know it was right and
a powerful decision. Maybe
I'll go back in a few years and go,
"Of course, it's obvious, silly."
But it seemed to sum up a lot of
things for me' —Björk, 2001

BEFORE WE DEBATE, LET'S BEGIN WITH AN INARGUABLE TRUTH: This ensemble appears on, if not tops, every Worst Dressed List since Björk wore it at the 2001 Oscars. Here's how it differs from nearly all other offenders in those rankings: The swan dress looked this way on purpose. It wasn't an accident of bad styling, an embarrassing wardrobe malfunction, or a misfire of supposed good taste. When the singer saw the dress in Macedonian designer Marjan Pejoski's animal-themed collection, it spoke to her. On Oscar night she wore it proudly, and with the good humor it deserved—by "laying" ostrich eggs along the carpet. Sure, it was a little unusual, but Björk was an outsider to the Academy: a musician since childhood surrounded by veteran actors; an iconoclast in a sea of starlets dressed by a few influential stylists. And, to that point, she was only one of a handful of Icelanders ever to be in Oscar contention; here she was nominated for Best Original Song, "I've Seen It All" from *Dancer in the Dark*, an art-house musical drama in which she also starred (and for which she would win Best Actress at Cannes). She was, in short, a guest in our celebrity house, and we weren't particularly kind to her. We joked. We mocked. We threw her to Mr. Blackwell, who cracked, "She dances in the dark, and dresses there too." Now to the question before us: Was it really so bad? Valentino, in a 2014 collection, offered an homage to the dress. New York City's Museum of Modern Art put it in a show. "It's great that we can celebrate it and talk about it still," noted the designer. How many dresses can you say that about?

SARAH JESSICA PARKER | *Charles Sykes, 2014*

'I SAID TO MR. DE LA RENTA,
"PLEASE LET ME USE
SCARLET EMBROIDERY
THREAD AND SPLASH
YOUR NAME ACROSS THE
BACK." IT WAS MY IDEA.
HE WOULD NEVER IN
A MILLION YEARS
HAVE DONE IT. HE'S FAR
TOO MODEST'
—**SARAH JESSICA PARKER**

SARAH JESSICA PARKER NEVER FAILS TO AMAZE WITH HER interpretations of the annual themes suggested to (or, if you like, imposed on) guests of the Metropolitan Museum of Art's annual Costume Institute Gala. But in 2014, when the theme was honoring the spirit of designer Charles James (1906-1978), Parker was a cochair of the event. She could not place a false foot going up those famous steps, and she didn't disappoint, honoring both James's tradition of sculptural couture and her longtime collaboration with designer Oscar de la Renta. A fan and a friend of de la Renta, Parker often wore his designs in real life, and they were featured by name in at least one *Sex and the City* plotline. In a gown that wittily suggested a couturier's dress form, she linked the two designers' legacies but gave the loudest shout-out in red thread to her pal. Five months after this winning pairing, the designer died at age 82. Parker told the *New York Times,* "I certainly hoped it wasn't going to be the last time I borrowed a dress from him or that he made a dress for me."

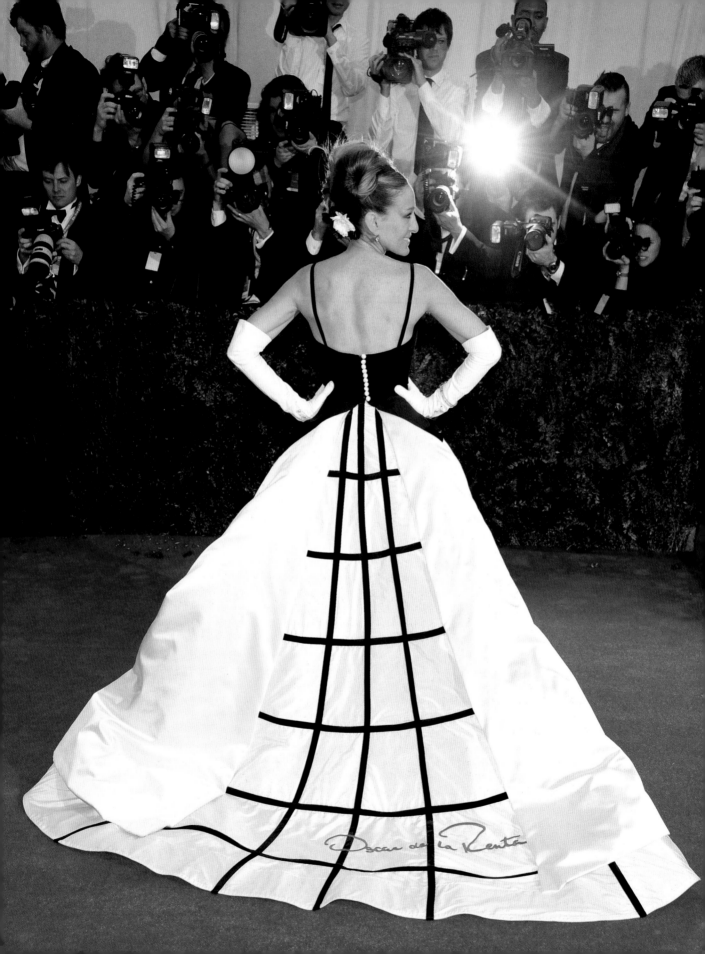

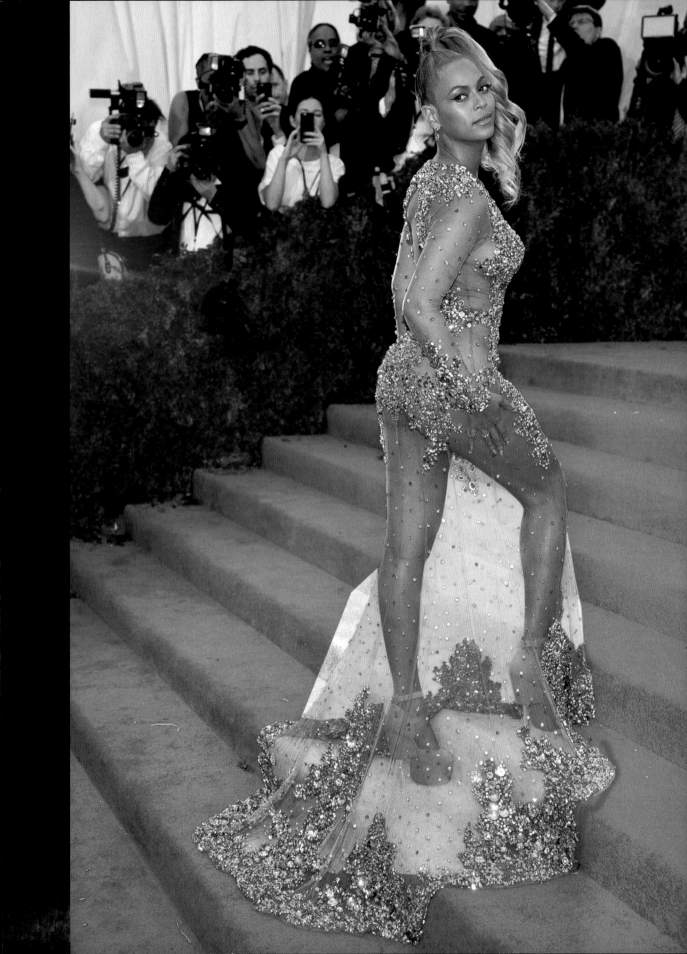

BEYONCE | *Charles Sykes, 2015*

'I'M SO RECKLESS
WHEN I ROCK
MY GIVENCHY DRESS...'
— BEYONCE, 'FORMATION'

HAIR. MAKEUP. JEWELS. SO MUCH MORE THAN A DRESS GOES into a look. One element of red carpet success that is too often discounted: timing. Celebrities spend the better part of an afternoon getting ready for an event like the Met Gala—start too early and your face could be melting with hours to go, but start too late and Manhattan traffic will get the better of your plans. (And you don't want perennial gala chair Anna Wintour cross with you.) On this May evening most invited A-listers arrived promptly to celebrate the Costume Institute's show "China: Through the Looking Glass," an exploration of Chinese influence on Western dress. By the time the last celebrity had wandered past, fashion analysts were already summing up what they had seen: Many stars had embraced the theme, others had trodden into Chinoise cliché, and still others had simply gone on-trend with an eye-popping sheer look. Either Jennifer Lopez (in Atelier Versace) or Kim Kardashian (Roberto Cavalli) would shortly be crowned by commentators as the Queen of the Nudes when, wait, there was—an hour after the last guest had climbed the stairs—one more arrival. Enter Beyoncé in sheer Givenchy by her pal Riccardo Tisci, her modesty preserved only by some thoughtfully applied Swarovski crystals. Jaws gaped. Cameras clicked. And Beyoncé had the spotlight to herself. Was it a page out of the Cinderella playbook, being the last and most spectacular girl at the ball? Nope. That Instagram-winning ponytail was styled after she had rejected a too costume-y updo; making that change had caused her to be late.

RIHANNA | *Charles Skyes, 2015*

'Not everyone can handle
that dress. Only women who
have the confidence
of a queen could wear it'
—designer Guo Pei

BEIJING COUTURIER Guo Pei, revered in her home country, knew she would be represented at the Met Museum's exhibit "China: Through the Looking Glass," as her work had been selected for display in the show. What she did not guess until later was that one of her creations would be worn by a celebrity guest that night. Rihanna found Guo by "researching Chinese couture on the Internet," the pop star told *Vanity Fair.* Guo, in turn, admitted that until then "I didn't know very much about Rihanna!" But they got to know each other over a caped gown from Guo's 2010 collection that had been handsewn for 20 months. "I can't really walk in it without any help—but it's so worth it. I love this dress so much!" said Rihanna, who won kudos that night, both for how she carried the outfit's drama and for honoring Chinese fashion by wearing—not merely translating—it. After dressing Rihanna, the designer showed in Paris and was named one of *Time*'s 100 Most Influential People, three decades into her career. Not at all too late for Guo, who told CNN at the time, "I believe the most beautiful dresses will be made tomorrow."

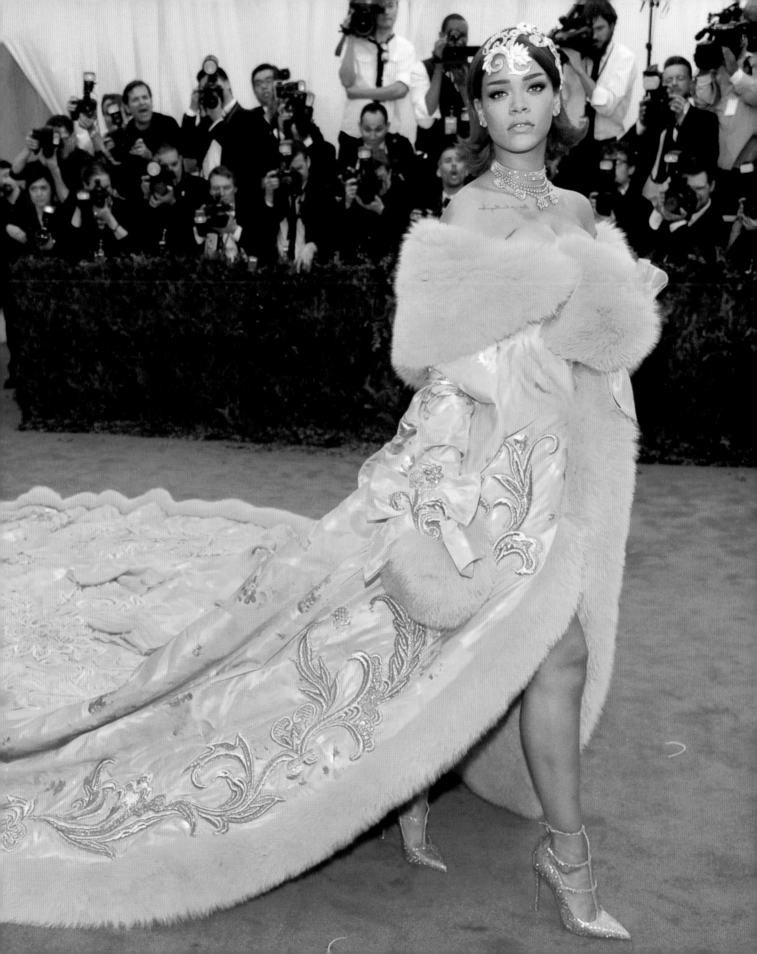

LUPITA NYONG'O | *George Pimentel, 2015*

'Her style is colorful,
experimental and
authentic to who she is.
When those elements
mix, magic happens'
—Micaela Erlanger,
Nyong'o's stylist

"GRASSHOPPER GREEN" IS HOW Lupita Nyong'o described the Gucci gown she chose for opening night of the 2015 Cannes Film Festival. It's enough just to take in the billowing layers of diaphonous chiffon paired with Chopard jewels and the Oscar winner's joyful smile. But Nyong'o offers more than just fashion and beauty with every thoughtful look. In an Instagram post of the event, she thanked the designers (Alessandro Michele created the gown for Gucci) but also "Uganda's women for the hair inspiration." (She had recently returned from filming *Queen of Katwe* there.) She also added a hashtag that might not have been an obvious reference to many on the French Riviera that day: #NseneneSeason. Click the link and you get several views of Nyong'o in this gown—as well as photos of plates of fried grasshoppers. A quick hop over to Wikipedia reveals that *nsenene* means grasshopper, a seasonal delicacy in Uganda and neighboring African countries: "Nsenene were collected by children and women. They were given to the women's husbands in return for a new *gomasi*," a traditional dress. And that's how the twirling star brings her fashion story full circle.

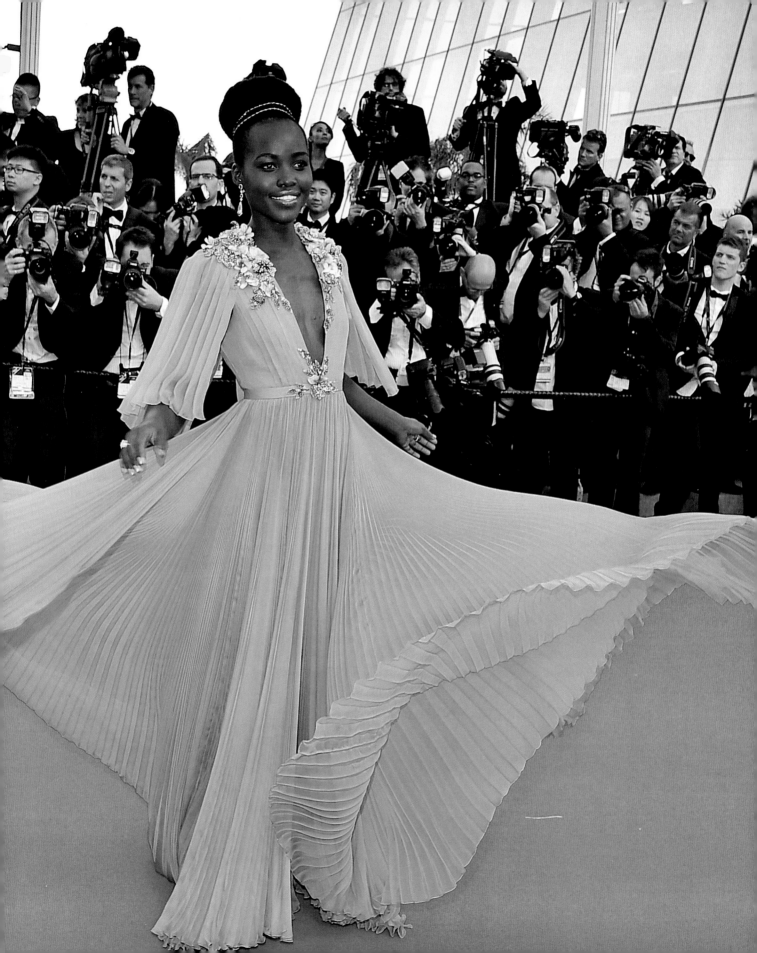

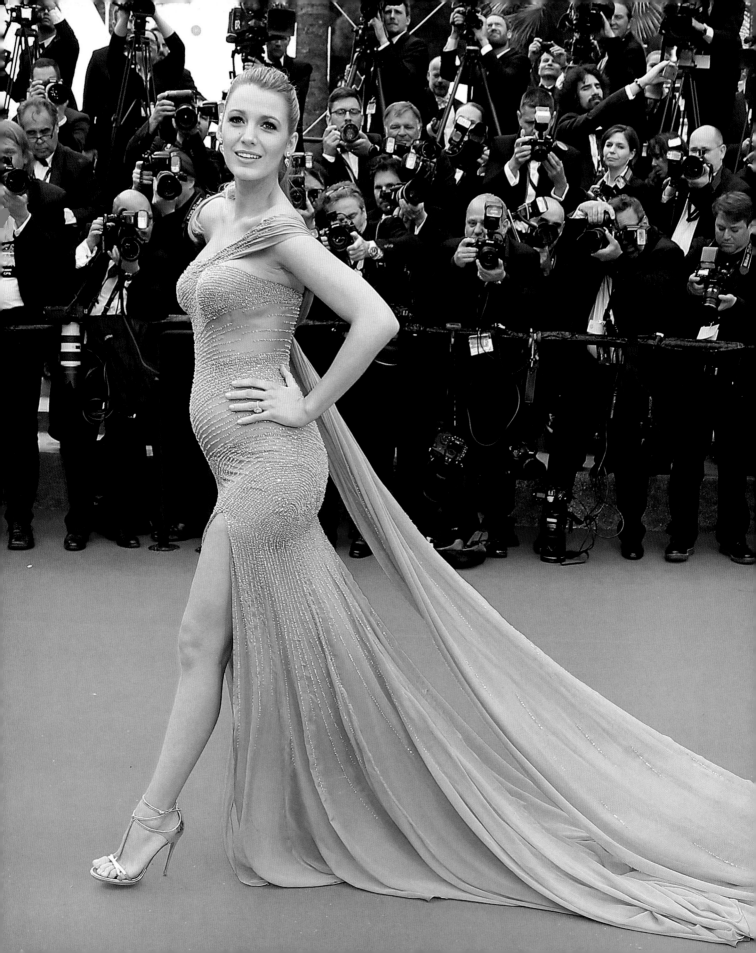

BLAKE LIVELY
Mike Marsland, 2016

'I don't understand why people make a fuss over [the fact that I do my own styling]. Everybody in the whole world does all of their own styling. They wake up in the morning and they put their clothes on themselves' —Blake Lively

MATERNITY WEAR had never looked this luxe. In Cannes while pregnant with her second child with husband Ryan Reynolds, actress Blake Lively turned out for the premiere of the film that she was in (Woody Allen's *Cafe Society*) and for a handful of others, each time wowing in body-hugging designs (here: Atelier Versace) and sky-high heels (Christian Louboutin). Even as she opted for grown-up glamour, Lively admitted she was indulging a childhood love of princess gowns, which she shares with her first daughter, James, then 18 months. "It's fun to dress up in a big sparkly number and a Cinderella-looking dress," she told *People.* "I came home to my baby, and she saw me and was like, 'Wow.' You know, because you just look like a Disney movie. It's fun to get to do that. Because when you're a little girl you play dress-up, and now I get to do it in big-girl life too." If icy-blue sparkles and a flowing train still thrill, why let it go?

PRIYANKA CHOPRA
Rob Latour, 2017

'I can't breathe in it. I will probably faint. But it's so cool!'
—Priyanka Chopra, to *Vogue*

THE INTERNET WAS divided: Either *Baywatch* and *Quantico* star Priyanka Chopra, wearing a custom Ralph Lauren trench dress, had the avant-garde spirit of the 2017 Met Gala honoring experimental designer Rei Kawakubo all buttoned up—or she had just walked into fashion's biggest night looking like a sexy Sherlock Holmes. The star herself was not at all torn: She loved the gown Lauren had created for her, from the way it referenced the designer's lineage of distinctly American classics, to the clever way the dramatic train detached. "Ingenious design by @RalphLauren and thank god for it!!" she wrote on Instagram. "Imagine the 20 foot train at the after party lol!" With the outfit already becoming online meme fodder, she swiftly added: "#inspectorGadget or #Sherlockholmes." It was a brilliant first time out for the Met Gala newcomer: Make a splash in an outfit that has everyone talking, look exceptionally gorgeous, and then show you're in on the joke.

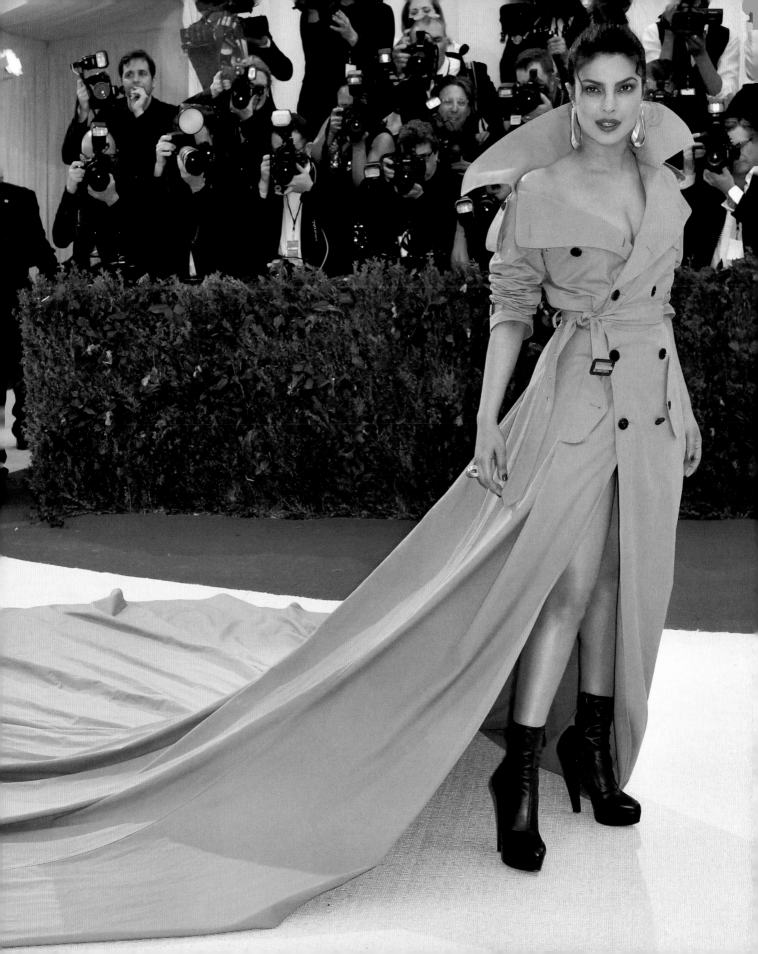

Metadata

$f/$ -- -- 3987 x 3095
-- -- 1.55 MB 300 ppi
-- ISO -- Untagged RGB

File Properties

Filename	547048.JPG
Document Type	JPEG file
Date Created	4/21/15
Date File Modified	8/1/17, 3:50:09 PM
File Size	1.55 MB
Dimensions	3987 x 3095
Dimensions (in inches)	13.3" x 10.3"
Resolution	300 ppi
Bit Depth	8
Color Mode	RGB
Color Profile	Untagged

IPTC Core
IPTC Extension
Camera Data (Exif)
GPS
Audio
Video
DICOM

Collectic | **Inspec** | **Folde** | **Favorit** | **Filter**

Keywords	
Orientation	
Landscape	2
Portrait	4
Aspect Ratio	
3:4	1
4:5	4
5:7	1
ISO Speed Ratings	
Exposure Time	
Aperture Value	
Focal Length	
Focal Length 35mm	
Lens	
Model	
Serial Number	
White Balance	
Camera Raw	
Copyright Notice	

Content

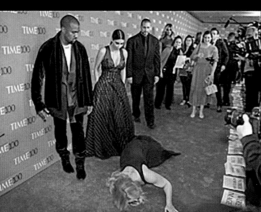

579510.JPG

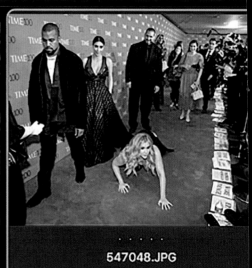

547048.JPG

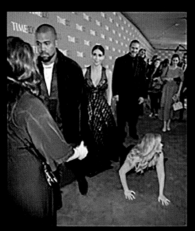

470578908.JPG

472734830.JPG

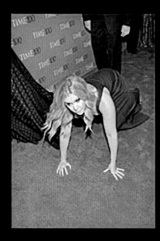

579496.JPG

472733274.jpeg

MAKING HEADLINES

BY J.D. HEYMAN

THE MODERN WORLD CHOKES ON MEDIA—WE ARE ADDICTED to our pinging devices, to a wash of digital information. In that cacophony, photography retains its singular ability to pin down a moment and sum up a culture in frantic motion. In these pages photojournalism captures some of the greatest newsmakers of their day, going beyond artifice to grasp essential character: a movie star and her director, tarnished by scandal but bound together by love; a handsome American prince in the prime of youth; the most effervescent sex symbol of the 20th century making movie history with little more than a skirt and a subway grate. Memorable photographs come to us in different ways. The wedding of Grace Kelly to Monaco's Prince Rainier made headlines worldwide in 1956—everyone wanted this story. But the intimate photos that Howell Conant took of the new Serene Highness were the result of a long working friendship between the photographer and the actress—he was the only one allowed such access, and the results are magic. But magic is often less planned. Robin Platzer's snap of Halston, Andy Warhol, Liza Minnelli, Bianca Jagger and Co. at Studio 54, sums up the disco era, just as Bradley Cooper's phone pic from the 2014 Oscars distills our social media age. Amy Schumer's red carpet shenanigans (seen at left on a *People* photo editor's screen) are a little of both: premeditated by the star but a happy surprise to press-line shooters.

News, by its definition, is perishable. Think of these images not as mere artifacts, but the closest we come to lightning in a bottle. That is their unfailing charm and unique power: to deliver a kind of immortality.

Heyman is a deputy editor at People.

JOAN CRAWFORD | *photographer unknown, 1946*

'Whether the Academy voters were giving the Oscar to me, sentimentally, for *Mildred* or for 200 years of effort, the hell with it; I deserved it'—Joan Crawford

JOAN CRAWFORD CLAIMED TO HAVE THE FLU THAT EVENING, but what actually ailed her was a terror of being humiliated—again. One of the biggest stars of the 1930s, Crawford had been labeled "box office poison" after a string of flops. Released by her longtime studio, MGM, she'd landed at Warner Bros., where filmmaker Michael Curtiz demanded, "Why should I waste my time directing a has-been?" before grudgingly casting her as the lead in 1945's *Mildred Pierce*. Crawford's performance as a mother who sacrifices everything for her sociopathic daughter earned her an Academy Award nomination for Best Actress. But she was so sure she would lose to odds-on favorite Ingrid Bergman (as a nun in *The Bells of St. Mary's*) that she begged off Oscar night at Grauman's Chinese Theatre, pleading illness. (In fact, her son Christopher, then 3, was reportedly home with the measles.) When Crawford heard on the radio that she'd won, as her daughter Christina later recalled, her "health seemed to improve dramatically." Fortunately her publicist had kept a hair and makeup crew on hand, just in case, and 20 minutes after the ceremony ended one of the oddest photo ops in showbiz history (recently reenacted in the FX series *Feud*) got underway. "It's too wonderful," the victor declared, weeping, as a delegation led by Curtiz carried the prize into her boudoir. After receiving her tuxedoed and evening-gowned peers in a coffee-colored negligee, wrote a reporter, "Miss Crawford blew her nose and started her year's reign as queen of Hollywood by going back to bed."

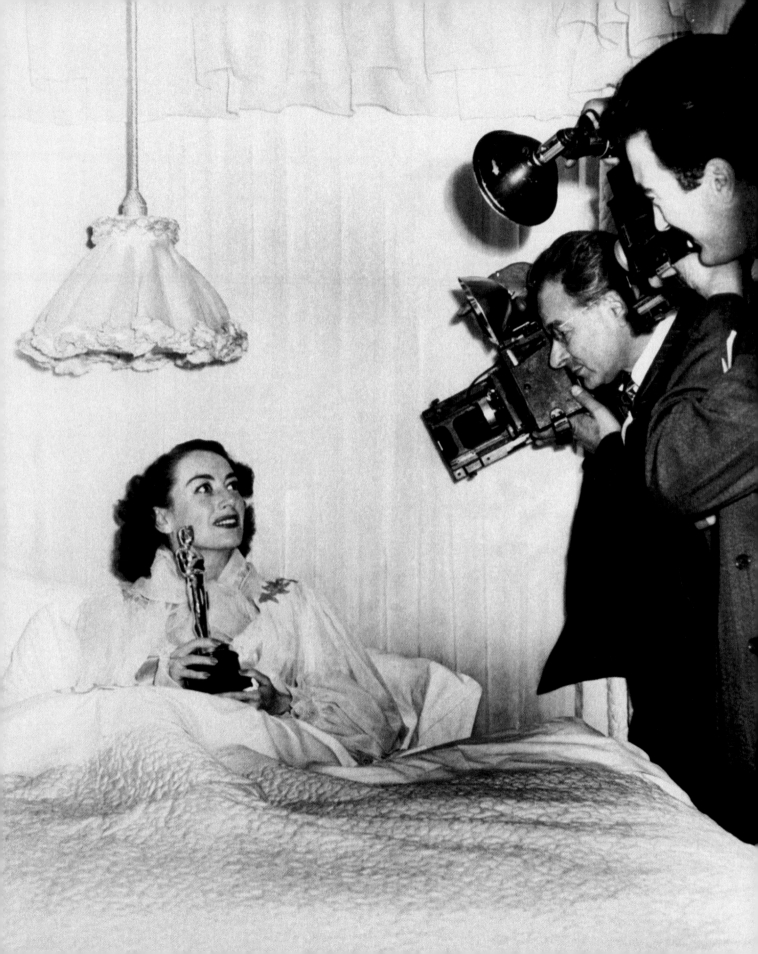

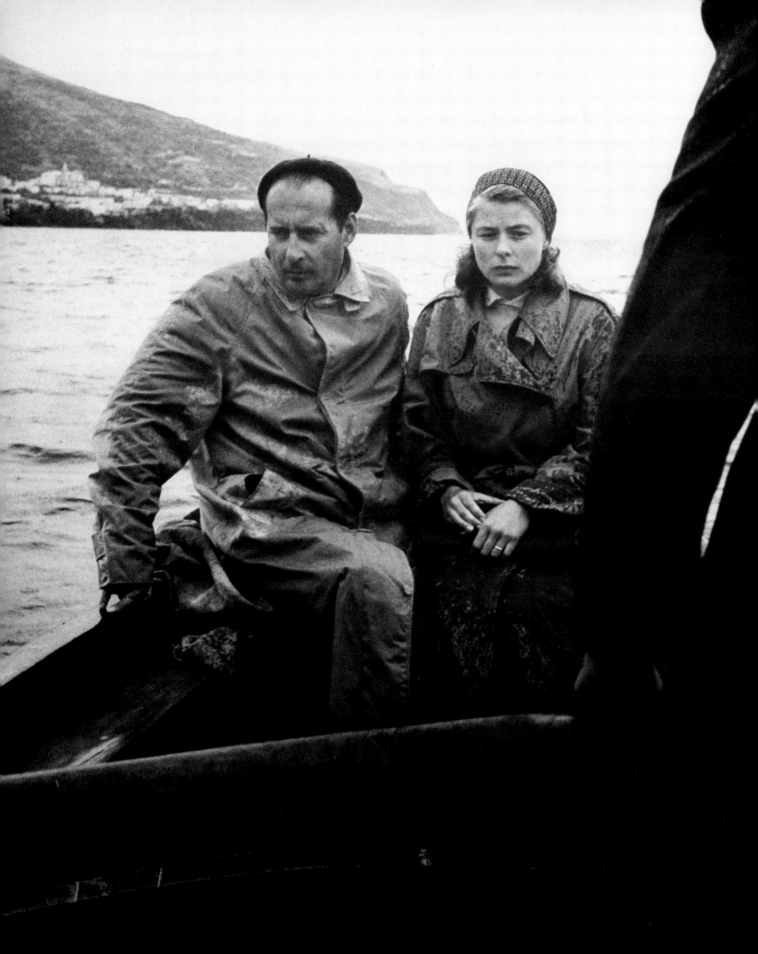

ROBERTO ROSSELLINI & INGRID BERGMAN | *Gordon Parks, 1949*

'I PUT MYSELF
IN OTHER
PEOPLE'S PLACES.
IF I KNOW THAT
I WOULDN'T
WANT TO BE
PHOTOGRAPHED
IN A CERTAIN
CONDITION,
I WON'T DO IT'
—GORDON PARKS

INGRID BERGMAN WAS ONE OF THE BIGGEST FEMALE STARS in Hollywood, known for *Casablanca* and *Notorious.* But the Swedish actress was tired of conventional roles—and of her unhappy marriage to neurosurgeon Petter Lindström. When she sent a fan letter to Italian neorealist director Roberto Rossellini, he invited her to Rome, where the two fell into a passionate affair. Leaving her husband and young daughter, she moved in with Rossellini, who quickly wrote a movie for her—*Stromboli,* set on the volcanic island of the same name off of Sicily. As filming got underway, scandal-hungry paparazzi swarmed the production, only to be banished by an angry Rossellini. But Bergman asked one to stay: Gordon Parks, the first African-American staff photographer for *Life,* whose portraits of Harlem street gangs had impressed her. The magazine wanted Parks to grab a candid shot of the couple embracing, but when he had the chance, he lowered his camera out of respect for their privacy. The grateful pair invited him to take all the pictures he wanted—including this one, in which they're heading off to ask Lindström for a divorce. Bergman later married Rossellini, with whom she had three children (including actress Isabella Rossellini) before they divorced in 1957. Parks (who died in 2006) went on to become one of the most influential photojournalists of his era, as well as a novelist, composer of music and director of films including 1971's *Shaft.*

MARILYN MONROE (WITH TOM EWELL)
Sam Shaw, 1954

'Sam thought the shoot was
a great success; it was.
People are still talking
about it' —Melissa Stevens,
Shaw's granddaughter

IT'S ONE OF THE MOST FAMOUS stills in movie history: Marilyn Monroe's skirt blown upward by a blast of air from a subway grate. Stills from the actual filming of Billy Wilder's comedy were taken on a set in Los Angeles; the New York City shots, like the one shown here, on Lexington Avenue near 51st Street, were from a publicity session designed to draw a crowd. "It was Sam's idea to use the 'skirt blowing' image to promote the film," says Shaw's granddaughter Melissa Stevens, who manages his archive (inset, one of the indelible images from the shoot). "Marilyn and Sam both loved New York, children, art. She had a nickname for all her close friends. She called my grandfather 'Sam Spade' after Humphrey Bogart's character in *The Maltese Falcon*. In the middle of the roaring crowd, Marilyn turned to him and called out, 'Hi, Sam Spade!'" One spectator was less than thrilled with the shoot—Monroe's husband, Joe DiMaggio, who cringed at seeing mobs of strangers ogling his wife. "It's widely recognized to have triggered Marilyn and Joe's divorce," Stevens says. Shaw, who died in 1999, remained close to Monroe until her death, at 36 in 1962. "We have letters he wrote to her, telling her to go see certain art exhibitions— they both loved the painter Goya—and suggesting books to read," Stevens says. "Sam always had a lot of respect for Marilyn and only talked about her as the fun and joyful young woman he knew."

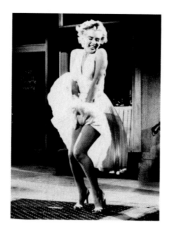

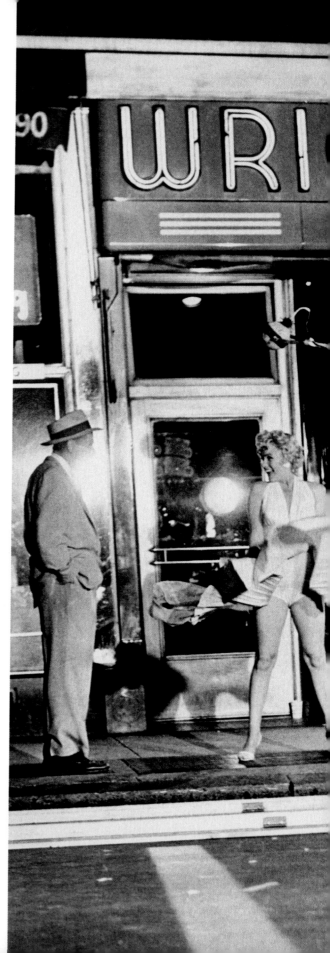

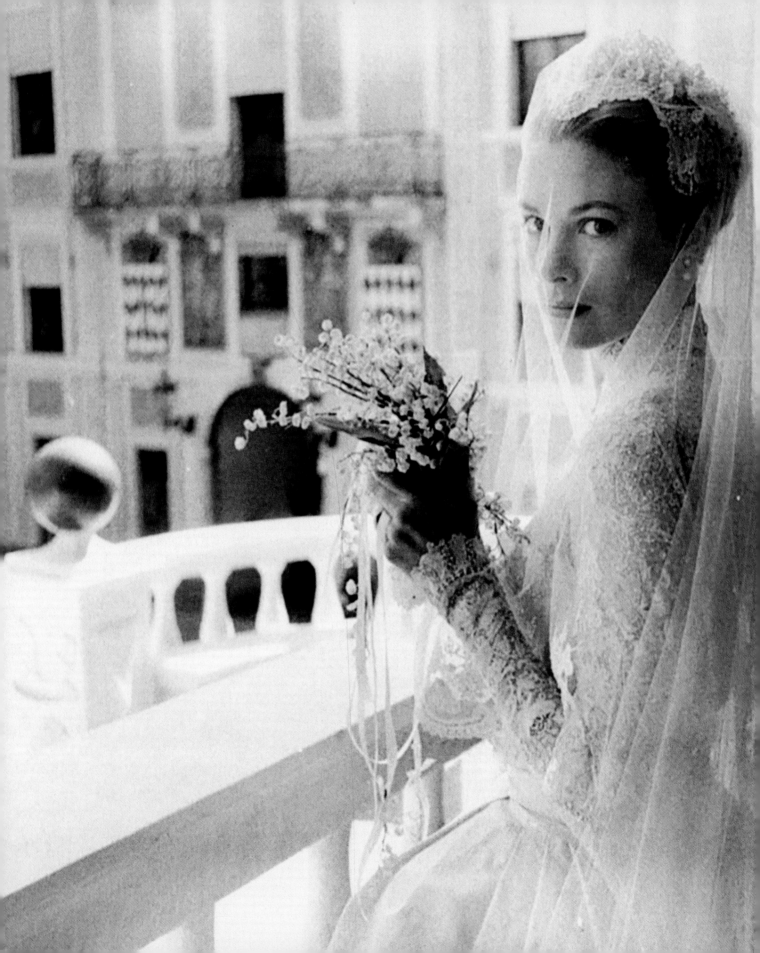

PRINCESS GRACE
OF MONACO
Howell Conant, 1956

'Mom said it was "overwhelming," that "excited" or the word "over-joyed" wasn't strong enough to express her feelings. My father said so too'
—Prince Albert of Monaco

HOWELL CONANT was nervous the first time he was hired to photograph Grace Kelly, in 1955. He was a fashion photographer but had little experience with stars. The actress, seeing Conant's uneasiness, took charge. "This is my good side," she said. "Now light it as you know how, and we'll be done with it." With that, a morning's work for *Photoplay* became a 26-year collaboration and friendship. From the start Kelly liked his unassuming manner; Conant knew not to photograph from under her broad jaw (her "only flaw," he said). In 1956 he was the one photographer allowed access when she sailed to Monaco for her wedding to Prince Rainer; after the ceremony, Conant captured the new princess in an unguarded moment. He would become the Grimaldi family's unofficial photographer, making dozens of trips from his Rhode Island home. When Grace died in a car accident, Conant was packing for Monaco to take the family's 1982 Christmas portrait. He traveled instead to the funeral, leaving his cameras behind.

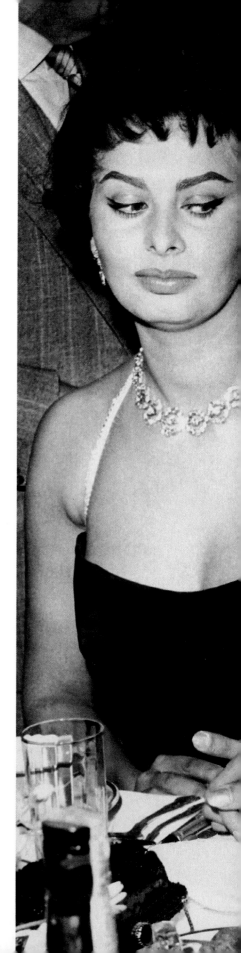

SOPHIA LOREN & JAYNE MANSFIELD | *Joe Shere, 1957*

'Well, there may be other photos, but this is the picture. This is the one that shows how it was.' —Sophia Loren

SEEING AS IT TOOK PLACE IN THE MID-20TH century, this fleeting moment was remarkable for its foreshadowing of several 21st-century Internet obsessions: side-eye, shade throwing and a threatened wardrobe malfunction. It happened at a glittering Beverly Hills welcome party for newcomer Sophia Loren, the Italian film star who was soon to sign a five-movie deal with Paramount. "All of cinema was there. It was incredible," Loren recalled to *Entertainment Weekly* in 2014. Then Jayne Mansfield arrived. The blonde bombshell came late and strategically went straight to the honoree's table. "She knew everyone was watching," said Loren. As Mansfield made a play for the cameras, Loren couldn't help but shoot a glance at her perilous cleavage. "I'm staring at her nipples because I am afraid they are about to come onto my plate," said Loren. "In my face you can see the fear. I'm so frightened that everything in her dress is going to blow—BOOM!— and spill all over the table." The photo was splashed across newspapers around the world, and decades later, despite her storied career—Loren has received two Oscars and made more than 90 films—she's still asked to autograph the photo. "And I never do," she said. "I don't want to have anything to do with that. And also out of respect for Jayne Mansfield, because she's not with us anymore."

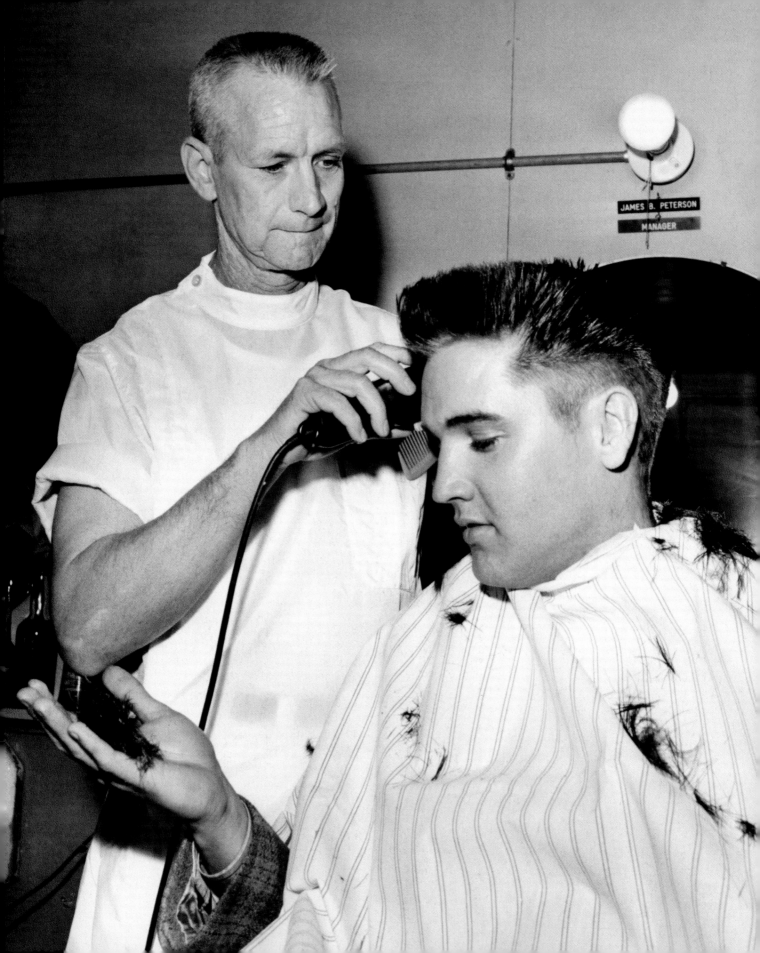

ELVIS PRESLEY | *photographer unknown, 1958*

'ELVIS DIED
THE DAY
HE WENT INTO
THE ARMY'
—JOHN LENNON

IN THE TWO YEARS AFTER RELEASING HIS FIRST SINGLE, Elvis Presley had scored 10 No. 1 hits, from "Heartbreak Hotel" to "Hard Headed Woman." In the process, he'd launched rock and roll into the mainstream, sparking a pop-cultural revolution. Yet resistance remained strong. What offended the old guard wasn't just the music, dissed by Frank Sinatra as a "rancid-smelling aphrodisiac"—it was Elvis's bad-boy style. That sneer. Those wriggling hips. That wild pompadour, with its slashing sideburns. When Presley was drafted, his crafty manager Col. Tom Parker saw an opportunity to make his client's image more broadly appealing: Here was Elvis as a young everyman, drafted like the rest of his generation. In March 1958, the new recruit reported for duty at Fort Chaffee, Ark., where an Army barber supplied him with a regulation buzz cut. For the next two years, under Parker's prodding, Presley played the role of obedient soldier, heading to a posting in Germany (where he was allowed to live off-base with his father, grandmother and several Memphis buddies) and mostly avoiding the spotlight. After his discharge in 1960, his first TV appearance was on a "welcome home" special hosted by none other than Sinatra. "He has come back from the Army easygoing, unassuming, fatherly," *Life* magazine declared. That same year *Bye Bye Birdie,* a musical about a rock idol drafted into the Army, opened on Broadway. With this faux Elvis onstage (and soon on film) the real King of Rock and Roll turned increasingly to fluffy movie musicals and crooning ballads. By the mid-'60s he had been toppled from rock's throne by a horde of rowdy British invaders.

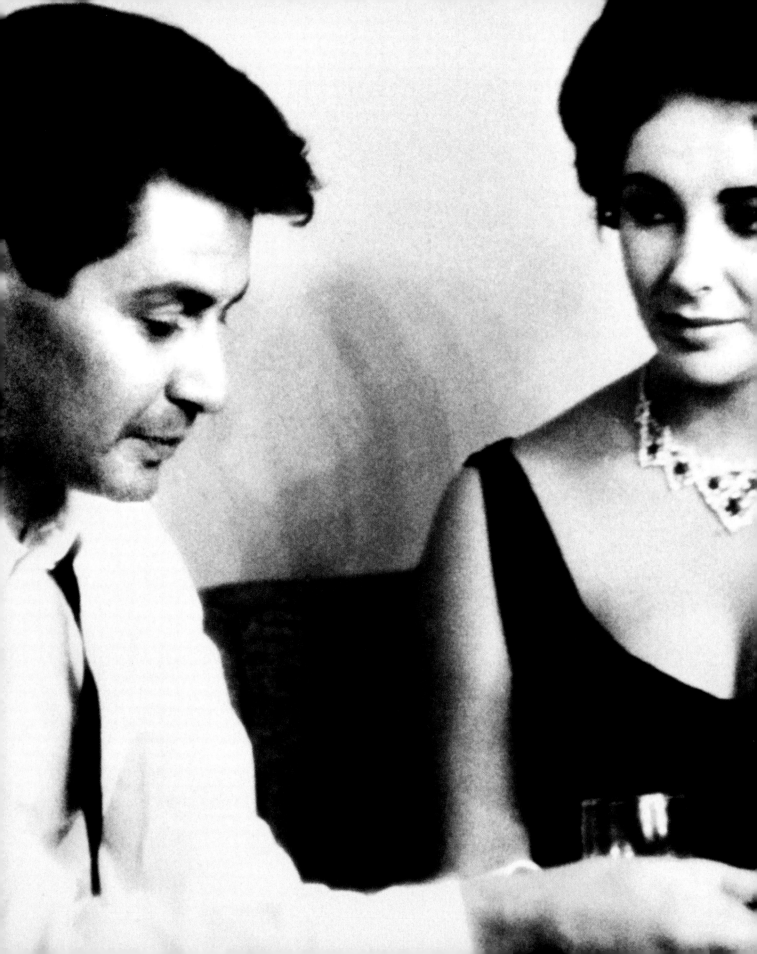

I◄— PREVIOUS SPREAD

EDDIE FISHER, ELIZABETH TAYLOR & DEBBIE REYNOLDS
photographer unknown, 1958

'Women liked her and men adored
her—my husband included' —Debbie Reynolds

DEBBIE REYNOLDS PLAYED SPUNKY INGENUES IN MUSICALS like *Singin' in the Rain.* Elizabeth Taylor was the seductive star of dramas like *Cat on a Hot Tin Roof.* Yet the pair had been pals since both were teen actresses. Reynolds's husband, crooner Eddie Fisher, was chums with Taylor's third husband, producer Mike Todd. Reynolds and Fisher had even served as matron of honor and best man at their friends' wedding. So when Todd died in a plane crash in March 1958, it made sense that Fisher would try to help Taylor. "I was sure he could comfort her," Reynolds said. That he did. (As Carrie Fisher would slyly put it decades later, he ran to Taylor's side, and "gradually made his way to her front.") By August, two months after this picture was taken at the Tropicana in Las Vegas, Reynolds had discovered the not-yet-public affair, which soon became a tabloid scandal. Fisher divorced Reynolds in 1959, leaving her with two kids (Carrie and Todd, who became a TV director). After five years of marriage, Taylor left Fisher for Richard Burton. Reynolds also remarried, and when she found herself on the same ship to Europe as Taylor, she invited her erstwhile rival to dinner. "We just said, 'Let's call it a day,'" recalled Reynolds, who counted Taylor as a friend until the latter's death in 2011. "We got smashed, and we had a great evening."

SIDNEY POITIER, HARRY BELAFONTE & CHARLTON HESTON
Rowland Scherman, 1963

'When I walked through the crowd, I looked
at each face and I marveled at the fact that America
could come together' —Harry Belafonte

THE MARCH ON WASHINGTON FOR JOBS AND FREEDOM was a watershed moment in the struggle for civil rights. Nearly a quarter-million people gathered before the Lincoln Memorial for a day of protest and prayers, climaxing with Martin Luther King Jr.'s incomparably eloquent "I Have a Dream" speech. The marchers included ordinary Americans of every ethnicity and religion—and dozens of A-list stars. Singer-actor Harry Belafonte helped organize the VIP contingent, which boasted such luminaries as Marlon Brando, Burt Lancaster, Sammy Davis Jr., Paul Newman, Joanne Woodward, Gregory Peck, Diahann Carroll and baseball great Jackie Robinson. Joan Baez, Bob Dylan, Mahalia Jackson and other popular performers serenaded the crowd. In this photo Belafonte (center) huddles with two other leading men: Sidney Poitier, the first black actor nominated for an Oscar (he would win the following year) and Charlton Heston, an outspoken advocate of racial equality before he turned his focus to gun-owner rights. Belafonte spent time mingling with the masses as well. "I moved into pockets of young people who were delighted at seeing celebrities in their midst but were also awed at the fact that our mission had reached so broad a circle of different citizens," he told *People* on the march's 50th anniversary. "There was no better place in the universe to be."

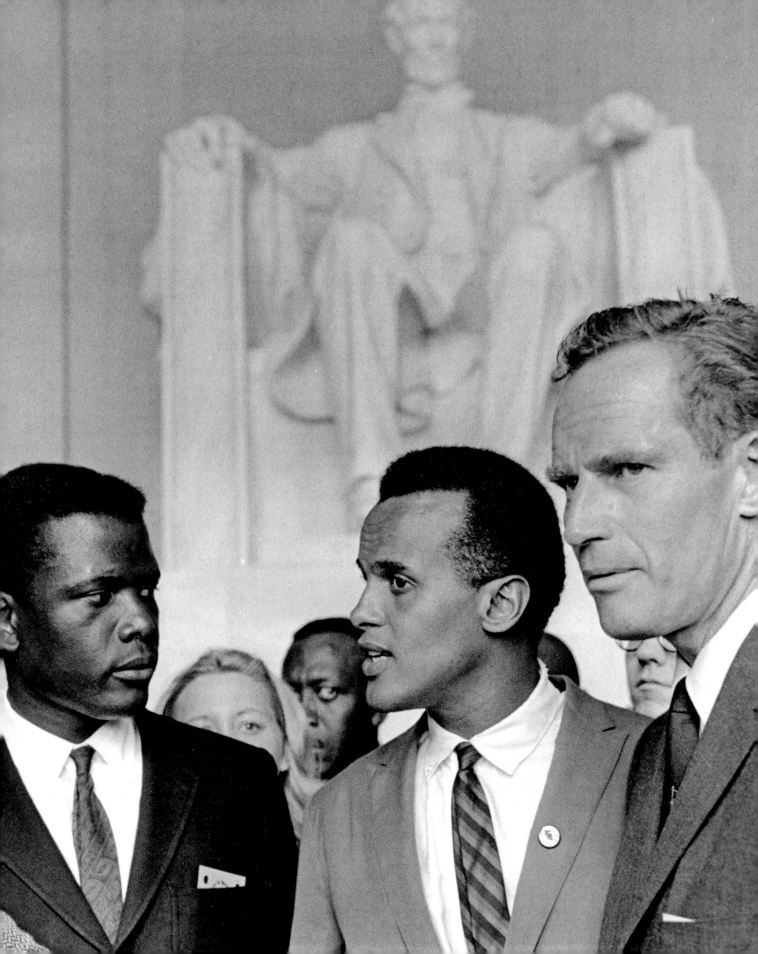

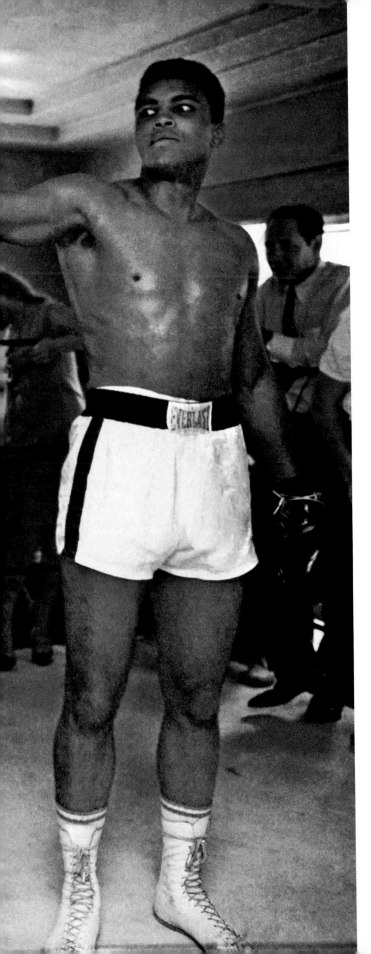

THE BEATLES & MUHAMMAD ALI
Harry Benson, 1964

'Ali completely dwarfed
them. He controlled them.
Do this! Do that! Who's
the most beautiful? And they
all had to say, "You are, sir"'
—Harry Benson

IN FEBRUARY 1964 THE BEATLES launched their conquest of America. With "I Want to Hold Your Hand" at No. 1 on the charts, they were mobbed by shrieking fans at New York's JFK airport. Days later their debut on *The Ed Sullivan Show* drew a record 73 million viewers. Scottish photojournalist Harry Benson accompanied the invaders to Miami Beach, from where their second Sullivan appearance was going to be broadcast. On his hotel-room TV he saw an interview with a handsome, funny, transcendently self-confident young boxer named Cassius Clay, in town to battle defender Sonny Liston for the world heavyweight championship. Sensing potential fireworks, Benson proposed a joint shoot. But John Lennon dismissed Clay as a "big mouth who's going to be beaten" and said he'd prefer to meet Liston. When the champ declined, Benson resorted to subterfuge: He told the Fab Four they were going to visit Liston but had them driven to Clay's gym instead. There they submitted gamely as the challenger stole the show. Dancing around the ring, Clay shouted, "You're pretty, but I'm prettier!" He pretended to knock them down like dominos, then demanded that they pray for mercy. "After it was over, the Beatles were a bit pissed," the photographer recalls. "Lennon said, 'He made us look like fools. And it was your fault, Benson!'" They soon forgave him, though, and went on to transform Western culture. Clay beat Liston, changed his name to Muhammad Ali and was acknowledged as the Greatest. Benson achieved comparable renown in his own field. At 87, he's still shooting, though he finds the view through his lens less thrilling. "People like Ali and the Beatles will never pass this way again. Such talent. Such charisma. Such everything."

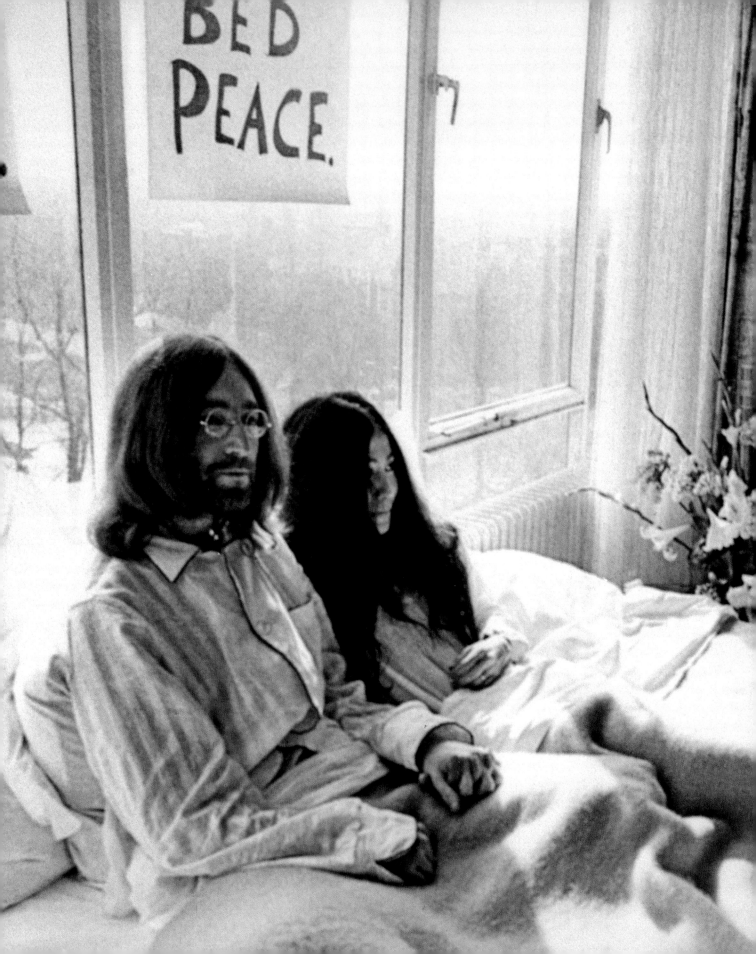

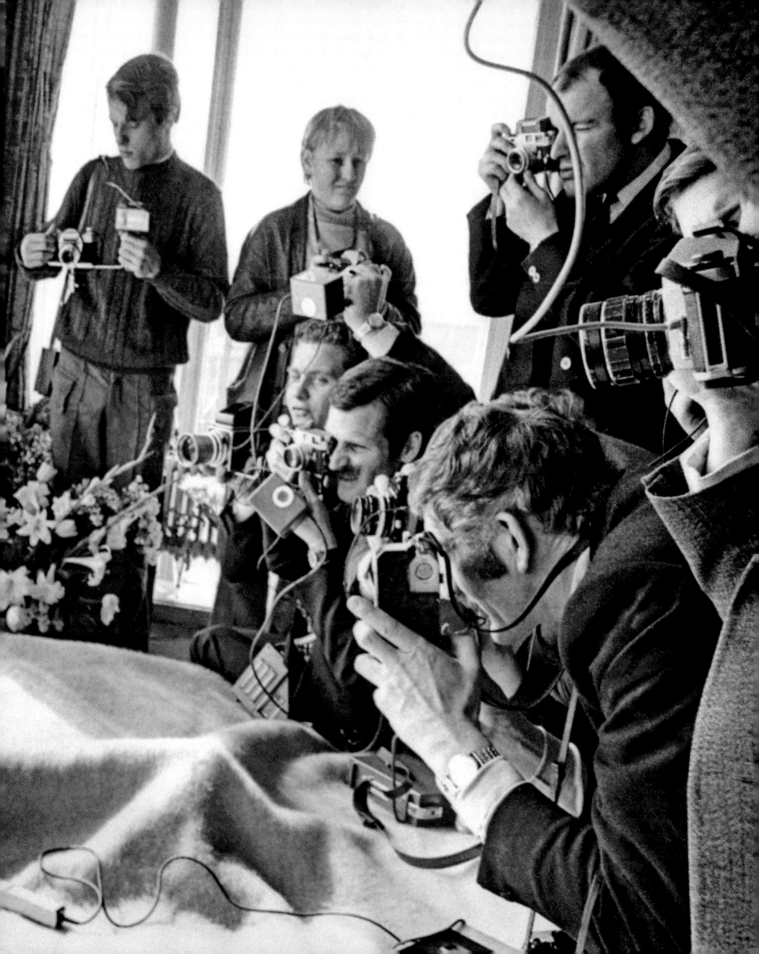

I← PREVIOUS SPREAD

JOHN LENNON & YOKO ONO | *Ruud Hoff, 1969*

'That's part of our policy not to be taken seriously. Our opposition … don't know how to handle humor' —John Lennon

AS THE VIETNAM WAR ESCALATED, AND PROTESTS TURNED violent, one high-profile couple found a gentler way to stand up for their beliefs: by lying down. John Lennon, very soon to be an ex-Beatle, and avant-garde artist Yoko Ono staged their "Bed-In for Peace" at the Amsterdam Hilton, where they honeymooned in March 1969 after a quickie wedding in Gibraltar. The newlyweds remained supine for a week in room 902, receiving the international press daily from 9 a.m. to 9 p.m. "Instead of going out and fight and make war," Ono explained to a reporter, "everybody should just stay in bed and enjoy the spring." Memorialized in the Beatles' "The Ballad of John and Yoko" ("The newspapers said/ 'Say what're you doing in bed?'/ I said, 'We're only trying to get us some peace'"), the stunt was followed by a Bed-In in Montreal, where the pair recorded the single "Give Peace a Chance." The Beatles broke up the following year, an event for which many fans unfairly blamed Ono. But the couple's creative collaborations continued—culminating in the album *Double Fantasy,* released three weeks before Lennon's murder in 1980. In 2017 Ono's name was added to the songwriting credits of the 1971 hit "Imagine" because, as Lennon had long ago noted, "a lot of it—the lyric and the concept—came from Yoko."

MARY TYLER MOORE | *studio photographer, 1970*

'We were out there in the middle of February in Minneapolis, freezing' —Mary Tyler Moore

PERENNIALLY PERKY AND WITH A STEINWAY-WIDE SMILE, Mary Tyler Moore's Mary Richards was a stealthy feminist trailblazer, spunky rather than strident. Moore had already busted the mold of the June Cleaver-esque sitcom housewife as Laura Petrie on *The Dick Van Dyke Show* in the 1960s. The next decade brought *The Mary Tyler Moore Show,* in which her character, a recently dumped Minneapolis TV news producer, proved that a woman without a husband "might just make it after all," as the show's theme song (Sonny Curtis's "Love Is All Around") had it. At the end of the opening credits, which featured a montage of Mary touring Minneapolis, Moore did a spin and triumphantly launched her blue knit beret skyward. Filmed at Nicollet Mall, the hat toss "was a spur of the moment idea," Moore, who died at 80 in 2017, said in a 1997 Archive of American Television interview. "I was in front of a department store, and they said, 'Oh! Look, here, run out into that intersection and take your hat—which I had in my hand—and throw it in the air, as if this is the happiest moment of your life.' I did, and that was it."

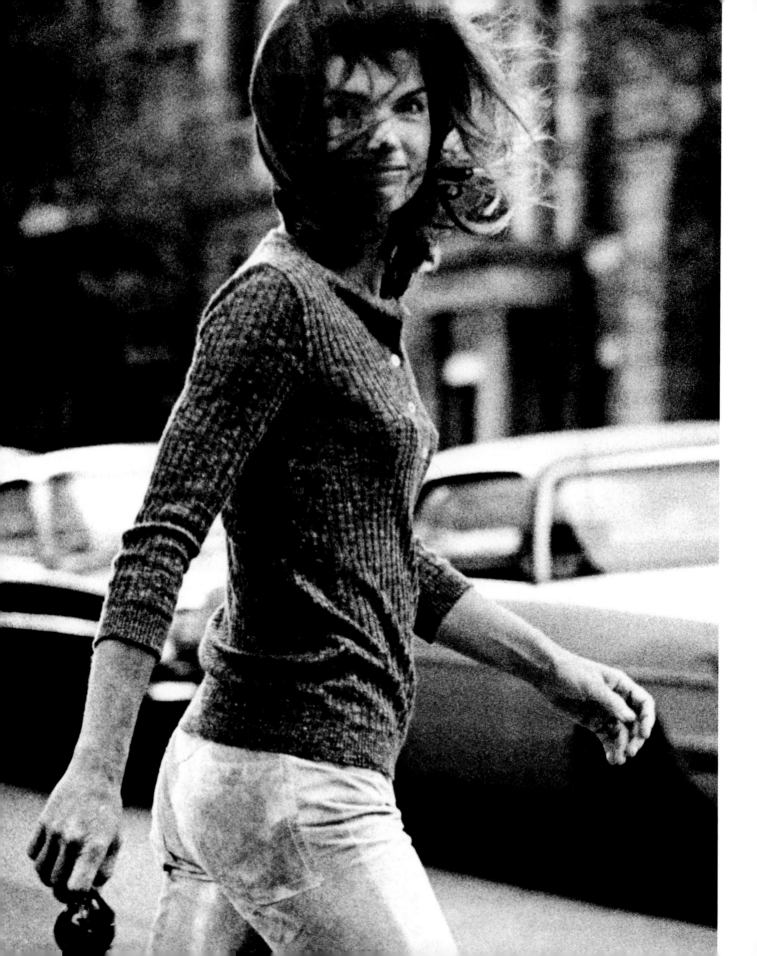

JACQUELINE KENNEDY ONASSIS | *Ron Galella, 1971*

'SHE LOVED TO BE
PHOTOGRAPHED. SHE
WAS TRAINED TO BE
WHISPERY-VOICED,
LOW-KEY, NOT GIVE
INTERVIEWS. SHE HAD
A MYSTIQUE AND
SHE WAS VERY CLEVER
IN THAT WAY'
—RON GALELLA

THE TERM "PAPARAZZO" COMES FROM THE NAME OF A news photographer in a 1960 Fellini film, *La Dolce Vita*; the character's name derived from the way the director described a buzzing insect. But it was a real man, Ron Galella, who virtually invented modern celebrity on-the-fly photography and who, throughout his long career, has been swatted away by stars, from Marlon Brando to Michael Jackson. But he most antagonized former First Lady Jacqueline Kennedy Onassis. "She was my ideal subject because she was full of life, always actively ignoring me—good, because I don't want her to pose," says Galella, now 86. Onassis, widowed a second time and raising her kids in New York City, let her lawyers do the swatting: She took him to court twice and, although he argued for his right to gather news, she won injunctions that required Galella to keep his distance. Before then, however, he made this image, which he calls his *Mona Lisa*. He hid in a taxi as Onassis strolled Madison Avenue on an autumn day. When the driver honked, Onassis looked round. "The moment she turned, she had a little smile like the *Mona Lisa*," he says. "She didn't know it was me. That's luck." In his heyday Galella was one of very few photographers staking out celebrities; their numbers and desperate tactics for catching stars in their elements had yet to swell dangerously. Asked if it bothers him to be known as the original paparazzo, he responds, "I don't mind that, but today it's a bad name. I took it off my business card."

JANE FONDA | *photographer unknown, 1972*

MORE THAN FOUR DECADES AFTER THIS PHOTO APPEARED, some veterans still call Jane Fonda "Hanoi Jane" and brand her a traitor. In 1972 the actress and activist, an outspoken critic of the Vietnam War, took a two-week trip to Hanoi, then the capital of North Vietnam. In and of itself, the visit wasn't unusual; by then, hundreds of American civilians had traveled to North Vietnam in an effort to find avenues for peace. Meanwhile, 60,000 U.S. troops, many of them draftees, had died in the streets and jungles, and at home the war was tearing apart the nation. As Fonda recounted in her 2005 memoir *My Life So Far,* on her last day in Hanoi she put on the required helmet and visited with North Vietnamese soldiers and civilians, singing songs, tearing up and sharing a few laughs, including while perched on artillery in view of photographers. "There'd been an emotional ceremony; I sat down and—click," she recalled to *People*'s sister publication, *Entertainment Weekly.* "I wasn't even thinking about where I was when I sat down there or that people could think I was actually shooting at or aiming at American [aircraft]. It was not an active gun." But the perception of the popular star of *Barbarella*—daughter of film hero and WWII Navy veteran Henry Fonda—appearing to side with America's enemy was hard for her to live down. "I'll go to my grave regretting that, and I've apologized for it," she said. "What I hope I've conveyed to soldiers is what was actually in my heart."

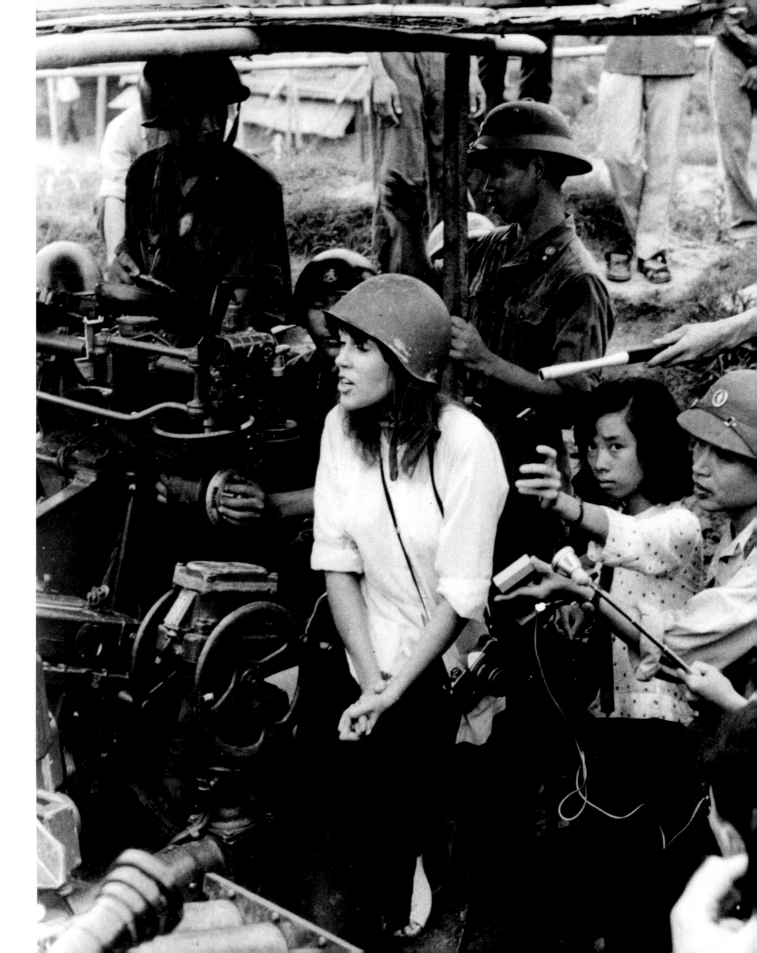

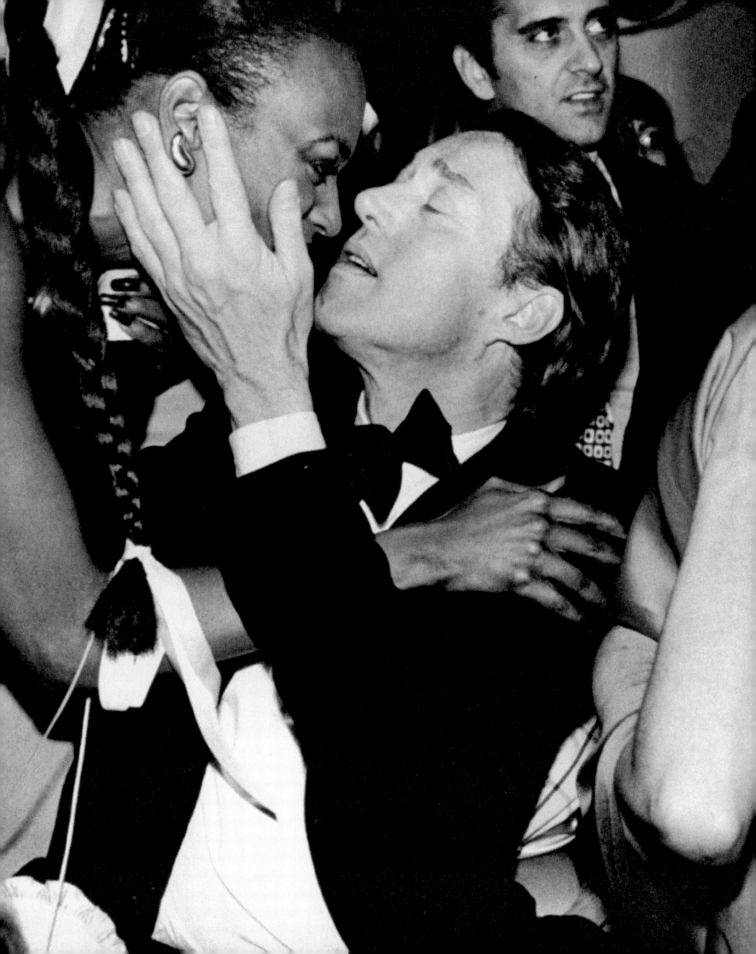

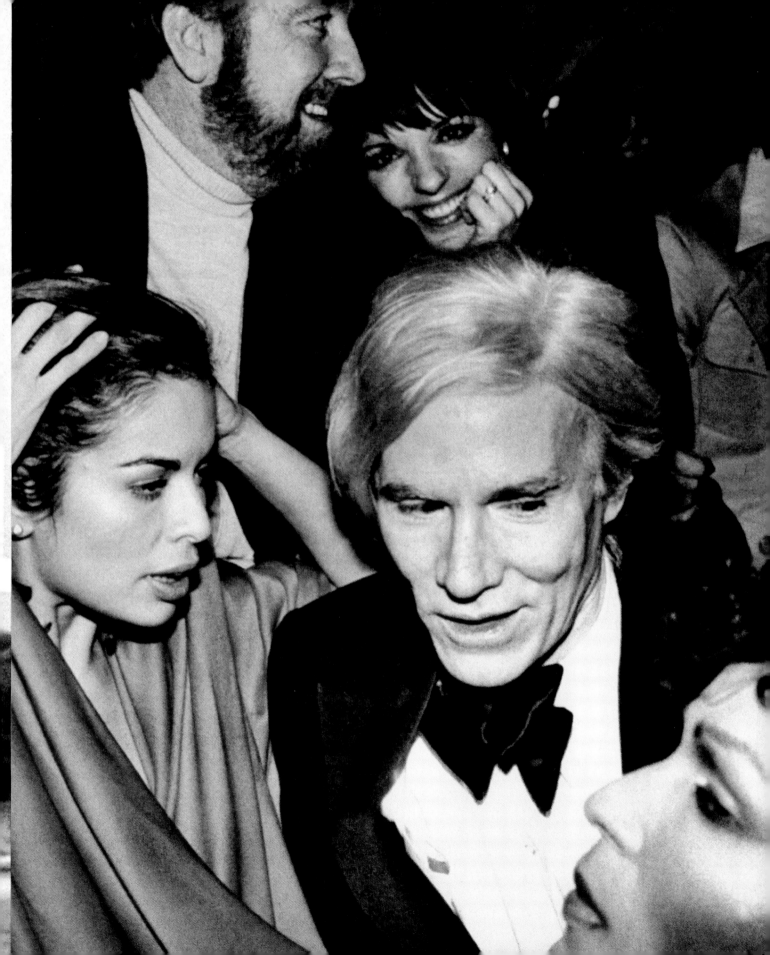

ROBIN WILLIAMS
& CHRISTOPHER REEVE
Walter McBride, 1982

'I'd sit back and hope to catch the
girls that were downstream'
—Robin Williams, onetime
wingman to Christopher Reeve

IN ITS TIME, Walter McBride's snap
was a little more than a photo of pals
on a night out. Today it's a gut punch:
How did we lose both these men so
soon? Roommates at Juilliard, they
each hit it big with roles they could
not have anticipated while at the
academy: Christopher Reeve
became a generation's *Superman*,
while stand-up savant Robin Wil-
liams broke out as an alien in *Mork
& Mindy*. "I'd never seen so much
energy contained in one person,"
Reeve, godfather to Williams's kids,
said in his memoir *Still Me*. His
friend's deep comic well helped in
the dark days after a 1995 equestrian
accident left him paralyzed. Wil-
liams arrived at the hospital in
scrubs, impersonating a "Russian
proctologist" there for an exam. The
laughs they shared, Reeve told Bar-
bara Walters, were "one of the first
indicators to me that life could be
good again." Reeve died in 2004. A
decade later Williams took his life
after suffering from a degenerative
brain disorder. Reeve's son Will
remembered Williams as a man who
"loved my father and his family so
fiercely he would do anything to
make them happy."

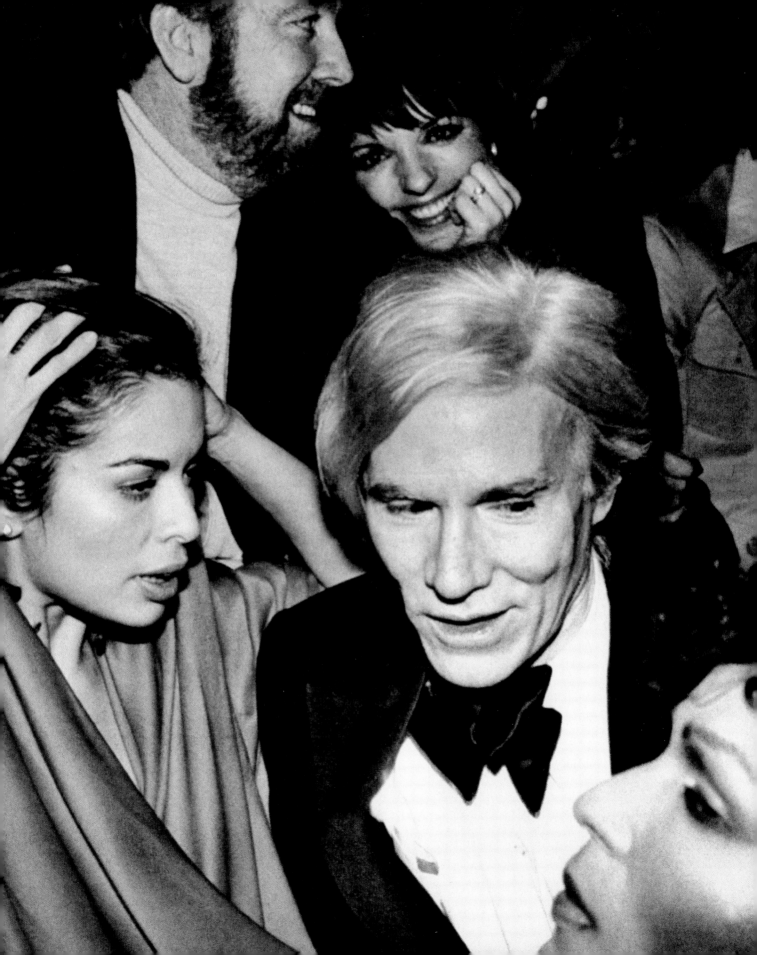

I← PREVIOUS SPREAD

STUDIO 54 | *Robin Platzer, 1978*

'The key to the success of Studio 54 is that
it's a dictatorship at the door and a democracy
on the dance floor' —Andy Warhol

AT THE HEIGHT OF THE DISCO ERA, A FORMER TV studio on West 54th Street in Manhattan became a nightly celebrity sandbox. At Studio 54—seen here on New Year's Eve 1978—regulars included (left to right) designer Halston; Mick Jagger's ex, Bianca; director Jack Haley Jr. and wife Liza Minnelli; and pop-art emperor Andy Warhol. On any given evening Woody Allen might kibitz with Michael Jackson while Mikhail Baryshnikov boogied with Jacqueline Bisset. Photojournalist Robin Platzer spent up to four nights a week there for *People* and other outlets: "I'd go at maybe 10 o'clock and they'd show up at 12 o'clock, after whatever else they were doing." But it wasn't just stars or the blizzard of illicit stimulants that gave the place its kick. Owners Steve Rubell and Ian Schrager also mixed in unknowns—as long as they were stunningly gorgeous, amusingly outlandish, or both. The partners' reign halted in 1980, when they went to prison for tax evasion. Rubell died in 1989, while Schrager is now a name in a quieter business: hotels. And the old Studio is now a Broadway theater.

JOHN F. KENNEDY JR. | *Ron Galella, 1980*

'To me, John could have had a great career
as an actor. He wanted to' —Ron Galella

A BEREFT AND FRANKLY CURIOUS NATION WOULD not be satisfied to have their last images of John F. Kennedy Jr. be those from his father's 1963 funeral: a 3-year-old boy saluting a flag-draped casket. So, although one could scarcely argue with his mother's desire to raise her children in comfortable anonymity, there was a yearning to witness him grow up. Seeing this, Ron Galella risked jail by violating a court order—to stay 25 ft. from the family—to sate the public's interest as well as his own. Unlike with Jacqueline Kennedy, in John Jr. (right, in Hyannis, Mass., on a summer break from Brown University), Galella says he found a more willing subject, who didn't mind the attention. "He'd say hello and shake my hand," recalls Galella. "And he was a handsome guy." The Kennedy heir also understood our curiosity, even as he protected the privacy he'd been raised to treasure. In 1996 he wed Carolyn Bessette in total secrecy, announcing the event after the fact with a photo. The couple and Bessette's sister Lauren died in a 1999 plane crash. Even in a life documented publicly from birth, there will never be enough pictures.

ROBIN WILLIAMS & CHRISTOPHER REEVE
Walter McBride, 1982

'I'd sit back and hope to catch the
girls that were downstream'
—Robin Williams, onetime
wingman to Christopher Reeve

IN ITS TIME, Walter McBride's snap
was a little more than a photo of pals
on a night out. Today it's a gut punch:
How did we lose both these men so
soon? Roommates at Juilliard, they
each hit it big with roles they could
not have anticipated while at the
academy: Christopher Reeve
became a generation's *Superman*,
while stand-up savant Robin Wil-
liams broke out as an alien in *Mork
& Mindy.* "I'd never seen so much
energy contained in one person,"
Reeve, godfather to Williams's kids,
said in his memoir *Still Me.* His
friend's deep comic well helped in
the dark days after a 1995 equestrian
accident left him paralyzed. Wil-
liams arrived at the hospital in
scrubs, impersonating a "Russian
proctologist" there for an exam. The
laughs they shared, Reeve told Bar-
bara Walters, were "one of the first
indicators to me that life could be
good again." Reeve died in 2004. A
decade later Williams took his life
after suffering from a degenerative
brain disorder. Reeve's son Will
remembered Williams as a man who
"loved my father and his family so
fiercely he would do anything to
make them happy."

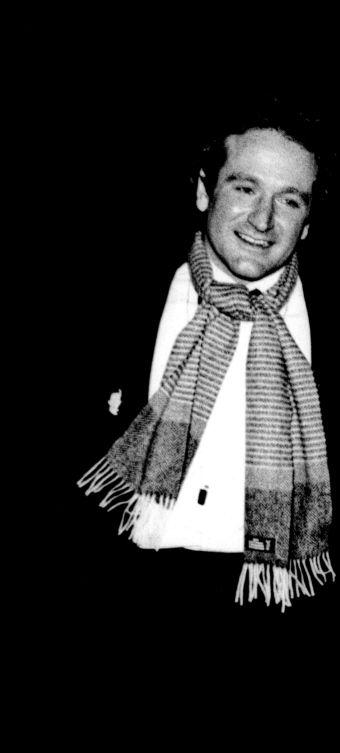

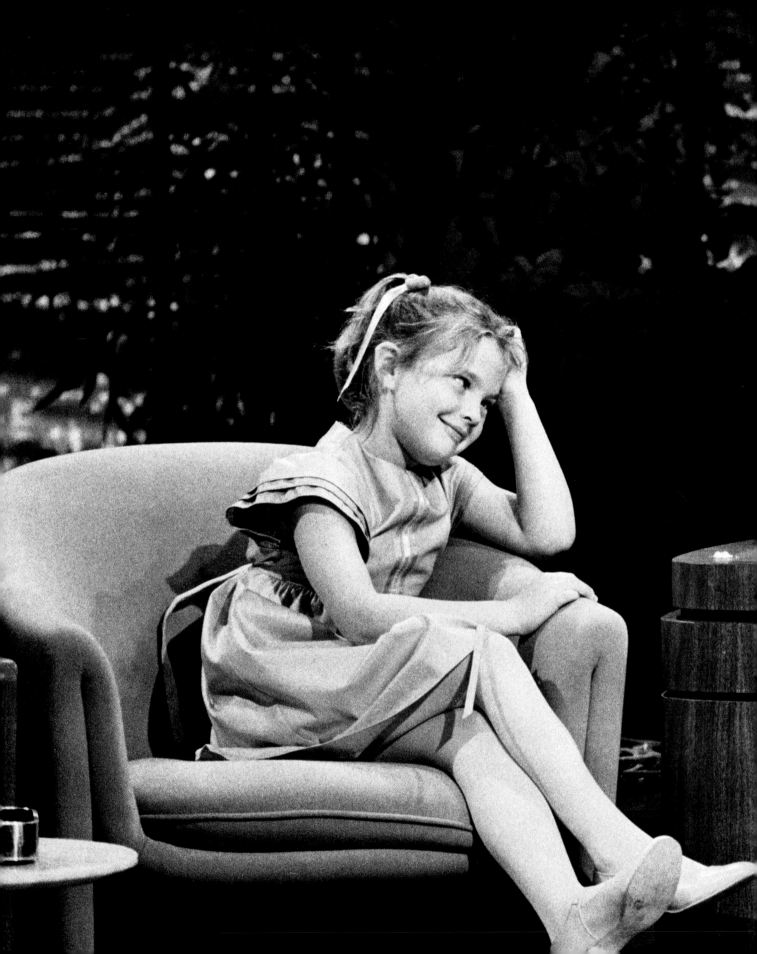

I←— PREVIOUS SPREAD
DREW BARRYMORE, JOHNNY CARSON | *Gene Arias, 1982*

'From the time I became famous in *E.T.*,
my life got really weird' —Drew Barrymore, 1989

AS GERTIE IN *E.T.*, 7-YEAR-OLD DREW BARRYMORE charmed audiences. She had the same effect on Johnny Carson, who invited her on *The Tonight Show* as the movie broke box office records. When he praised her smile, she removed a dental plate to show that several baby teeth were missing. "Most women I know would not do that," Carson joked. "They wouldn't like anybody to know that secret." But Barrymore tends to be forthcoming. At 14, she published a memoir, *Little Girl Lost,* detailing how she had her first drink at 9, pot at 10 and cocaine at 12; by the time she wrote the book she'd done multiple stints in rehab. Yet Barrymore subdued her demons, went on to become the producer and star of hits like the big-screen *Charlie's Angels* and is now mom to two little girls of her own. "I'm happy where I am in my life," a grown-up Barrymore told *People.* "I've made mistakes that I don't have to make anymore."

DIANA ROSS | *Ron Frehm, 1983*

'It took me a lifetime to get here,
and I'm not going anywhere'
—Diana Ross to the rain-soaked crowd

"FOR ONE AND FOR ALL," DIANA ROSS'S FREE concert in New York City's Central Park, had been in the works for a year, with plans to beam it to 50 countries. When Ross stepped onstage with a delighted "Hello, New York!" some 450,000 fans cheered in reply, despite sweltering in 95° heat. Ross, then 39, began with her hit "Ain't No Mountain High Enough" and sang for 20 minutes before an ominous black cloud materialized, swept in by nearly 60 mph gales. Suddenly it was the Supremes' diva versus the Supreme Being: Lightning flashed, and down came a pummeling rain. Ron Frehm captured a windswept Ross as she defied the elements and kept belting them out. "It's okay," she assured the soggy crowd, "we're just going to get a little wet." Only when conditions became dangerous did Ross give in. "Do you love me?" she called out. "Yes!" the lingering faithful responded, and Ross ordered: "Then get out of the goddamned park!" She returned the next night for a full show. Now in her 70s, Ross still packs 'em in, headlining the 2016 *Essence* Festival. "There are so many songs I love to perform," she told *People*, adding, "I think [my favorite] may be 'Ain't No Mountain High Enough.'" Nothing can stop her.

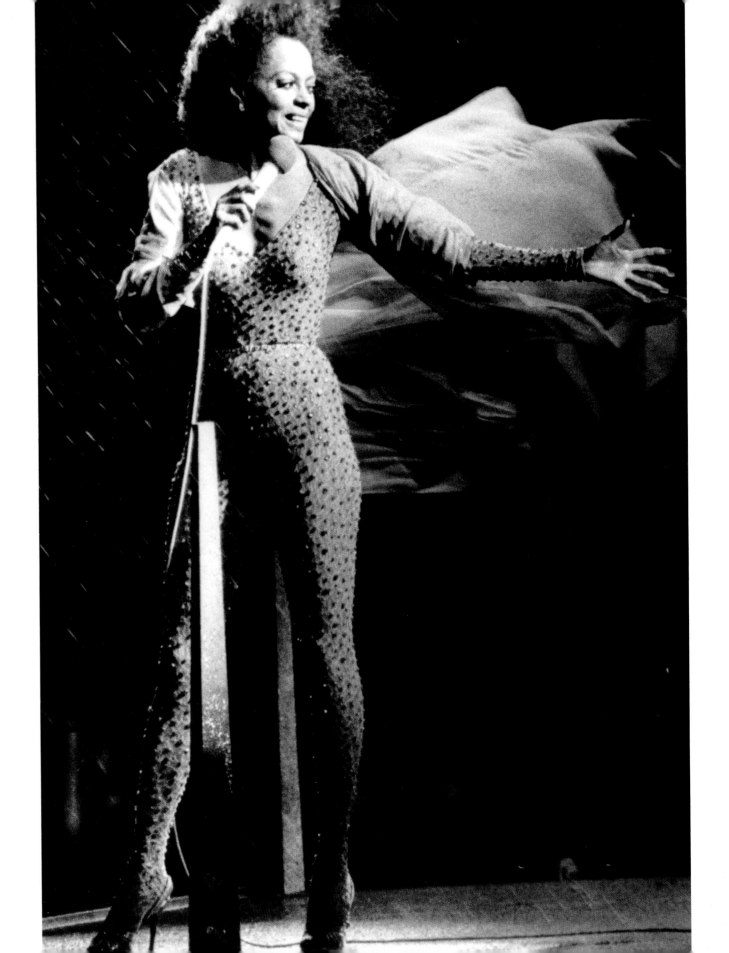

JOHN TRAVOLTA & DIANA PRINCESS OF WALES
Pete Souza, 1985

'That was one of the
highlights of my life'
—John Travolta

WHEN PRINCE Charles and Princess Diana came to Washington, D.C., Nancy Reagan wanted the princess to enjoy herself thoroughly. So she made discreet inquiries: What eminent personages would most please Her Highness as dinner companions? Guests included Neil Diamond, Clint Eastwood, Tom Selleck and Mikhail Baryshnikov, who, reportedly suffering from sore ankles, did not dance that night. Diana took a turn with each of the others, as well as President Ronald Reagan. But it was John Travolta who had strict instructions from the First Lady: At midnight he was to tap the Princess on the shoulder and ask, "Would you care to dance?" When Travolta approached her, remembers Pete Souza, then the White House photographer (a role he reprised for President Obama), "Diana was visibly blushing." As the Marine Band played a medley from Travolta's films, the pair gamboled for nearly 30 minutes. "I felt that I had taken her back to her childhood, when she had probably watched *Grease*, and for that moment I was her Prince Charming," Travolta recalled in *The Telegraph*. He later said, "At the end, she curtsied and I bowed, and—well, I guess I turned back into a pumpkin."

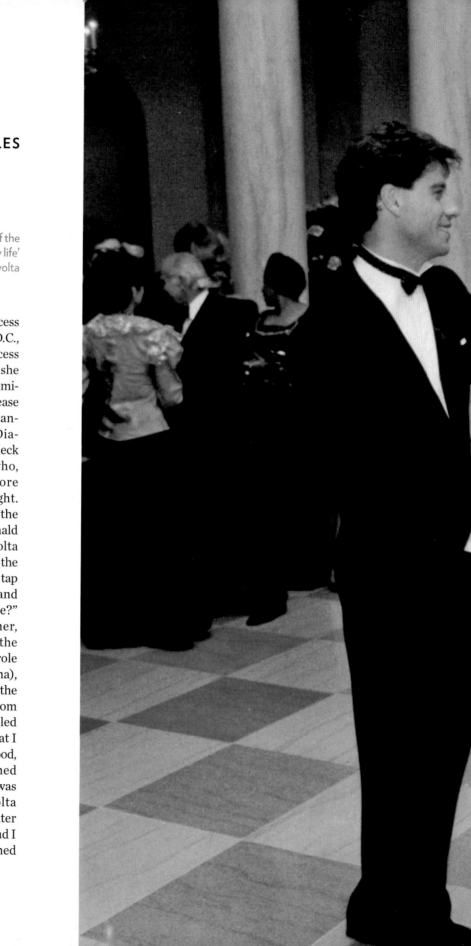

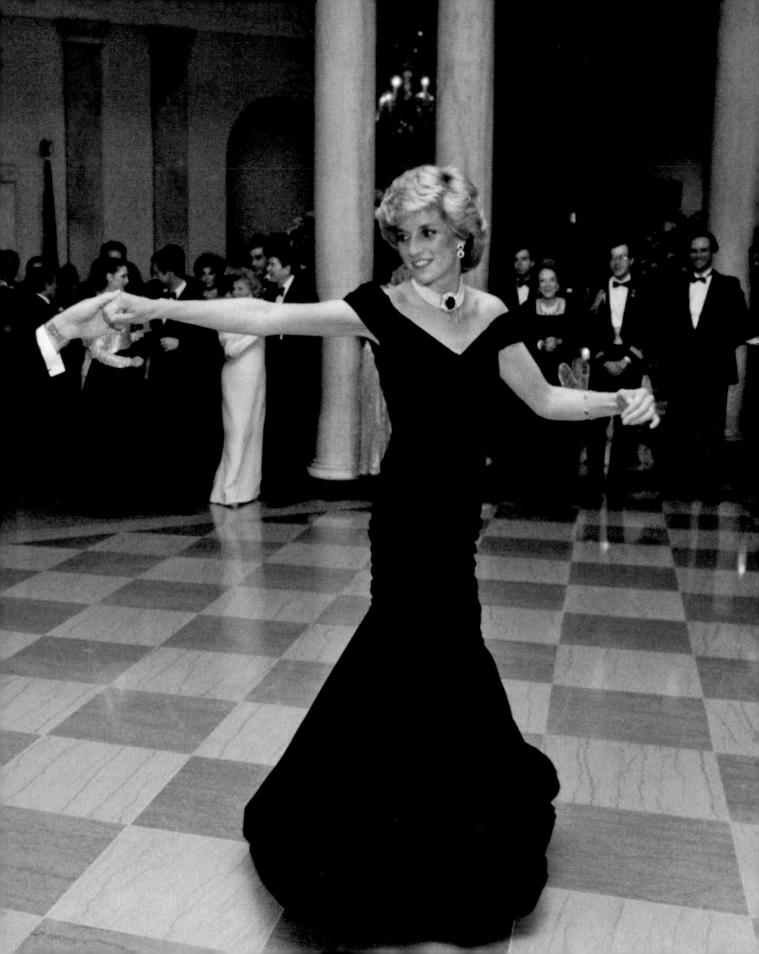

OPRAH WINFREY
Paul Natkin, 1988

'I took 20,000 photographs over five years. This was the most famous picture I ever took of her' —Paul Natkin

CHICAGOAN PAUL Natkin was an official photographer for *The Oprah Winfrey Show* from the time the local talk program went national. When he started, "I had no idea who she was," he admits. But she was low-key and friendly. "She used to come to my house and watch Bears games." Then, he recalls, "about a year into it, she couldn't walk down the street without being mobbed." Winfrey won a lot of empathetic fans by being forthright about personal struggles, including with weight. At last, in 1988, she could show off a hard-won goal: Her 67-lb. drop (achieved on a liquid diet) was to be a surprise. "I came in that morning, and the little red wagon was backstage with the big pile of fat in it," says Natkin. "It was a brilliant TV move." (It earned the show its highest ratings to date.) But Winfrey, who has settled into a relationship with Weight Watchers (she's a success story and owns a share of the company), regretted the stunt. "Big, big, big, big, big, big, big mistake!" she told *Entertainment Tonight* in 2011. "I think it was one of the biggest ego trips of my life."

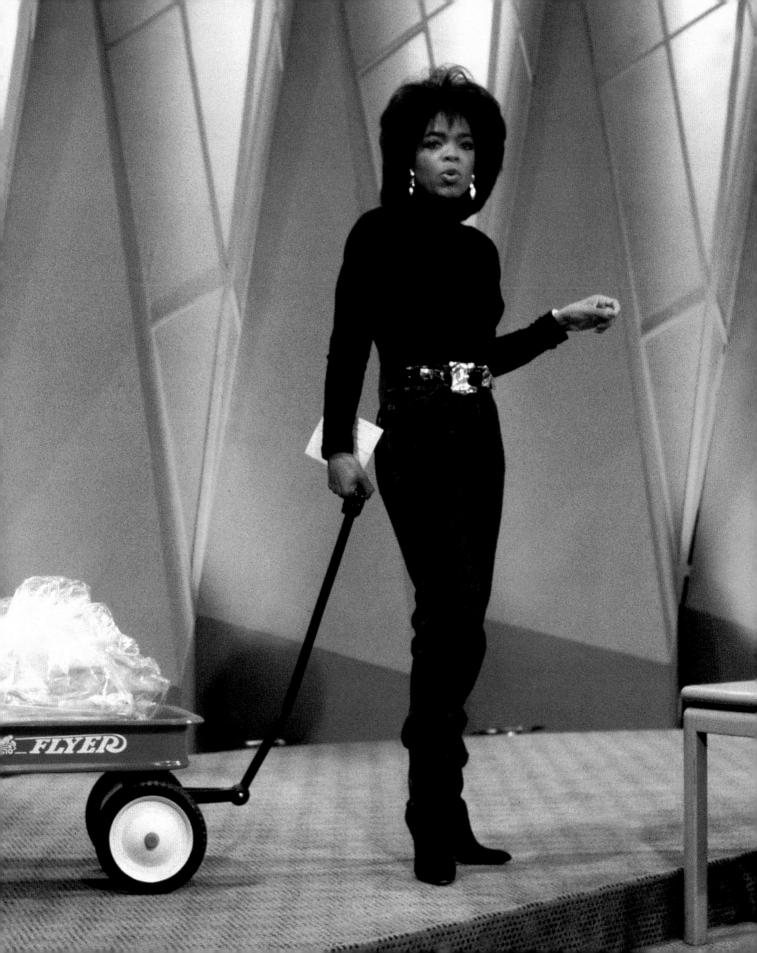

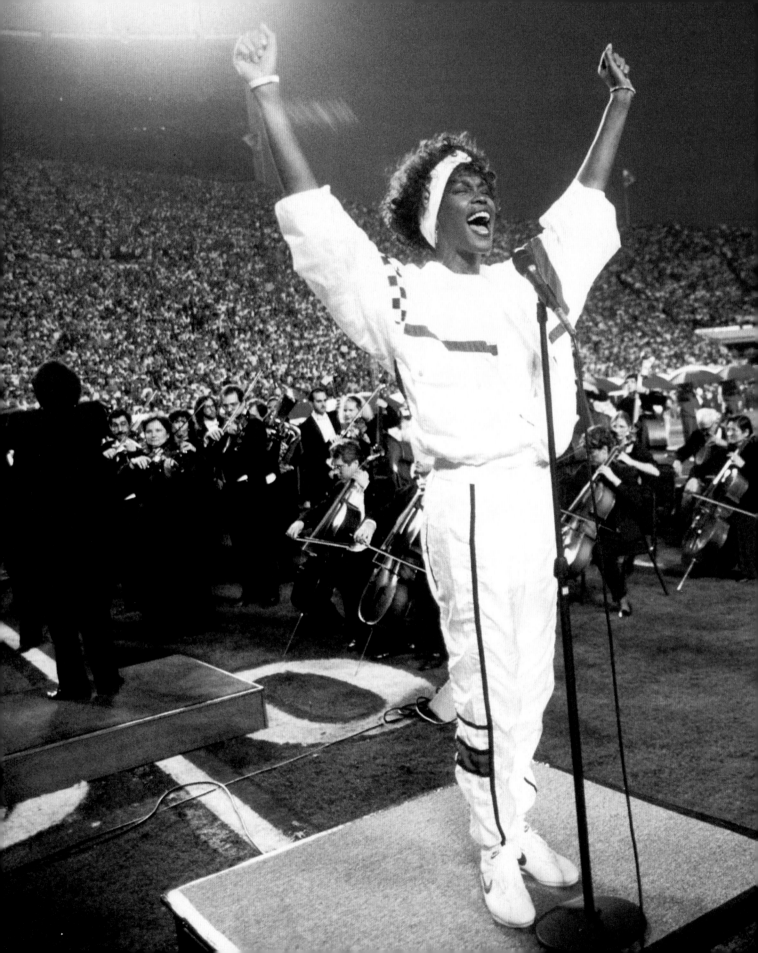

WHITNEY HOUSTON
Michael Zagaris, 1991

'I remember standing there and
looking at all those people,
and it was like I could see in their
faces the hopes and prayers
and fears of the entire country'
—Whitney Houston, to *People*, 1991

AMERICA WAS NEWLY at war. Ten
days earlier, President George H.W.
Bush launched Operation Desert
Storm to liberate Kuwait from Iraq's
Saddam Hussein. So when the New
York Giants met the Buffalo Bills in
Super Bowl XXV, patriotic fervor at
Tampa Stadium ran high—reaching
a crescendo as Whitney Houston,
then 27 and soaring on the success of
her album *I'm Your Baby Tonight*,
gave a transcendent rendition of
"The Star-Spangled Banner." On
assignment to cover the football play-
ers, Michael Zagaris caught it all.
"Whitney was set up in front of the
bench, and I happened to be there,"
he recalls. "I didn't say, 'This is going
to be an incredible shot.' I lived it.
When I looked at the proof sheets
later, it was, 'Wow, this is great.'" He
captured the superstar in triumph, a
moving image in light of Houston's
death two decades later. By then it
had long ago been revealed that her
Super Bowl performance was deliv-
ered to a disconnected microphone—
audiences heard a track that Houston
had recorded earlier. A fake-out?
Perhaps. But the emotion? One hun-
dred percent real.

PRESIDENT BILL CLINTON, ANNE HECHE & ELLEN DeGENERES
Neshan H. Naltchayan, 1997

'Her courage and candor helped change the hearts and minds of millions' —Barack Obama

"YEP, I'M GAY." WITH those words, on the cover of *Time* in 1997, Ellen DeGeneres—then starring in an eponymous sitcom—became the first lead on a TV show to come out as gay. Twelve days later DeGeneres and girlfriend Anne Heche attended the White House Correspondents' Dinner, where Neshan Naltchayan snapped them chatting with President Bill Clinton (as George Clooney looked on). "It's the closest thing Washington has to the Oscars," says Naltchayan. The new couple "lit up the room," a gay-rights lobbyist told *People.* But their nuzzling outraged others: a "freak show," fumed the wife of a Cabinet member; a *New York Times* column harrumphed over the "ostentatious display of affection." Today "it's easy to forget now just how much courage was required for Ellen to come out on the most public of all stages 20 years ago," said President Obama, when he awarded DeGeneres (now wed to actress Portia de Rossi) the Presidential Medal of Freedom in 2016. "Just how important it was—not just to the LGBT community, but for all of us."

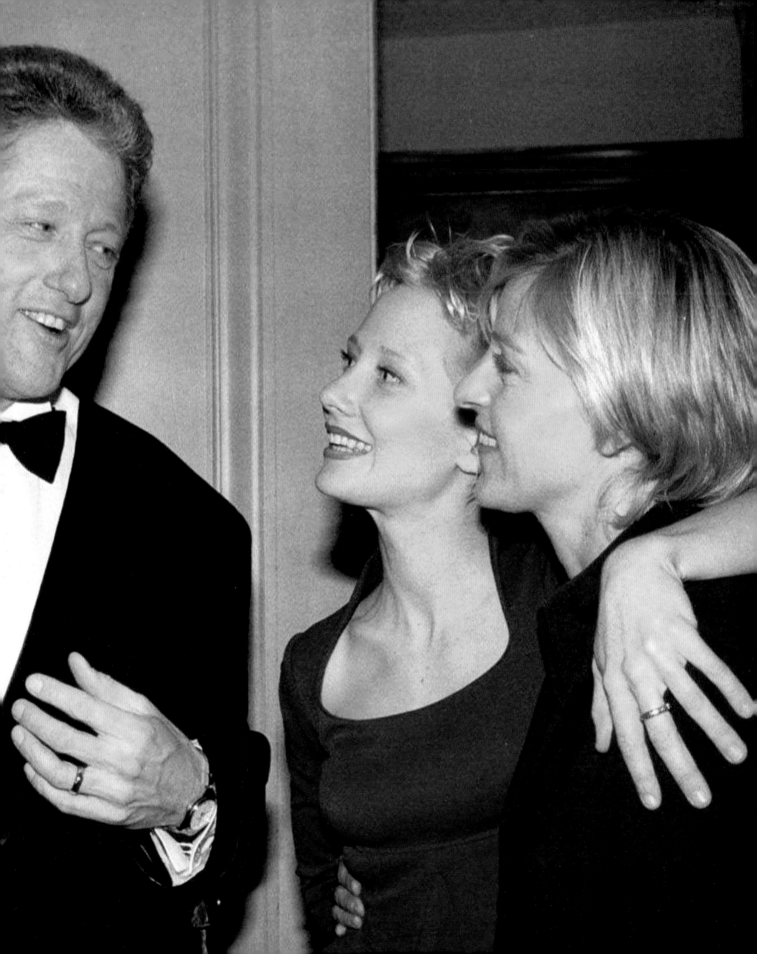

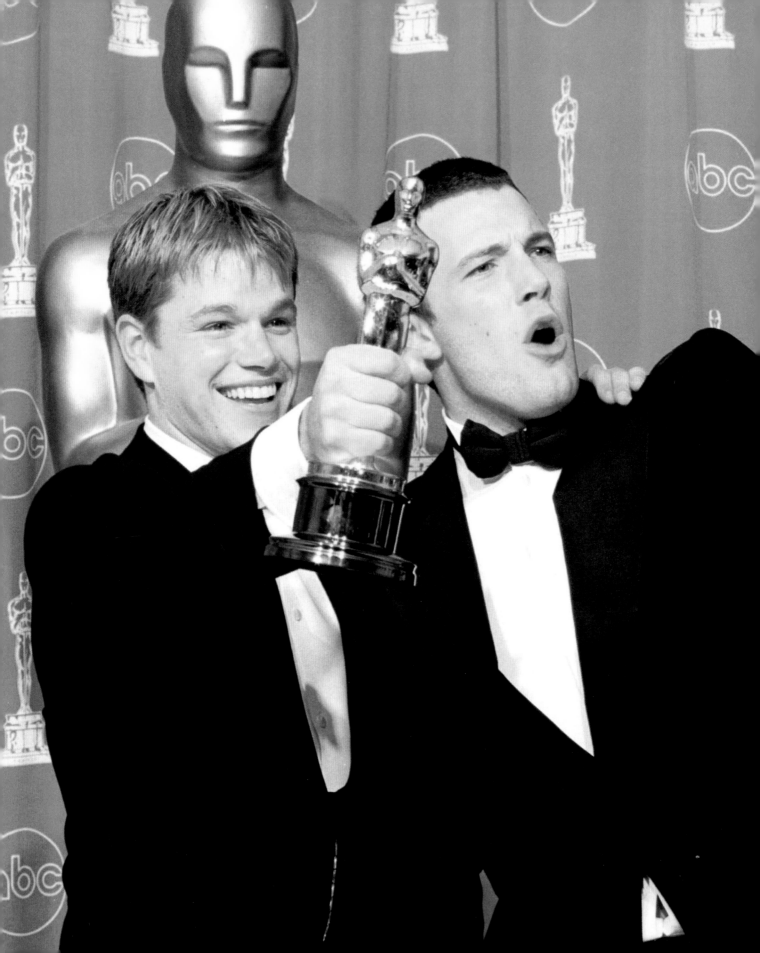

MATT DAMON & BEN AFFLECK | *Hal Garb, 1998*

'We look at things in exactly the same way.
It wasn't like someone was good at structure and
someone at dialogue. The only difference
between us is Ben can type' —Matt Damon, to *EW*, 1998

THE GREAT SHOWBIZ FRIENDSHIPS usually date back to before either buddy hit it big. *The Office* stars John Krasinski and B.J. Novak used to play Little League together. Nicole Kidman and Naomi Watts met at a Sydney girls' high school. But the bond between two Boston boys, Matt Damon and Ben Affleck, who started conspiring to make movies back at the Cambridge Rindge and Latin School, may be the gold standard. As struggling actors, the pair cowrote the it's-okay-for-men-to-feel film *Good Will Hunting,* in which Damon played a Southie math genius and Affleck his construction worker friend. When they earned a Best Original Screenplay Oscar it made for an instant lore—two kids from nowhere, with their moms as dates, grabbing the gold. (So compelling was the tale that Mindy Kaling, before finding her own TV fame, made a splash with an Off-Broadway play, *Matt & Ben,* in which she and coauthor Brenda Withers portrayed the actors in a scenario that imagines the award-winning script fell from heaven into Affleck's nachos-littered apartment.) On the big night the real Affleck, 25, and Damon, 27, gave a giddy acceptance speech. "I just said to Matt, 'Losing would suck and winning would be really scary.' It's really, really scary," Affleck began. He then went into a protracted jag of gratitude, as Damon interjected, "Whoever we forgot, we love you!" In his photo Hal Garb crystallized their wide-eyed "we're not in Beantown anymore" exuberance. Today, with three Oscar nods for acting, Damon is one of the movies' most bankable stars, while Affleck directed 2013's Best Picture, *Argo.* "We were both in love with the same thing: acting and filmmaking," Damon said in 2016. " I think we fed on each other's obsession during really formative, important years, and that bonded us for life."

ANGELINA JOLIE | *J. Redden, 2005*

'After seeing real suffering,
you never complain anymore'
—Angelina Jolie

IN THE SPRING OF 2005 ALL eyes were on Angelina Jolie, but not for the reasons that she wanted: She and her *Mr. & Mrs. Smith* costar, Brad Pitt, had started spending time together in the wake of his separation from Jennifer Aniston. Weren't there more important goings-on in the world? Sure, but that was one bit of relationship trigonometry from which only the most resolutely incurious could turn away. So Jolie let people look on, then redirected the spotlight toward a cause close to her heart: the plight of those displaced by war or disasters. A onetime wild-child-turned Oscar-winning actress, director, mother and, quite simply, massive celebrity, Jolie is also a humanitarian who, since 2001, has been a Goodwill Ambassador for the United Nations High Commissioner for Refugees (UNHCR), a role that has taken her from Sudan to Cambodia to Pakistan, where, at the Kactha Gari refugee camp, she met this Afghan boy. She isn't the first to use fame to highlight the global work of a U.N. agency. (Danny Kaye, in fact, was the first celebrity representative for UNICEF, and Audrey Hepburn, who had received aid as a child in World War II, later gave back as a Goodwill Ambassador.) But Jolie, the erstwhile Lara Croft, brought not only a grasp of the issues, but a bit of action-star excitement to the job. During her Pakistan trip she came across a convoy of Afghan refugees returning home. Suddenly "she shot up the side of the truck and sat up there talking to the women and children," a regional UNHCR public information officer told *People*. Afterward "she dexterously zipped down again. There was a group of 100 men staring with considerable surprise." Now that she had the world's attention, it was time to let everyone know how they could help.

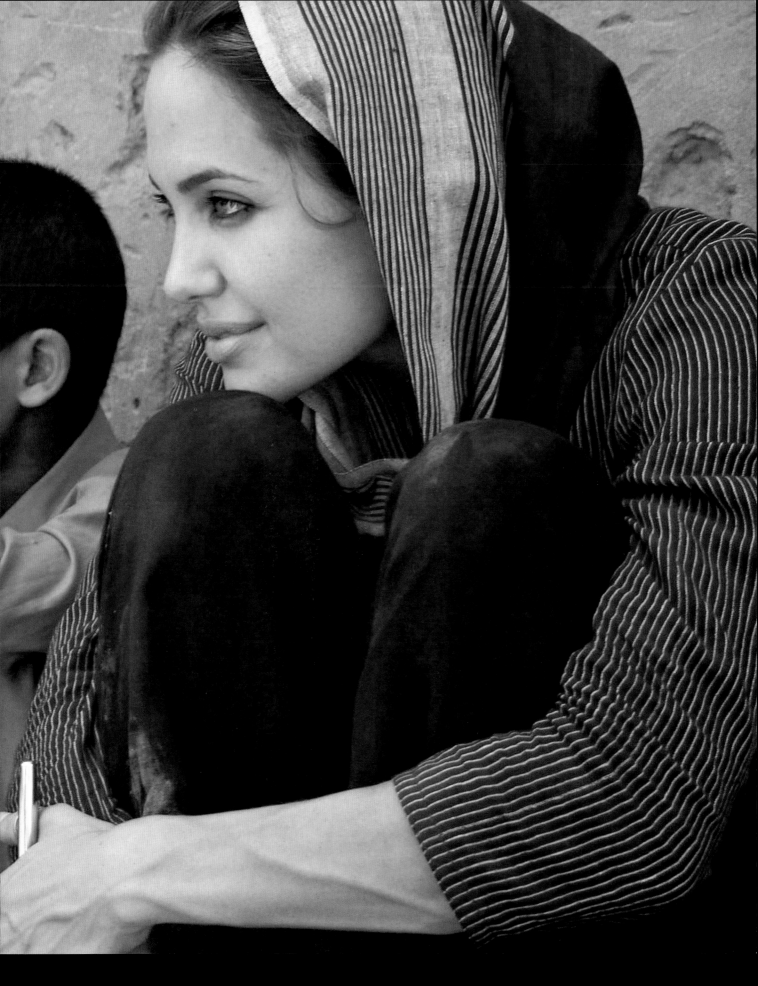

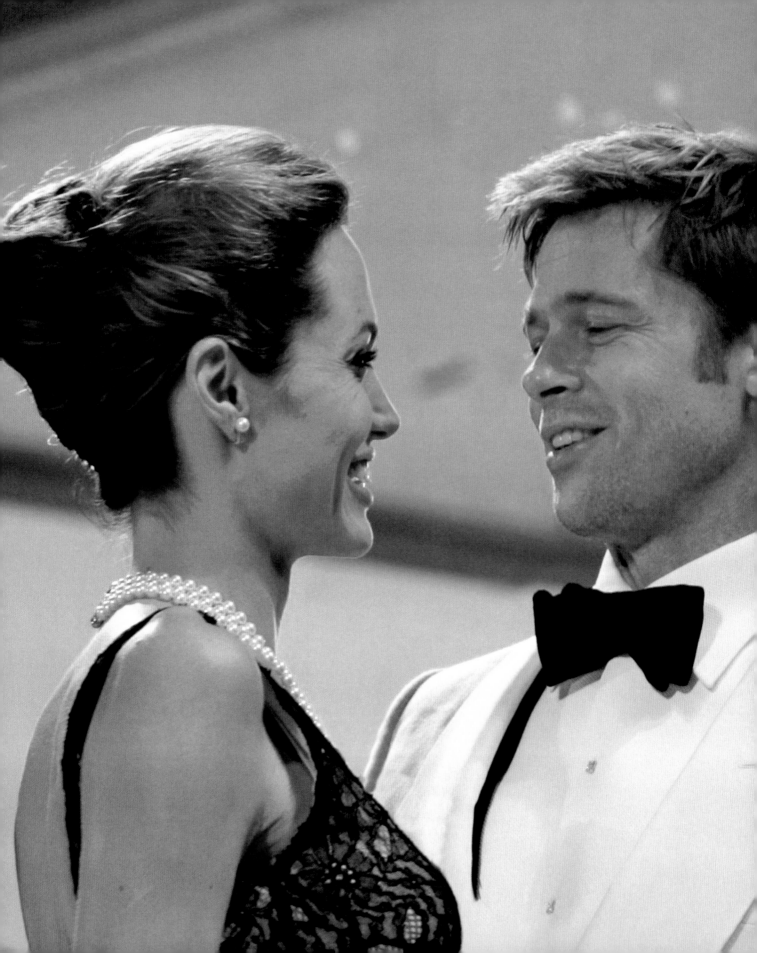

ANGELINA JOLIE & BRAD PITT
Alessandro Bianchi, 2007

'My focus is … our children.
We are and forever will be a family'
—Angelina Jolie, after her divorce from Brad Pitt

IN TERMS OF CELEBRITY MOMENTS, this one is hard to beat: two of the best-looking people on the planet, all cleaned up for one of the starriest events of the year— the Venice Film Festival—caught sharing a completely genuine look of love, by Italian photographer Alessandro Bianchi. Brad Pitt and Angelina Jolie were, by 2007, Hollywood's most famous couple. That year they adopted a fourth child (son Pax joined Maddox, Zahara, and Shiloh) and together mourned the loss of her mother, Marcheline Bertrand. They supported each other's charitable goals and kept busy at work: She starred in a film he produced, *A Mighty Heart,* while he appeared in *The Assassination of Jesse James by the Coward Robert Ford* (which took them to Venice). By 2008 they had welcomed twins Vivienne and Knox, and made being parents of six look impossibly glamorous. When she faced a cancer scare in 2013, he was movingly supportive of her choice to undergo an elective double mastectomy. The next year, at long last, they married in a ceremony attended by just 20 guests, who hummed Mendelssohn's "Wedding March" as the bride entered in a gown decorated with the children's artwork. Then, two years later, it ended in a divorce filing. Said one insider of their final years together: "It was more like their honeymoon was over and they entered a real marriage."

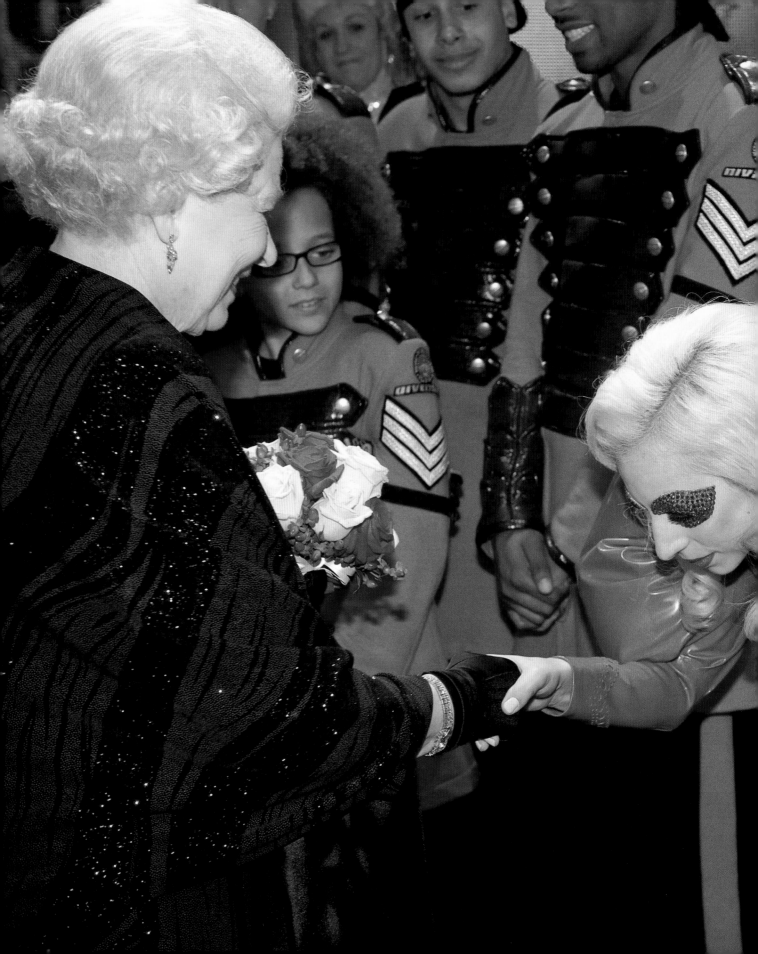

QUEEN ELIZABETH II & LADY GAGA
Leon Neal, 2009

'She was very polite
and courteous toward
the Queen, with
none of the rebellious
image evident' —Leon Neal

STEFANI JOANNE ANGELINA Germanotta—a.k.a. Lady
Gaga—didn't temper her flamboyant style while per-
forming for Queen Elizabeth II at the annual *Royal
Variety Show* in Blackpool, England. Then 23, she dolled
up as Her Majesty's ruffled namesake, Elizabeth I—that
is, if the Virgin Queen wore red latex dresses and match-
ing eye patches. Sitting at a surrealistic piano mounted
on stilts, Gaga closed the show with a heartfelt rendition
of "Speechless," a ballad she wrote for her father, who
was in attendance that night. Photographer and docu-
mentarian Leon Neal was among a select group of
media on hand for the post-performance receiving line.
"Everybody there knew the meeting between Lady
Gaga and Queen Elizabeth II was set to be the moment
of the evening, so there was more than a little polite
pushing and shoving to ensure we got the shot," he
recalls. "Strangely the lineup was held onstage in front
of thousands of audience members." For QE II—83 at
the time and in the 57th year of her reign—the meet
and greet was old hat, but Gaga seemed awed. "She was
very polite and courteous toward the Queen, with none
of the rebellious image evident," Neal says.
Perhaps she knew she was being upstaged. "A queen
trumps a lady any day of the week."

PRINCESSES EUGENIE & BEATRICE | *Steve Parsons, 2011*

'IT HAS ITS OWN
PERSONALITY'
**—PRINCESS BEATRICE,
ON HER ROYAL
WEDDING HAT**

IT WAS THE HAT THAT LAUNCHED A THOUSAND MEMES. When Princess Beatrice of York attended the April 29, 2011, wedding of her cousin Prince William to Kate Middleton, she could have gone for dignified subtlety. She could have taken a cue from her sister, Princess Eugenie (left), who opted for whimsy just this side of wacky. But the younger daughter of Prince Andrew and Sarah, Duchess of York, instead capped herself with this Byzantine bowed number—properly called a "fascinator"—by favorite royal milliner Philip Treacy. The attention-grabbing accessory soon had its own Facebook page and was quickly likened to an octopus, a toilet seat, a bagel, a pretzel and (sorry) internal reproductive lady parts. Meanwhile, Photoshop pranksters disseminated viral images: the headpiece with animals jumping from it like a circus hoop or framing a portal to another dimension. Treacy, who outfitted 35 heads that day (including Eugenie's), defended his creation, telling Britain's *Observer* he saw Beatrice as a "beautiful, exotic Victorian doll" and thought the look suited her. Treacy also criticized snarky wags for "bullying" the princess, who was 22 at the time. But Beatrice took it all in stride—and silenced critics, or at least shamed them a bit, by auctioning off the notorious hat on eBay for $130,710. The proceeds went to the UNICEF and Children in Crisis charities. "I am so happy that we have raised the most incredible amount of money," Beatrice said, "and can make an even bigger change for the lives of some of the most vulnerable children across the world."

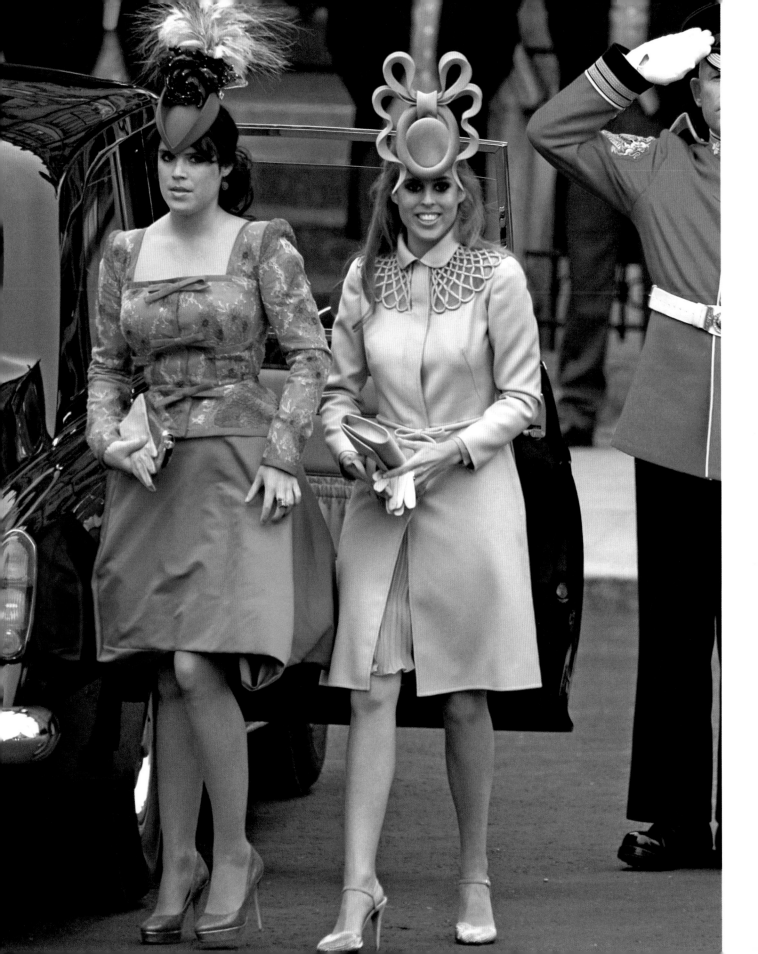

JENNIFER LAWRENCE
Robert Gauthier, 2013

'What went through
my mind? A bad word...
that starts with "F"'
—Jennifer Lawrence

WHEN JENNIFER Lawrence
tumbled on the stairs at the 2013
Academy Awards, it burnished her
real-gal image and resonated with
anyone who had ever experienced an
epic fail at the worst possible time.
"I remember that moment quite
vividly," says *Los Angeles Times* pho-
tographer Robert Gauthier, who was
in a control booth above the balcony
in Hollywood's Dolby Theatre with
several other shooters. "It's quite a
distance, and we are all equipped
with long lenses." When Lawrence
was announced as Best Actress for
Silver Linings Playbook, "I thought as
she stood up that my lens is a bit too
long to show her dress and the scale
of the stairway leading to the stage,"
Gauthier recalls. "The second I
concluded that thought, *Boom!* she
stumbles, pauses a little and walks to
the stage. I immediately wished I had
used a shorter lens to give the photo
more context. But over time I real-
ized the closer look brought a better
level of intimacy." Lawrence, who
has three additional Oscar nods,
didn't bother trying to act as if the
whole thing were planned. Asked
moments later in the press room
what happened on the stairs, she
retorted, "What do you mean, 'What
happened?' Look at my dress!"

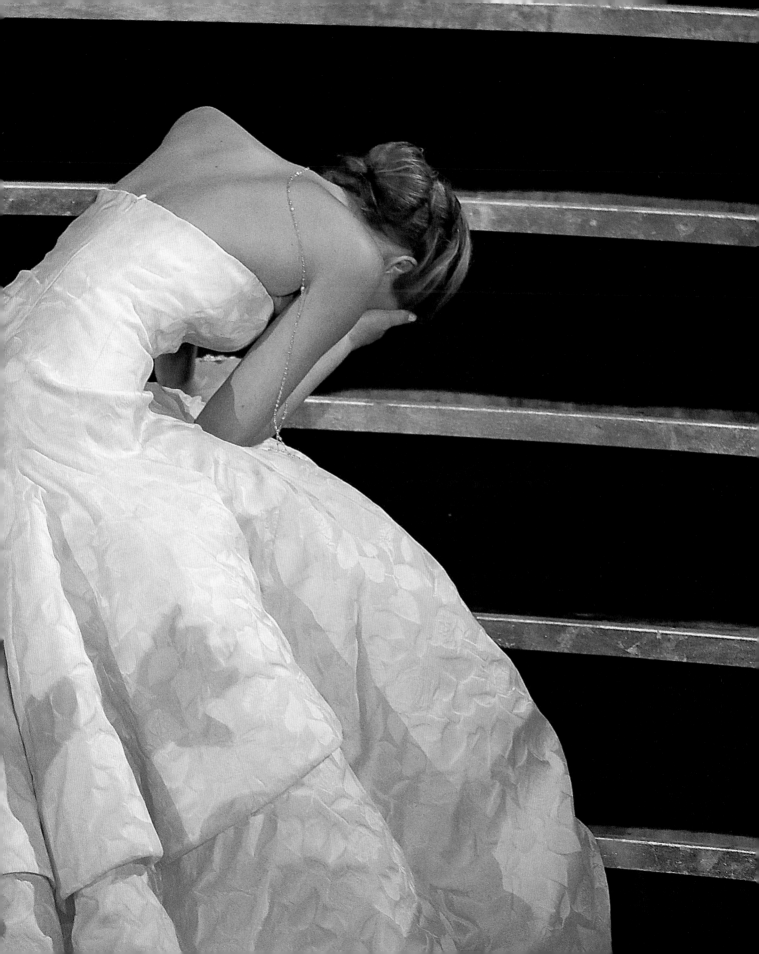

OSCAR GROUP SELFIE
Bradley Cooper, 2014

JUST FOR FUN, LET'S pull back the curtain on a little-discussed aspect of getting pictures into a magazine: credit. When a celebrity posts a photo on her social media account and it's clearly a selfie, the credit goes to the star herself if *People* gets permission to reproduce the image. But though it debuted on Beyoncé's Instagram, the photo of her with her twins is properly credited to the photographer, Mason Poole. If you've seen the picture at right, you probably think of it as "Ellen's Oscar Selfie." (If you haven't seen it…Does the light hurt your eyes after years of living under a rock?) Let's review: It was Oscar host DeGeneres's idea to set a retweet record by gathering famous friends into a group selfie. She pulled in (from left) Jared Leto, Jennifer Lawrence, Channing Tatum, Meryl Streep, Julia Roberts, Kevin Spacey, Bradley Cooper, Brad Pitt, Lupita Nyong'o (and her brother Peter, in glasses) and Angelina Jolie. With more than 3 million retweets, the photo did set a record, which it held for three years. Mission accomplished, Ellen! (And Samsung, for the product placement.) So why is Bradley Cooper's name at the top of this page? After the phone passed from DeGeneres to Streep, it fell to Cooper to press the button; he had the longest arms.

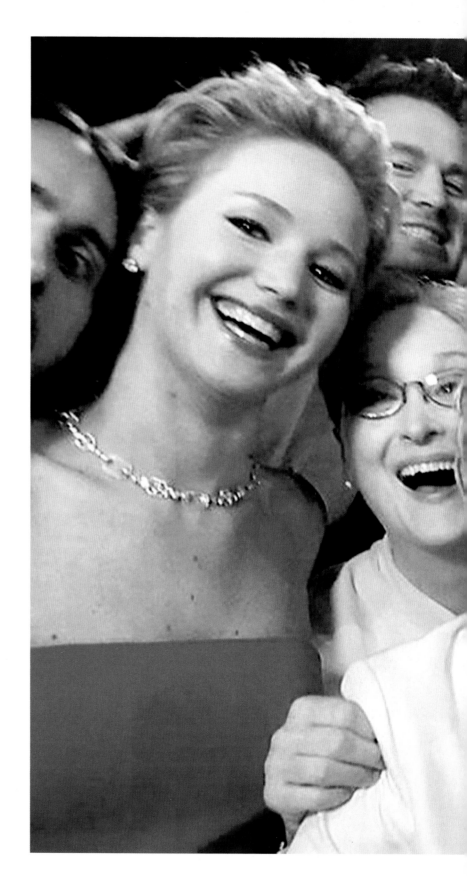

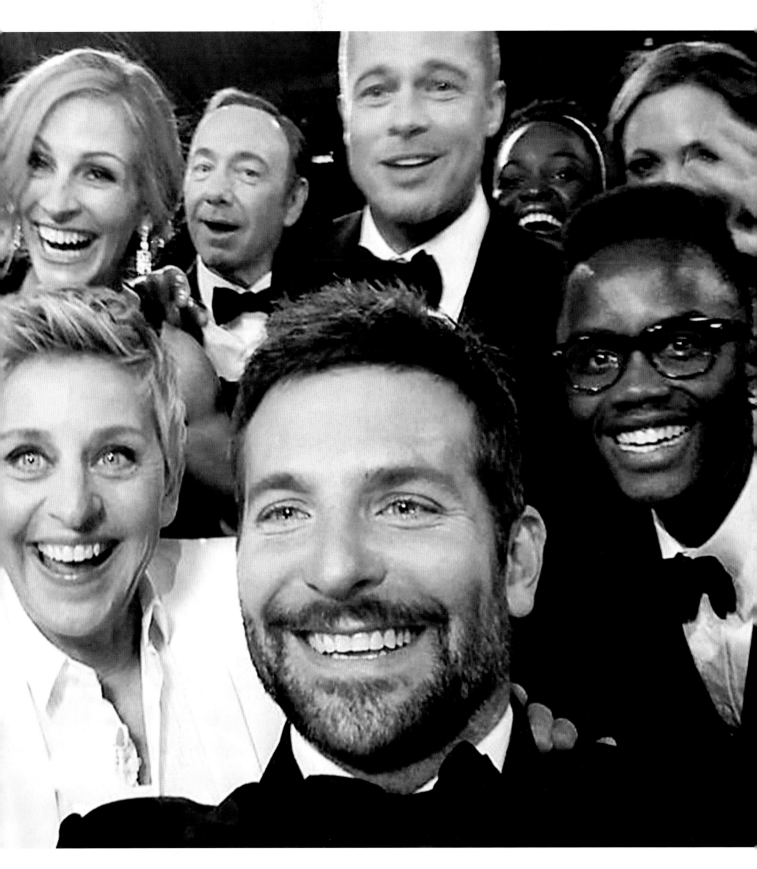

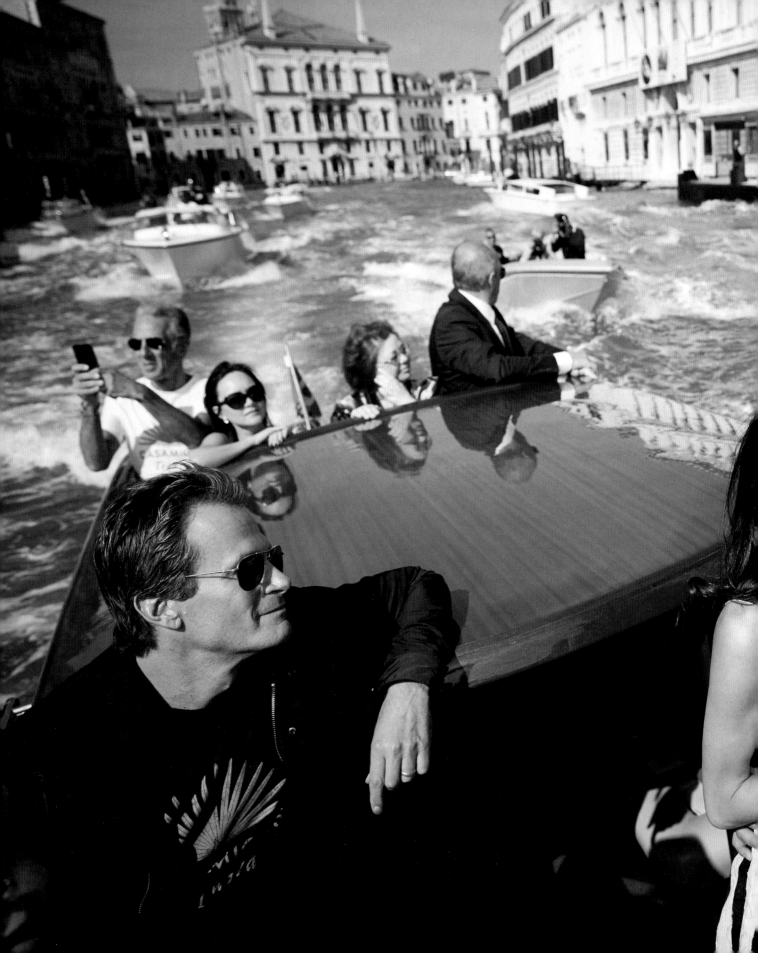

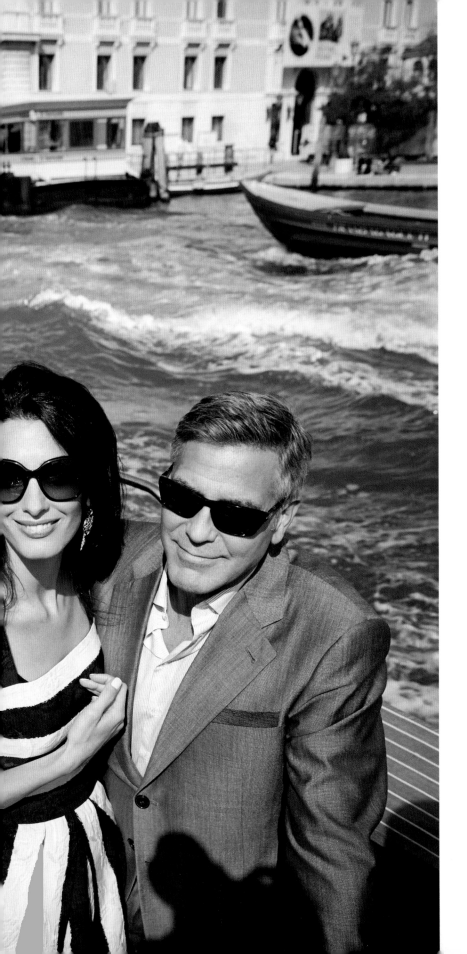

GEORGE CLOONEY & AMAL ALAMUDDIN
photographer unknown, 2014

'Venice is the most
romantic city in the world'
— George Clooney

IN MANY WAYS, George Clooney is a throwback: a leading man in the Grant-and-Gable mold—requisitely handsome but with the rakish glint of someone who doesn't take himself, or this whole movie star business, too seriously. The Oscar winner and social activist was also a resolute bachelor and serial dater—until British human-rights attorney Amal Alamuddin came along. They met at a 2013 dinner with mutual friends in Italy, where Clooney owns a home on Lake Como. "She was obviously very charming, gorgeous and so clearly accomplished," Clooney's father, Nick, who dined with them that evening, told *People*. "It was clear there was a kindness to her." By meal's end, Nick recalled, "his and her fates were sealed, both of them." A year later Clooney, then 53, and Alamuddin, 36, exchanged vows in Venice's Aman Canal Grande, a 16th-century palazzo turned hotel. (Among the guests: Clooney pal and business partner Rande Gerber, left, seen before the festivities.) Marriage "feels pretty damn great," Clooney told *People*. "We're looking forward to everything." In the spring of 2017 that included the arrival of their twins Ella and Alexander.

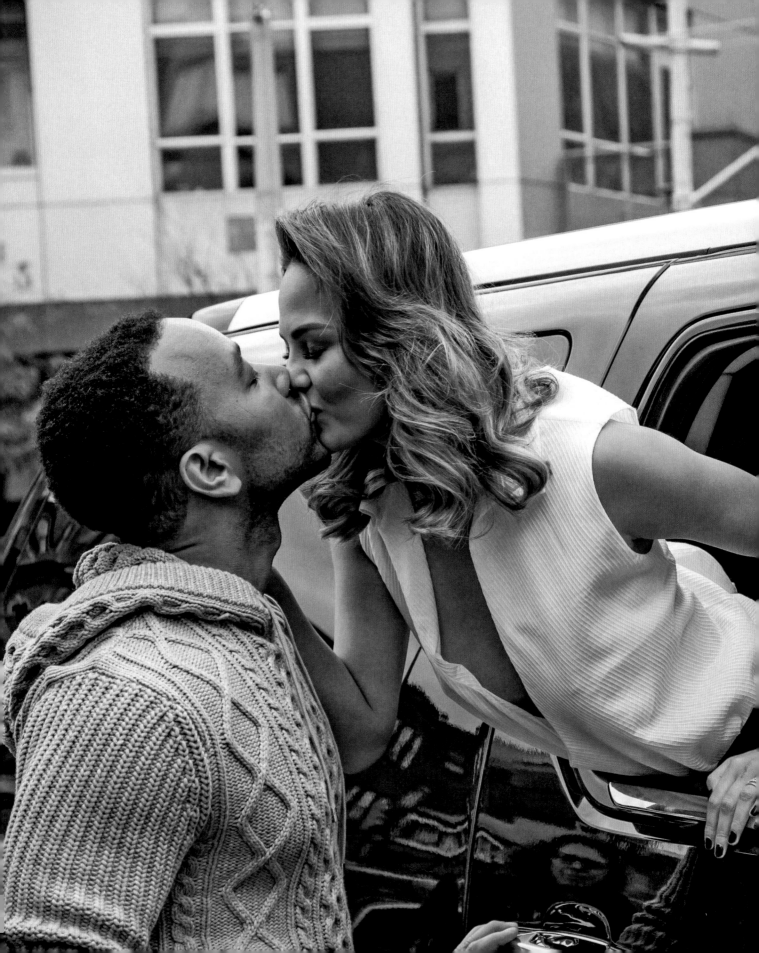

JOHN LEGEND & CHRISSY TEIGEN
Alessio Botticelli, 2014

'She's brought me out
of my shell a bit and made
me enjoy life a little
bit more' —John Legend

ALESSIO BOTTICELLI CAPTURED this smooch-with-pooch moment during a shoot in which the conceit was that singer John Legend and his wife, model Chrissy Teigen, were on a shopping spree to celebrate her 29th birthday. Teigen is a social media favorite whether she's sharing (or oversharing) Instagram intimacies or throwing Twitter darts at Donald Trump, who blocked her on that platform mid-2017. Naturally she posted this shot, captioned with characteristic exuberance: "Thank you to my beautiful, wonderful husband for throwing me such a wonderful birthday weekend spent with some of the most wonderful friends I could ever imagine, as if I'm not lucky enough year round." She and Legend, who calls theirs an "opposites attract" romance, wed in Lake Como, Italy, in 2013 and three years later welcomed daughter Luna, whom they presented on Instagram. Teigen was just as open about struggling with postpartum depression, showing that their seemingly picture-perfect lives are more complicated. Putting herself out there has invited sometimes unwelcome commentary, for instance as she worked to get back in the shape her modeling career requires. "You'll never be right to everybody," she said. "So you just live and do what you can do best."

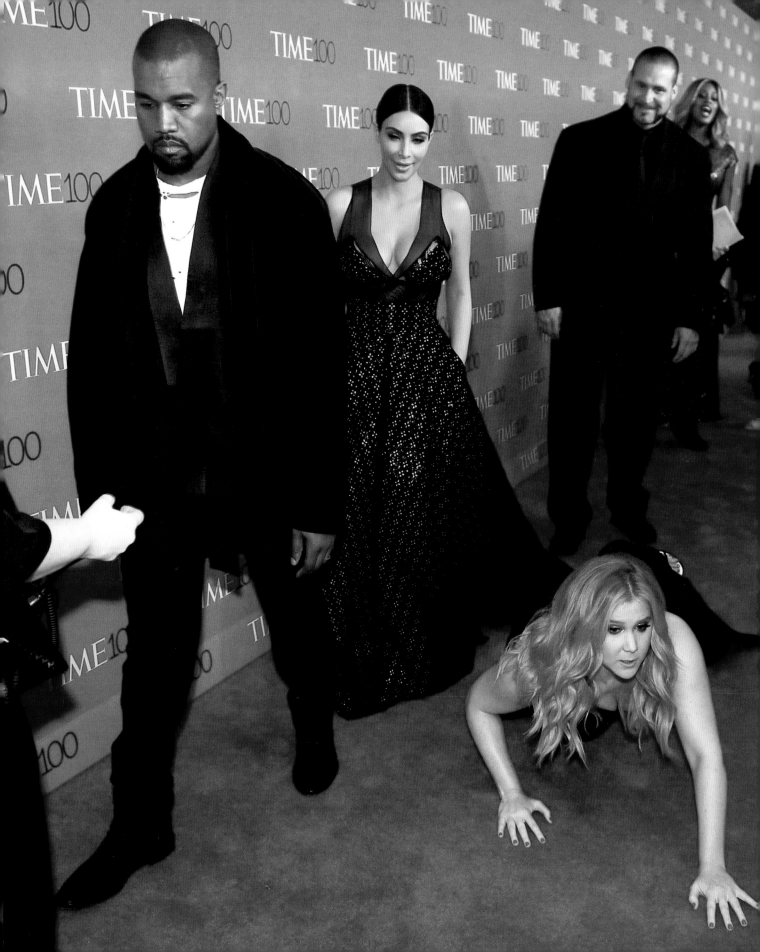

KANYE WEST, KIM KARDASHIAN & AMY SCHUMER
Timothy A. Clary, 2015

'Kim was worried for me, and I think Kanye was just, like, scared'
—Amy Schumer on her prank fall

IT'S THE COMEDIAN'S role to deflate pomposity, which is precisely what Amy Schumer did at the *Time* 100 Gala in 2015. The august annual event honors the world's most influential people, which that year included—along with Ebola-fighting geneticist Pardis Sabeti and German chancellor Angela Merkel—Schumer and the husband-wife duo of rapper Kanye West and reality TV empress Kim Kardashian. Sensing an opportunity when she realized she was behind "Kimye" in the press line, "I asked my publicist, 'Can I dive in front of them and act like I fell?' And she said, 'I can't stop you,'" Schumer later told *People*. "I just dove right down." Countless shutters snapped, but Timothy Clary's perfectly caught not only the pratfall but also Kardashian's bemusement and West's trademark scowl. Schumer, however, said there were no hard feelings when she approached the couple afterward. "They were really sweet," said Schumer. "[Kim] goes, 'Oh my God, I was like, "Does this girl need help?"' She was like, 'That was really funny.'" Whether they got the joke or not, Schumer couldn't pass it up. "They were right there! The epicenter of America! Gotta do it."

BEYONCE | *Christopher Polk, 2017*

"Beyoncé did all the work. The production lit it. And yes, I did the rest. I picked the right spot" —Christopher Polk

SHE WAS FOUR MONTHS PREGNANT with twins. So, while she is known for energetic choreography, it was understandable when Beyoncé opened her 2017 Grammy-night performance with a video projection, while the woman herself stood onstage, still and serene as a stone fertility goddess. To be honest, it would have been understandable if she had skipped the whole event and watched at home in her sweatpants, expending only the effort it takes to twist apart an Oreo. But it was a big night: She was nominated for nine awards for the very personal album *Lemonade*, which seemed to track the near-dissolution of her marriage. That night her union with Jay-Z (in attendance with their daughter Blue Ivy) looked stronger than ever as the couple anticipated their family expanding by two. (Sir Carter and Rumi would arrive in June.) And besides, this is Beyoncé, who announced her first pregnancy during her performance at the 2011 Video Music Awards (inset). The only other suggestion that she was taking it easy came when, before she began the first of two songs ("Love Drought" and "Sandcastles"), she strolled to a wooden chair and had a seat. But then the chair began to tip back into space, back and back, and back some more, as Beyoncé appeared to defy gravity. It was clear that she wouldn't be skimping on spectacle. In anticipation of that, Christopher Polk stationed himself away from the other shooters, who were aiming for her profile. "A lot of photographers may have thought her bump was the big story," says Polk. "I thought her musical performance was the big story."

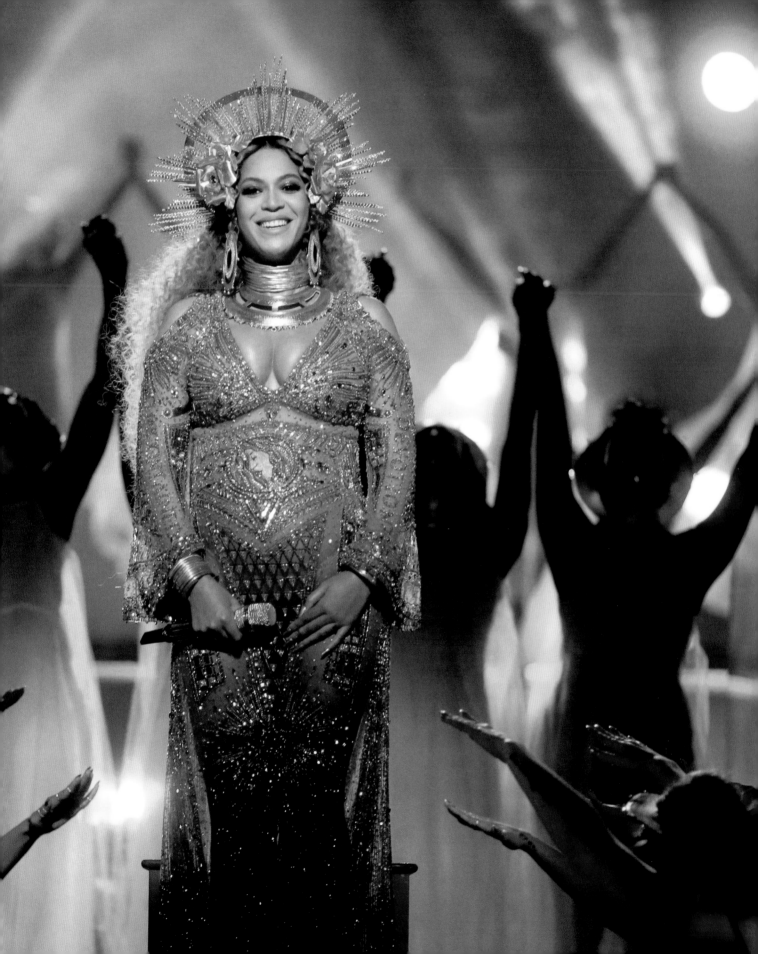

VIOLA DAVIS | *Andrew H. Walker, 2017*

'THIS IS SORT
OF LIKE THE
MIRACLE OF GOD,
OF DREAMING
BIG AND JUST
HOPING THAT IT
STICKS AND
IT LANDS.
AND IT DID'
—VIOLA DAVIS

HUNDREDS OF PHOTOGRAPHERS LINE THE RED CARPET before the Academy Awards each year, but only a handful get to shoot from backstage. After years of working arrivals, Andrew Walker finally landed a coveted spot in the wings and planned to make the most of his first time: "A split second is all it takes to catch something really cool or miss it." (Among the moments he caught: a PricewaterhouseCoopers accountant tweeting when he might better have kept track of which envelope he was handing to Best Picture presenters Warren Beatty and Faye Dunaway.) Onstage, another first. Actress Viola Davis was no newcomer to the Oscars. She had been nominated twice before. But this night she finally heard her name, a tribute to her work as Rose, the put-upon wife and mother in *Fences,* but also an acknowledgment of a career that spanned Shakespearean stages to a hit TV show. After receiving a standing ovation, she tearfully thanked God, playwright August Wilson, director and costar Denzel Washington, her husband and daughter. But in the split second that Walker caught, "she was taking a moment to collect herself briefly—your heart must be pounding out of your chest, and your breath must be racing. You must want to own that moment, and I think she's taking a second to do that." He saw her again offstage, and "'grateful' was the word I kept thinking. You could see it in her face."

Howell Conant
with Grace Kelly

Mary Ellen Matthews

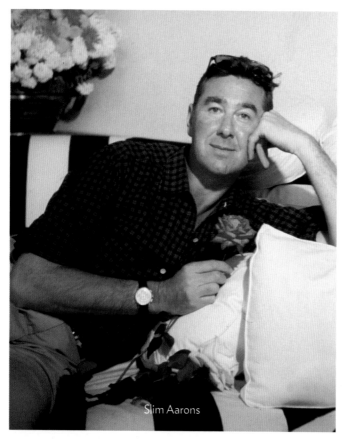

Slim Aarons

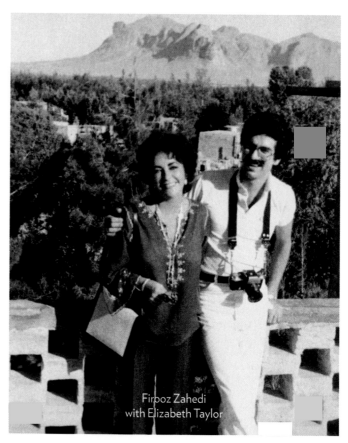

Firooz Zahedi
with Elizabeth Taylor

Image **CREDITS**

➔ı COVER / ENDPAPERS

Cover: (front) GC Wedding/Contour Photos/Getty Images; (back, from top) Steve Schapiro/Corbis/Getty Images; Timothy A. Clary/AFP/Getty Images; Endpapers: (front) Mark Shaw/MPTV Images; (back) Ken Regan/Camera 5

➔ı SNAPSHOTS FROM HOLLYWOOD'S MOUNT OLYMPUS

6 James Whitmore/The LIFE Picture Collection/Getty Images; **8-9** (from left) Movie Poster Images Art/Getty Images; Robin Platzer/Twin Images; **10** (from left) Kevin Winter/Getty Images; Courtesy Ellen DeGeneres/via Twitter; **11** (clockwise from top left) MPTV Images; Harry Eelman; Alfred Eisenstaedt/The LIFE Picture Collection/Getty Images; Nick Tooman

➔ı STRIKING A POSE

12, 15 Mark Shaw/MPTV Images; **16** Allan Grant/Time Life Pictures/Getty Images; **19** Paul Popper/Popperfoto/Getty Images; **20, 23** Steve Schapiro/Getty Images; **25** Terry O'Neill/Getty Images; **26** Robert Whitman; **28** Evelyn Floret/The LIFE Picture Collection/Getty Images; **30** Neal Preston; **32** Ken Regan/Camera 5; **34** Christopher Little; **36** Robert Trachtenberg/Trunk Archive; **38** Julian Wasser; **41** Michael Edwards/Redux Pictures; **42** Robert Trachtenberg/Trunk Archive; **44** Emily Shur/August Image; **46** Jeff Riedel; **48** Art Streiber/August Image; **50** Martin Schoeller/Art+Commerce; **52, 55** Ruven Afanador/CPI Syndication; **56** Chris Jelf/Kensington Palace/Getty Images; **59** Art Streiber/August Image

➔ı PRIVATE WORLDS

60 ©Harry Benson; **62** Jerome Zerbe/John Kobal Foundation/Getty Images; **65** The Kobal Collection/Rex Shutterstock; **66, 68** Sid Avery/MPTV Images; **70** CBS Photo Archive/Getty Images; **73** Warner Brothers/Getty Images; **74** Slim Aarons/Getty Images; **76** Sid Avery/MPTV Images; **78** Sunset Boulevard/Corbis/Getty Images; **81** Lawrence Schiller/©Polaris Communications Inc.; **82** Gene Trindl/MPTV Images; **84** Bob Willoughby/MPTV Images; **86** Ken Regan/Camera 5; **88** Michael Ochs Archive/Getty Images; **90** Julian Wasser; **92** Douglas Kirkland/Corbis/Getty Images; **94** ©Harry Benson; **97** Edie Baskin; **98** Julian Wasser; **100** John Jay/© Lucasfilm LFL 2016; **102** Brian Hamill/Getty Images; **104** Firooz Zahedi/My Elizabeth/Glitterati Incorporated/Trunk Archive; **106** Patrick Lichfield/Getty Images; **108** Ted Thai/Time & Life Pictures/Getty Images; **111** Courtesy Goldie Hawn; **112** Steve Smith; **114** Andrew Schwartz; **116** John Bryson/The LIFE Images Collection/Getty Images; **118** Ken Regan/Camera 5; **121** Ron Batzdorff/MPTV Images; **122** Neal Preston; **124** Danielle Levitt/August Image; **126** Mary Ellen Matthews/NBCUniversal

→I RED CARPET MOMENTS

128 Mike Marsland/Wireimage; **131** Reed Saxon/AP Images; **132** Jim Smeal/Wireimage; **135** Scott Gries/ImageDirect/Getty Images; **136** Andrew Winning/Reuters; **139, 140, 143** Charles Sykes/Invision/AP Images; **145** George Pimentel/Wireimage; **146** Mike Marsland/Wireimage; **148** Rob Latour/Rex Shutterstock

→I MAKING HEADLINES

150 (clockwise from top left) Timothy A. Clary/AFP Photo/Getty Images(2); Taylor Hill/Getty Images(2); Evan Agostini/Invision/AP Images; Kevin Mazur/Getty Images; **153** Photofest; **154** Gordon Parks/The LIFE Picture Collection/Getty Images; **156, 157** Sam Shaw/Shaw Family Archives/Getty Images; **158** Howell Conant/Bob Adelman Books, Inc.; **160** Joe Shere/MPTV; **162** Bettmann Archive/Getty Images; **164** Zuma Press; **167** Rowland Scherman/PhotoQuest/Getty Images; **168** ©Harry Benson; **170** Ruud Hoff/AFP/Getty Images; **173** CBS Photo Archives/Getty Images; **174** Ron Galella/Wireimage; **177** Nihon Denpa News/AP Images; **178** Robin Platzer/Twin Images; **181** Ron Galella/Wireimage; **182** Walter McBride/Corbis/Getty Images; **184** Gene Arias/NBCU Photo Bank/Getty Images; **187** Ron Frehm/AP Images; **188** Pete Souza/Ronald Reagan Library/AP Images; **190** Paul Natkin; **192** Michael Zagaris/Getty Images; **194** Neshan H. Naltchayan/Reuters; **196** Hal Garb/AFP/Getty Images; **198** J. Redden/UNHCR; **200** Alessandro Bianchi/Reuters; **202** Leon Neal/AFP/Getty Images; **205** Steve Parsons/Press Association/AP Images; **206** Robert Gauthier/Los Angeles Times/Polaris; **208** Ellen DeGeneres/via Twitter/AP Images; **210** GC Wedding/Contour Photos/Getty Images; **212** Alessio Botticelli/GC Images/Getty Images; **214** Timothy A. Clary/AFP/Getty Images; **216** Kristian Dowling/Getty Images; **217** Christopher Polk/Getty Images; **219** Andrew H. Walker/Rex Shutterstock

→I IMAGE CREDITS

220 (clockwise from top left) ©Howell Conant/Bob Adelman Books, Inc.; David X Prutting/Patrick McMullan/Getty Images; Arthur Bruckel/My Elizabeth/Glitterati Incorporated; Slim Aarons/Hulton Archive/Getty Images

People

PEOPLE
Editorial Director Jess Cagle
Deputy Editor Dan Wakeford
Creative Director
Andrea Dunham
Director of Photography
Catriona Ni Aolain
Director of Editorial Operations
Alexandra Brez

PEOPLE 100 PHOTOS
Editor Allison Adato
Art Director Greg Monfries
Photo Editor C. Tiffany
Lee-Ramos (*People* Books)
Photo Editor Sarah Burrows
(*People* Magazine)
Writers Richard Jerome,
Kenneth Miller
Reporters Mary Hart,
Ellen Shapiro, Logan Verlaque,
John Wojno
Copy Desk Joanann Scali (Chief),
James Bradley (Deputy),
Ellen Adamson, Gabrielle
Danchick, Richard Donnelly,
Ben Harte, Rose Kaplan,
Matt Weingarden (Copy Editors)
Production Designer
Peter Niceberg
Premedia Executive Director
Richard Prue

Imaging Production Manager
Romeo Cifelli
Premedia Manager
Rob Roszkowski
Imaging Production Associate
Ana Kaljaj
Special Thanks J.D. Heyman,
Andrea Lavinthal

TIME INC. BOOKS
Editorial Directors
Kostya Kennedy, Anja Schmidt
Creative Director Gary Stewart
Editorial Operations Director
Jamie Roth Major
Managing Editor
Elizabeth Austin
Manager, Editorial Operations
Gina Scauzillo

Prepress Manager
Alex Voznesenskiy
**Assistant Project and Production
Manager** Kelsey Smith

Copyright © 2017
Time Inc. Books

Published by Liberty Street,
an imprint of Time Inc. Books
225 Liberty Street
New York, NY 10281

ISBN: 978-1-68330-067-0
Library of Congress Control
Number: 2017942485
First edition, 2017
1 QGV 17
10 9 8 7 6 5 4 3 2 1

We welcome your
comments and suggestions
about Time Inc. Books.
Please write to us at:

Time Inc. Books
Attention: Book Editors
P.O. Box 62310
Tampa, FL 33662-2310
(800) 765-6400

timeincbooks.com

Time Inc. Books products
may be purchased for
business or promotional use.
For information on bulk
purchases, please contact
Christi Crowley in the
Special Sales Department
at (845) 895-9858.

THE 1OO BEST CELEBRITY PHOTOS

Visit 100photos.people.com
for an interactive gallery, video, interviews
and more stories behind the pictures.

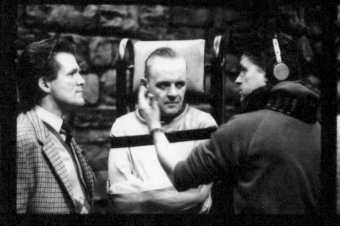

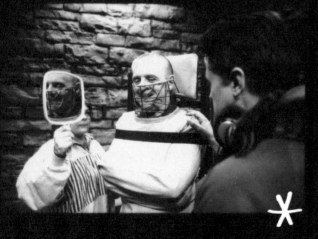
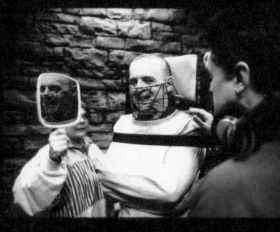